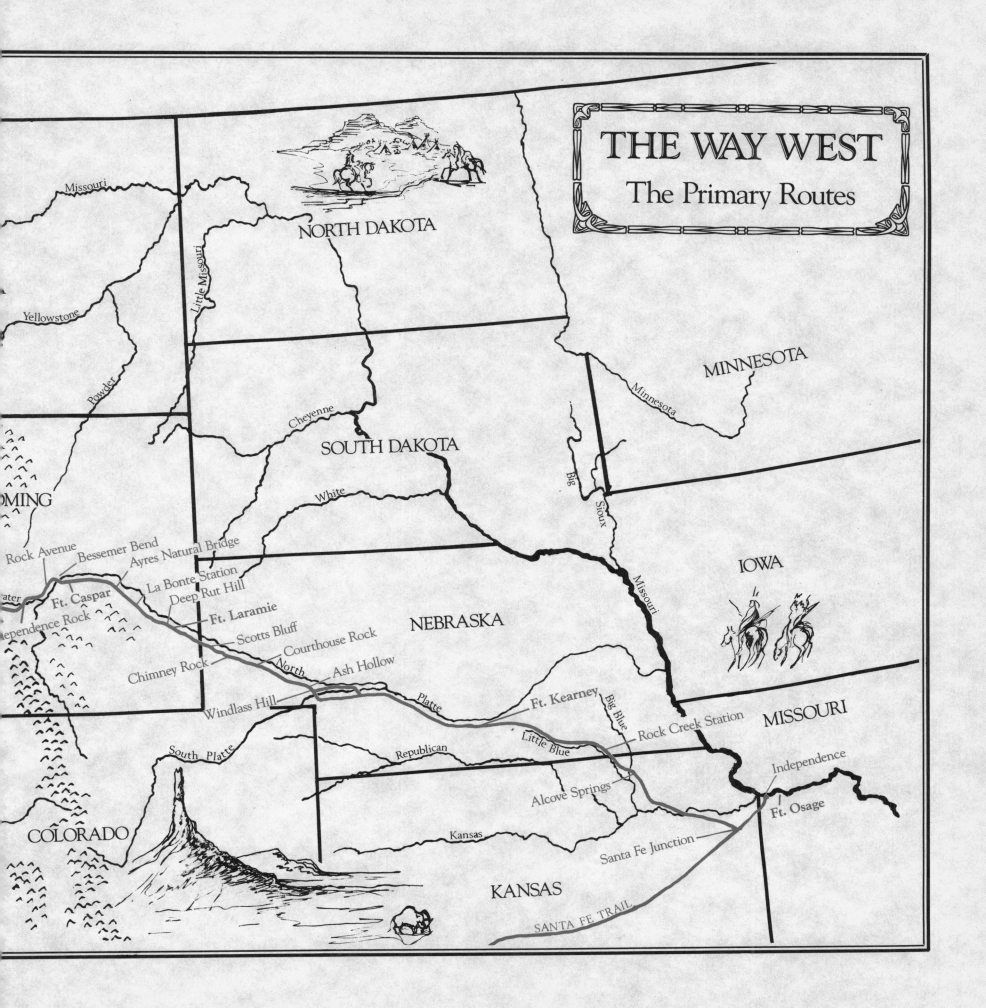

THE WAY WEST
The Primary Routes

NORTH DAKOTA

MINNESOTA

SOUTH DAKOTA

Cheyenne

White

Big Sioux

Missouri

IOWA

WYOMING

Yellowstone

Powder

Missouri

Little Missouri

Rock Avenue

Bessemer Bend

Ayres Natural Bridge

La Bonte Station

Deep Rut Hill

Ft. Caspar

Independence Rock

Ft. Laramie

Scotts Bluff

Courthouse Rock

Chimney Rock

North

Ash Hollow

Windlass Hill

NEBRASKA

Ft. Kearney

Big Blue

Rock Creek Station

MISSOURI

Platte

Little Blue

South Platte

Republican

Alcove Springs

Independence

COLORADO

Kansas

Santa Fe Junction

Ft. Osage

KANSAS

SANTA FE TRAIL

ON THE OREGON TRAIL

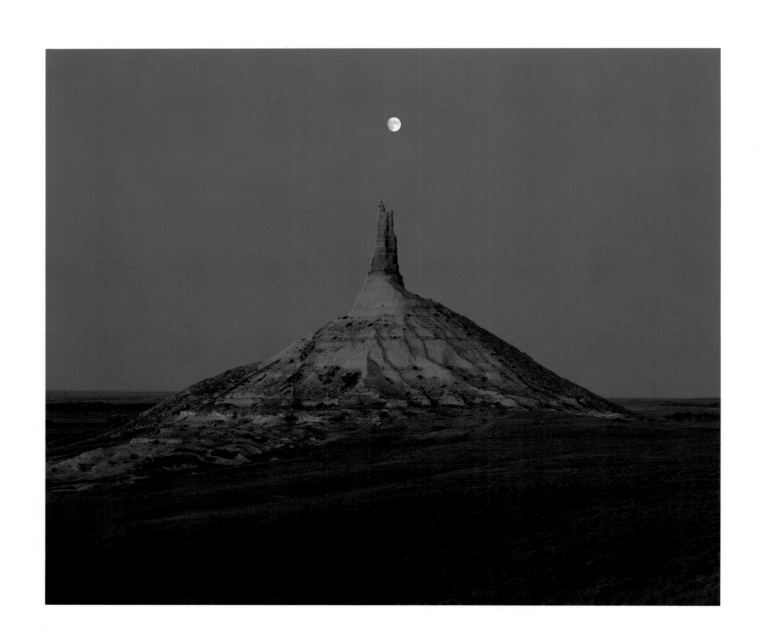

ON THE OREGON TRAIL

TEXT BY

JONATHAN NICHOLAS

PHOTOGRAPHY BY

RON CRONIN

GRAPHIC ARTS CENTER PUBLISHING COMPANY, PORTLAND, OREGON

To the land,
which asks only that we walk gently.

JONATHAN NICHOLAS

ACKNOWLEDGMENTS

In making the photographs for this book, I received assistance from a great number of people. Among them were Jeanne Miller and Pauline Fowler with the Oregon-California Trails Association in Independence, Missouri; Dr. Ted Barkley, director of the Konza Prairie Research Natural Area, Kansas; Gordon Howard, owner of the land at Chimney Rock, Nebraska; Chief Ranger Palma Wilson and the staff at Scotts Bluff National Monument, Nebraska; Nancy Russell, friend of the Columbia Gorge; Nancy Wilson, curator of the McLoughlin House in Oregon City, Oregon; Chet Orloff and the staff at the Oregon Historical Society; the Historic Preservation League of Oregon; the Museum at Warm Springs; the Oregon Trail Coordinating Council; the Office of Historic Properties, Oregon; and Photo Craft, Inc., in Portland, Oregon.

RON CRONIN

Stephen Dow Beckham
Historical Consultant

International Standard Book Number 1-55868-101-9
Library of Congress Number 92-71576
© MCMXCII by Graphic Arts Center Publishing Company
P.O. Box 10306 • Portland, Oregon 97210
President • Charles M. Hopkins
Editor-in-Chief • Douglas A. Pfeiffer
Managing Editor • Jean Andrews
Designer • Maria and Ron Cronin
Typographer • Harrison Typesetting, Inc.
Color Separations • Agency Litho
Printer • Dynagraphics, Inc.
Bindery • Lincoln & Allen
No part of this book may be reproduced by any means
without the permission of the publisher.
All paintings are by Alfred Jacob Miller and are
courtesy of Walters Art Gallery, Baltimore.
Printed in the United States of America

Contents

THE OREGON TRAIL CROSSING SOUTH PASS, WYOMING. For years, the soaring wall of the Rockies was regarded as a virtually impenetrable barrier to pioneer traffic across the continent. The 1812 journey of fur trader Robert Stuart through this low-lying pass opened the way for subsequent wagon traffic.

*It ill comports with the ideas we have formed of a pass through the Rocky Mountains, being
merely a vast, level and sandy plain, sloping a little on each side of the summit,
and a few hills, for we could not call them mountains, on each side.*
Cecelia Adams, 1852

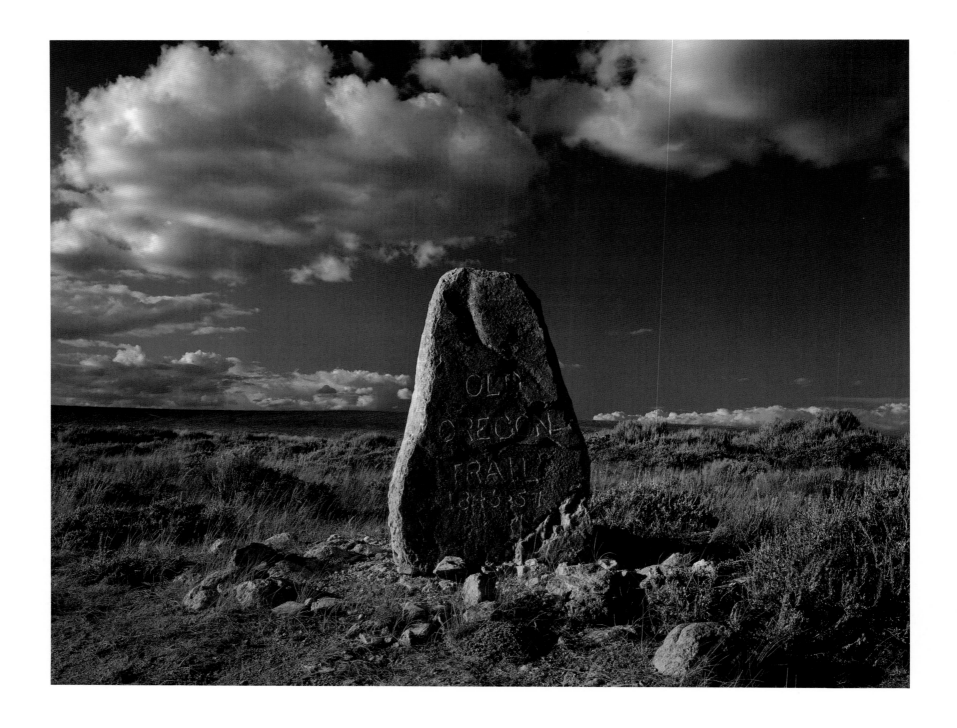

EZRA MEEKER MONUMENT, SOUTH PASS, WYOMING. Ezra Meeker, an 1852 pioneer, retraced his steps in 1906, urging communities along the route to mark and memorialize the historic highway. He personally hauled this slab to the summit of the pass through which more than two hundred thousand pioneers walked.

From my boyhood, I have had a preference for Oregon —
a desire to visit and examine for myself,
and see if the half had been told.
Origen Thomson, 1852

Walking in the Footsteps

In the cold spring of 1843, almost three hundred men, half that number of women, and more than five hundred children gathered at the Missouri River and turned their eyes toward the West. Then they waited. On May 22, when the new grass on the prairie finally was tall enough for oxen to graze, they loaded up their wagons and set off to walk two thousand miles to Oregon. One hundred fifty years later, we set out to walk in their footsteps.

We had in mind creating a book that might provide a glimpse of how the West looked to those who blazed a trail across it, to those who marched from the small Missouri town of Independence to Oregon's Willamette Valley, the place emigrants called "The land at Eden's gate."

To that end, almost all of the photographs in this book were taken of, or from, the Oregon Trail. In many cases, the camera's tripod actually stood in the ruts and swales, those enduring scars etched deep into this fragile landscape by the passing of tens of thousands of heavily laden wagons.

We strove to visit, and to record, each section of the Trail in the month when the pioneers walked it, for their journey was, above all else, seasonal. They began when spring grass greened, hurried to reach Independence Rock by the Fourth of July, then pressed on to cross the Cascade Mountains before the arrival of the winter snows.

The Trail we followed ran from Independence to Oregon City. The Oregon Trail was, however, much more than that. Pioneers basically followed a single route to crest the Rockies at South Pass, then fanned out across the West. Some, mostly Mormons, turned toward the Great Basin. Many pressed forward into California. Others followed the Applegate Trail to the southern Oregon valleys of the Umpqua and the Rogue.

In the process of retracing one of these trails and some of its supposed short-cuts, we encountered much of what the pioneers endured—blazing sun, sudden blizzards, torrential downpours, seamless gales, hailstones the size of tobacco pouches. We saw thunder, lightning, much dust, much mud . . . and much grandeur. We camped in the places where pioneers "nooned" or bedded down for the night. We bathed in the same springs, dozed in the same shadows, slept beneath the same stars.

Much of the Oregon Trail has been lost, plowed under, drowned by dam builders, erased by those who dug pipelines. Less than fifteen percent of the Trail remains clearly visible. More still is being lost. Of the miles surviving, many cross public lands easily accessible to those with a team of mules, a sturdy motor vehicle, or the will for a hike.

We had much assistance in the completion of this work. It came from the hundreds of historians and scholars, researchers and "rutnuts" who traveled the Oregon Trail before us. Time after time, their diligence unearthed figurative needles in literal haystacks, accurately identifying, after years of obfuscation, authentic historic sites. We are especially indebted to the work of four men.

In 1969, the Nebraska State Historical Society published *The Great Platte River Road* by Merrill J. Mattes, former superintendent of Scotts Bluff National Monument. Mattes' research involved more than seven hundred original manuscripts detailing the pioneer experience.

In 1972, the United States National Park Service commissioned Aubrey L. Haines, a retired park historian at Yellowstone National Park, to research the most important sites along the entire length of the Oregon Trail. His work, published in 1981 by the Patrice Press, is an indispensable guide to 394 *Historic Sites Along The Oregon Trail.*

In 1979, the University of Illinois Press published *The Plains Across,* an exhaustively researched work by John D. Unruh, Jr., that finally laid to rest many of the most enduring myths of the pioneer experience.

In 1982, Gregory Franzwa, the founder of the Oregon-California Trails Association, published a series of *Maps of the Oregon Trail,* recording the entire 1,924-mile length of the Trail, clearly identifying all remaining visible ruts.

We are also indebted to all those Oregonians, descendants of pioneers, who shared with us letters, scrapbooks, and memories; to the Oregon Historical Society; and to owners of private land crossed by the Trail who granted us access to their property.

Many of the excerpts from pioneer diaries included herein have been amended for consistency of punctuation and spelling. Though initial encounters with such phrases as "the bote sunck" may seem charming, we feared the reader might too soon tire of struggling across the "prearia," the "pariare" and the "parie." Not all of the diarists quoted ended their journey in Oregon. Many went to California or Salt Lake.

The nineteenth-century oil paintings and watercolors that grace this and other pages of text are the work of Alfred Jacob Miller, the son of a Baltimore grocer. Miller was twenty-seven when he joined an American Fur Company expedition as it traveled into the Oregon Territory to attend the annual fur trappers' rendezvous of 1837. His paintings provide a remarkable glimpse of life along the Oregon Trail on the eve of the Great Migration. They are the most accurate visual representation we have found of the canvas upon which the pioneer experience was etched.

It is our hope that, 150 years hence, people still may walk this Trail and cross a canvas as magnificent as that we encountered on our journey.

JONATHAN NICHOLAS

The Lost Greenhorn

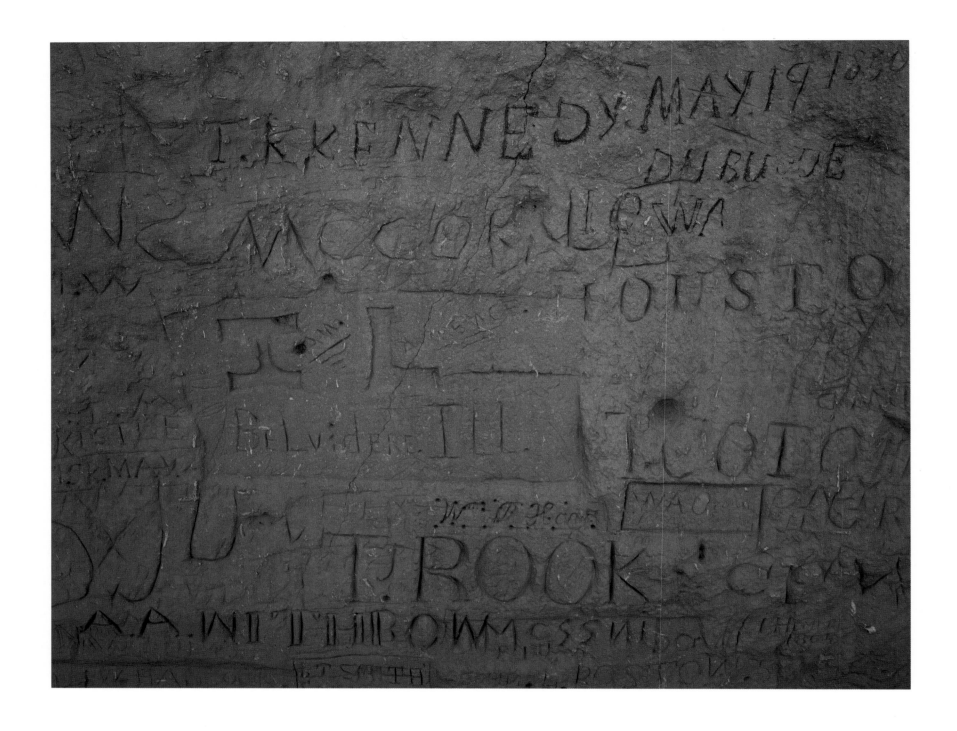

REGISTER CLIFF, WYOMING. The emigrants who left Missouri in 1843 were headed for an uncertain future in an uncertain land. Among the few things they knew about the Willamette Valley was that it was not even part of the United States. Still, they walked west, leaving their mark on every available rockface.

Only think of it, men, women, and children forsaking their homes . . . setting out on a journey of over 2,000 miles upon a route where they will have to make their own roads, construct their own bridges, hew out their own boats, and kill their own meat . . .
Congressman John Wentworth, 1843

DEEP RUT HILL, WYOMING. Deep Rut Hill boasts the most remarkable of all surviving Trail ruts. This erosion, which was begun by pioneer wagons, was completed by freight and military supply trains that traveled this route through the 1860s. Still, wagons were so uncomfortable most pioneers walked.

The younger women were rather shy in accepting the inevitable
but finally fell into the procession, and we soon had
a community of women wearing bloomers.
Ezra Meeker, 1852

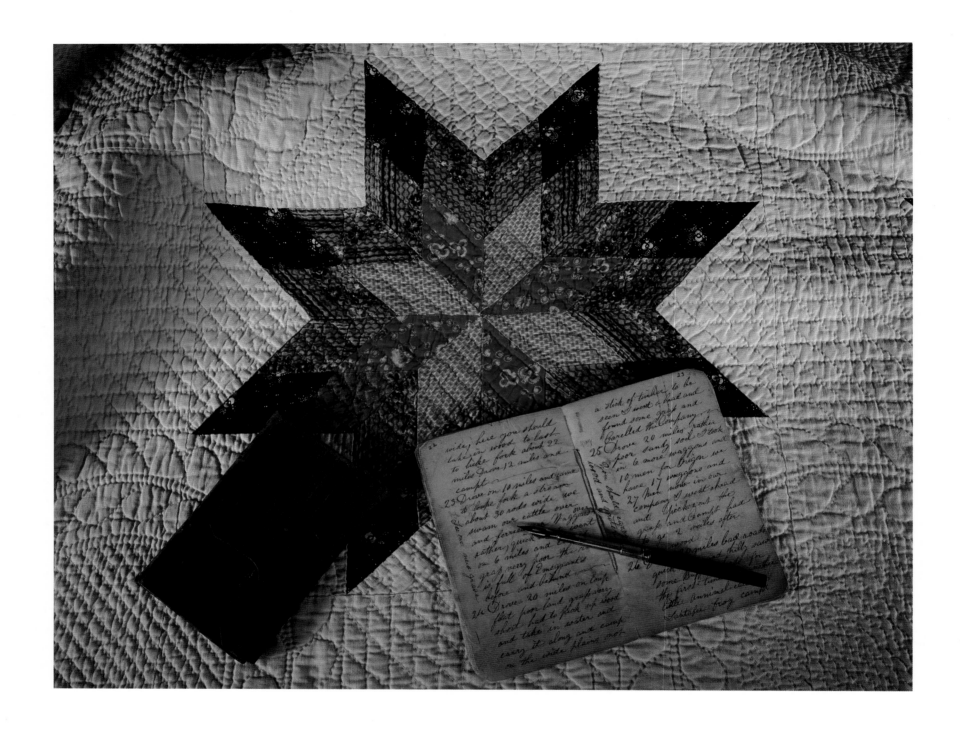

THE DIARIES OF GEORGE BELSHAW AND A PIONEER QUILT. On March 23, 1853, George Belshaw left Lake County, Indiana, leading a company of ten wagons and twenty-five people bound for Oregon. With him were his wife and three children, his parents, and his three brothers and their families.

Getting our provisions as fast as possible and holding on a little for the grass to grow here,
yet we have been to town today and got the balance of our provisions
and making preparations to try the Plains.
George Belshaw, 1853

The Pages of History

The diary is small, about five by three and one-half inches. It fits into the palm of a single hand. Its leather cover, blackened by use and burnished by time, feels soft, smooth. A single tongue of hide snakes around the slim volume, closing tight its secrets.

On page one, the writer, inspired by the challenge of all those blank pages, dutifully inked a list. "Friends to write to: John Jones. Alfred Foster. James Brannon. William McCarty. Smiley McCarty. Archer Diamond. George Daniels. Uncle Ben."

Clearly this author was a man who knew what lay before him, for he reserved pages two and three of his diary for the recording he knew would fill the months ahead: "Dead Cattle. New Graves." Then, in neat, ordered hand and simple, understated prose, George Belshaw recorded, day by day, the remarkable story of his 1853 crossing of the Oregon Trail.

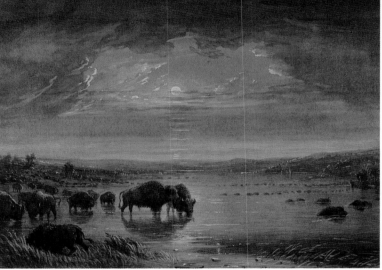

The men and women who walked two thousand miles to Oregon did not have to be told they were marching into history. From the moment they left Missouri, the pioneers sensed they were engaged in an adventure that would not be forgotten. Hundreds of them recorded the joys and the heartaches, the terrors and the splendors, of their journey to settle the West. Researchers have located more than eight hundred pioneer diaries, but the literature does not end here. In addition, there are thousands of emigrant letters, some written from the Oregon Trail and then carried east by turn-arounds, many others composed from the wintering calm of the land emigrants found at the end of the road.

There are also the reminiscences—some penned soon after the pioneers arrived in Oregon, others emerging as old-timers were spurred to reflection by the autumn of their years. Pioneer reminiscing, while entertaining, tends to be far less reliable than the diaries. In retrospect, the Trail seems to have been heavily populated with attacking Indians and marauding grizzlies. In hindsight, coyotes howl louder and buffalos stampede longer. Wolves don't just chase a fellow up a tree, they stick around to gnaw at its trunk.

The careful researcher approaches even the diaries with a wary eye. Some pioneers, well versed in the poetry of the nineteenth century, waxed lyrical over each and every dawn. Consider Peter Decker's 1849 prose: "The golden beams of the sun kissed the undulating plains and lighted a clear and beautiful sky. The heavy drops of dew hung like pearls in the wild oats"

Then there were those, tired of the effusive prose that packed so many Trail guidebooks, who confined themselves to the "No Big Deal" school of writing. In 1854, when Benjamin Ferris reached Chimney Rock, he had this to say about the Trail's most famous landmark: "This curiosity has been well described. I will not inflict another upon the reader."

Some diaries tend to the factual. H. D. Barton's less-than-spirited account proclaims of the kind of day he had on May 3, 1865: "Nothing remarkable—drove about 20 miles." Others tend more to the details. In 1856, Helen Carpenter caught her first glimpse of the Pawnees. "They have no clothing but are wrapped in very unsanitary looking blankets, and are adept in the management of them. Without pins or string, the blankets are kept in place, and there is no undue exposure of the person."

Paper and ink were at a premium. This perhaps explains the pioneer fondness for extremely small writing, and for consistently disregarding many of the proprieties of both punctuation and paragraphing. This practice can make especially laborious the business of reading the original manuscripts. Add to that the frequency with which the wagons were flooded, leaving prose with that washed-out look, and the laborious takes two giant strides toward the impossible. Finally, researchers reserve a special place in their hearts for that handful of emigrants, pioneer conservationists, who were determined to eke the most from each square inch of every page. They engaged in crisscross writing— penning vertical lines that crossed back over the horizontal.

There were, too, those who crossed the Trail specifically for the purpose of writing about the experience. In 1846, Francis Parkman, Jr., a twenty-two year old fresh from Harvard, set out to "study the manners and character of Indians in their primitive state," a task he set himself because he sensed their way of life was doomed. Parkman regarded the Indians as little more than colorful "savages." However, his subsequent book, *The Oregon Trail*, portraying pioneers with their "broad-brimmed hats, thin visages and staring eyes," is one of a handful of enduring classics of nineteenth-century literature from the West.

Still, when all is read and done, the most remarkable legacy of the extensive pioneer literature is how different a picture it paints than the Hollywood version of the West. Hardly ever did pioneers rush to circle their wagons in the face of attacking Indians. Far more emigrants accidentally shot themselves than fell to arrow and bow. There was drama enough in the story to leave one wondering why it had to be so embellished. The answer surely lies in the American need for myth-making as a salve for its history, in the young nation's yearning for an interpretation of its beginnings that might deny the genocide that accompanied the opening to settlement of the West.

Buffalos Drinking and Bathing at Night

SUNSET, MISSOURI RIVER, FORT OSAGE, MISSOURI. In the middle of the nineteenth century, thousands of pioneers began their journey by riding steamboats upriver to the great bend where the "Big Muddy" swings north. From there, emigrants "jumped off" from the known to the unknown world.

We were now about to penetrate a country at least two thousand miles in width,
on which the foot of civilized man has never trodden; the good or evil
it had in store for us was for experiment yet to determine.
Meriwether Lewis, 1804

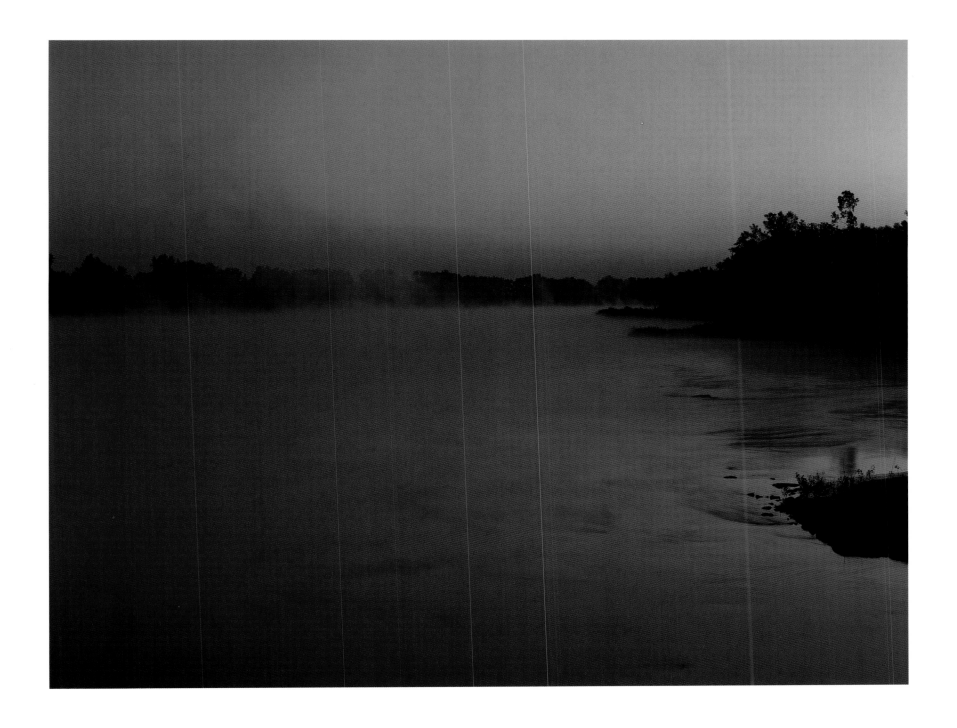

SUNRISE, MISSOURI RIVER, INDEPENDENCE LANDING, MISSOURI. Proudly trumpeting its role as the "Queen City of the Trails," Independence was a boom town serving pioneers heading for both the Santa Fe and Oregon trails. Among its many attractions were an uncommon number of grogshops.

We had a barbecue, tapped a keg of good old brandy,
and all hands got gentlemanly tite.
Simon Doyle, 1849

ROAD TO BLUE MILLS LANDING, MISSOURI. The early days along the Trail served as a shakedown cruise for families and their livestock. Many emigrants "jumped off" having little experience with wagons. Accidents were common, but nothing, not even fear of the unknown, could deter the pioneer spirit.

We are told that the Elephant is in waiting, ready to receive us . . . if he shows fight
or attempts to stop us on our progress to the golden land,
we shall attack him with sword and spear.
James D. Lyon, 1849

Mileage is calculated from the courthouse square in Independence, Missouri. Mile 9

CROSSING OF THE BIG BLUE RIVER, MISSOURI. People had little time to settle into the tricky business of handling a wagon and raw team before contending with their first river. Negotiating the steep banks of the Big Blue was the first of countless challenges.

Several persons are drowned at this crossing every year . . . Such horrid noises caused by the braying of the asses, lowing of oxen, screaming of women and children . . . was enough to becraze the greatest stoic . . .
Dr. E. A. Tompkins, 1850

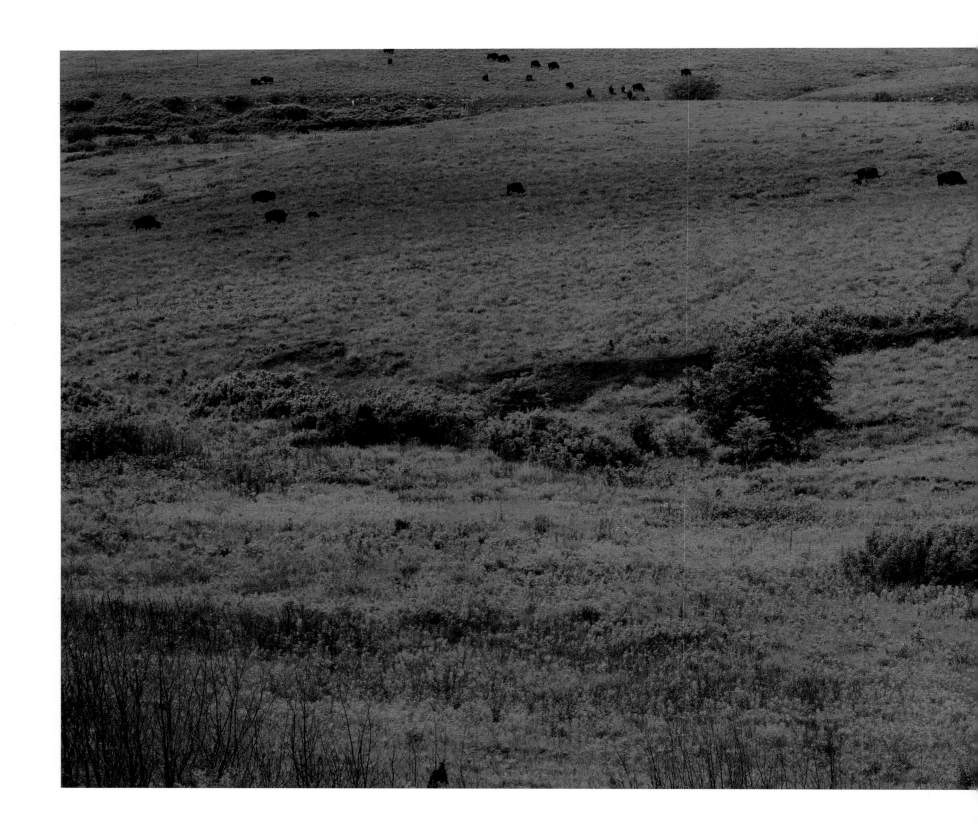

BUFFALO GRAZE ON THE KONZA PRAIRIE, KANSAS. Native Americans hunted the buffalo that once roamed in vast herds across the prairie, supplying many of the tribes' needs. Pioneers seemed to prefer killing them for sport. This wanton destruction was one early cause of conflict between Indians and Whites.

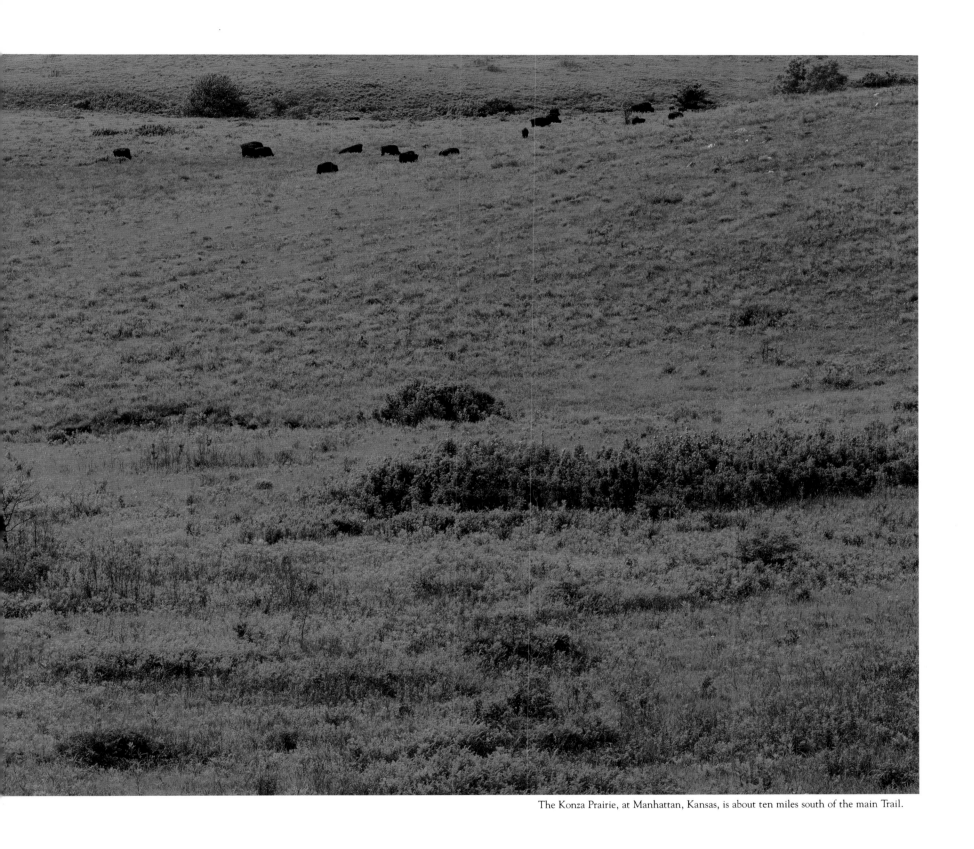

The Konza Prairie, at Manhattan, Kansas, is about ten miles south of the main Trail.

The valley of the Platte for two hundred miles presents the aspect of . . . a slaughter yard . . .
Such waste of the creatures that God has made for man seems wicked, but every
emigrant seems to wish to signalize himself by killing a buffalo.
Isaac Foster, 1849

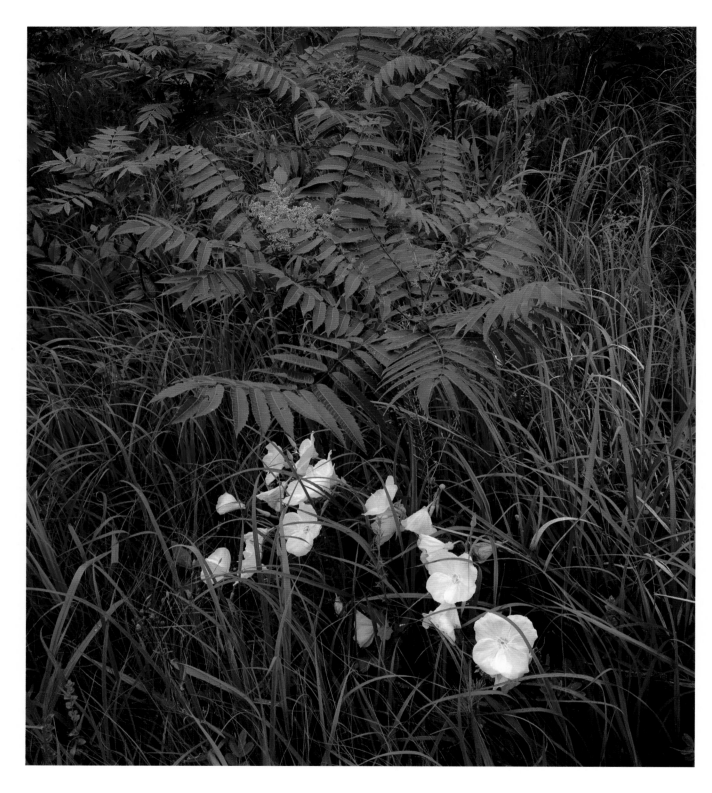

SMOOTH SUMAC AND PRIMROSE, FLINT HILLS PRAIRIE, KANSAS. In the summer, the so-called tall-grass prairie sends grasses towering over head height; but first, in the spring, it bursts into flower. However, Mother Nature is not the only one full of surprises.

The woman rode with one foot on one side of her pony and the other
foot on the other side. This is the greatest curiosity I have
ever seen, it knocks everything else into the shade.
Loren B. Hastings, 1847

Mile 165

ALCOVE SPRINGS, KANSAS. Almost constant thunderstorms and torrential rain across the prairie caused rivers to swell and run muddy. Clear springs were all too rare a find. Here, pioneers found both good water and a tranquil, parklike setting that afforded respite from the rigors of the emigrant road.

About three-fourths of a mile from our camp we found a large spring of water, as cold and pure as if it had just been melted from ice. It gushes from a ledge of rocks. The whole is buried in a variety of shrubbery of the richest verdure. We named this "Alcove Spring."
Edwin Bryant, 1846

9

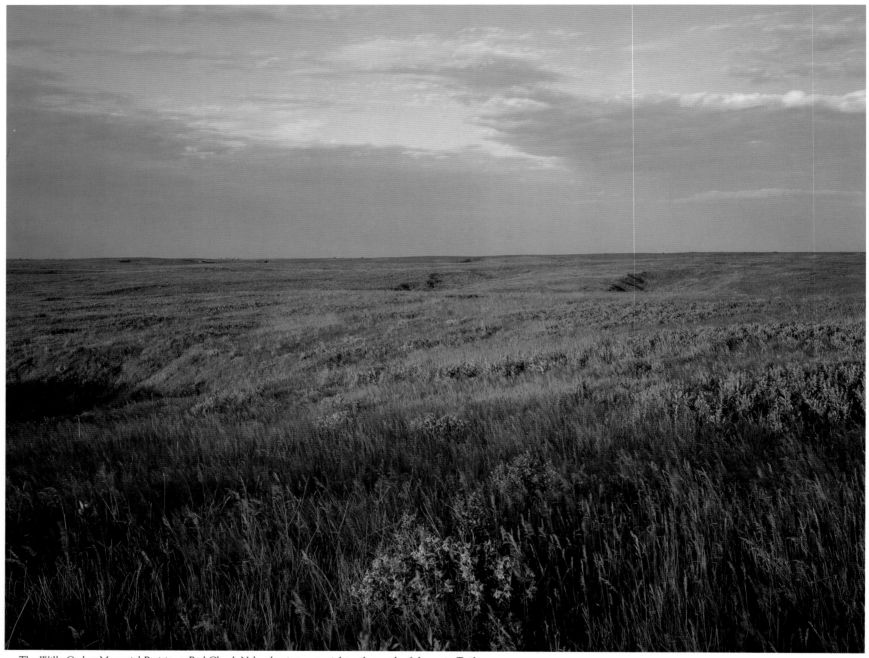

The Willa Cather Memorial Prairie, at Red Cloud, Nebraska, is twenty-eight miles south of the main Trail.

TALL-GRASS PRAIRIE, NEBRASKA. By the time pioneers crossed into present-day Nebraska, prairie grasses were tall enough to provide a feast for hungry mules and oxen. As they gazed across what looked like an endless ocean of green, some pioneers thought they already had reached the promised land.

Some suggested we go no further and start a colony.
Edward W. McIlhany, 1849

Mile 200

MORNING DEW ON THE PRAIRIE, NEBRASKA. While struggling to cross the open prairie, pioneers faced all sorts of new challenges, none more daunting than the restless mood swings of the weather. Blistering hot days frequently were followed by bitterly cold nights, and always there was that wind.

The high winds lately have interfered . . . with our dresses, blowing them about and leaving the pedal extremities in an immodest condition . . . Aunt Sis and Emily pinned some rocks in the bottom of their skirts never dreaming of the black shins they would carry.
Helen Carpenter, 1857

11

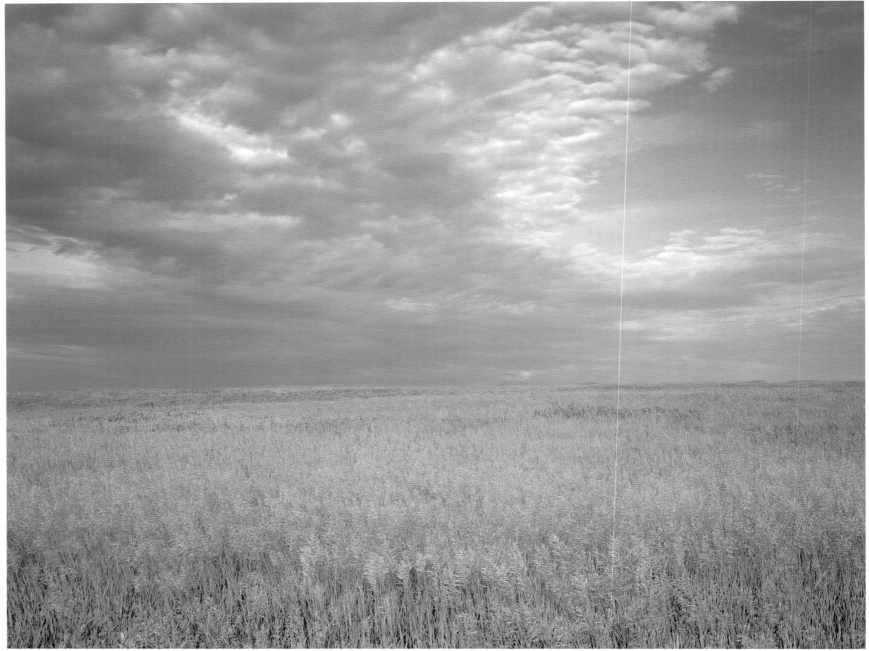

This preserved natural grassland is almost thirty miles south of the main Trail.

WILLA CATHER MEMORIAL PRAIRIE, NEBRASKA. This small, carefully preserved remnant of the Nebraska prairie is typical of the unfenced, windswept landscape pioneers encountered in their early weeks on the Oregon Trail. Most of these natural grasslands long since have been lost to the plow.

Wind shakes wagon so much I cannot write.
Israel Hale, 1849

Seeing the Elephant

The world looked a lot bigger in 1843, and appeared much more mysterious. It was a time before television, before movies, before even *National Geographic*. For most Americans farming in states east of the Missouri, life was a daily struggle to coax a crop from the soil. A family's outlook frequently extended no farther than the horizon, the valley where they watered their livestock, the nearest market town. But this does not mean people did not dream.

They dreamed of a better life, in a better place, with deeper grass and sweeter water. When they heard that such a place existed, they were determined to go see it, even if they had to walk.

They had to walk.

Since Colonial times, a clear line had been drawn across the national conscience. It marked the western border of the known world. Beyond it lay a landscape thought as unforgiving as any Sahara. But as the nineteenth century unfolded, the feeling grew that this wilderness must be tamed. President Thomas Jefferson was among the first to realize that the security of his young nation might depend upon having control from sea to shining sea. In 1803, he spent $15 million on the Louisiana Purchase, bringing into the nation 900,000 square miles of land west of the Missouri River. One year later, Jefferson dispatched Meriwether Lewis and William Clark to search out an overland passage to the Pacific.

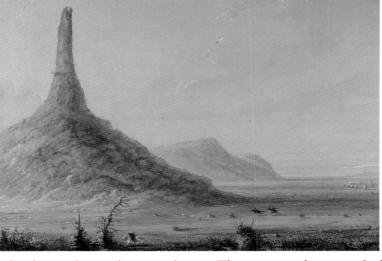
Chimney Rock

The young Army officers succeeded, thanks to the guidance and assistance of Indian tribes along the route. Their journey—without wagons—took them far north of the path that would become the Oregon Trail. But their reports detailing both the beauty and the bounty of Oregon helped fuel the campaign for colonizing the West.

There was plenty of other reading material for those interested in the West, from Washington Irving's *Astoria*, published in 1836, to the letters and reports of missionaries who had traveled the Pacific slope. Still, in 1843, most Americans had a limited vision of what actually lay between them and the Pacific. What they did know sounded scary.

"Seeing the elephant"—that is what they called it. The phrase had nothing to do with the notion that pachyderms prowled the prairie. It had everything to do with the notion that whatever roamed that vast land, they likely had not encountered it before.

Some people had wandered west, and something—the vastness, the privation, the loneliness, the Indians—had made them turn back. They had "seen the elephant," and they had retreated. Others pressed forward, eager to "jump off." This popular nineteenth-century phrase perfectly captures the spirit of plunging from the known into the unknown world.

The people who gathered along the Missouri River in 1843 came from all walks of life, and for all sorts of reasons. Some surely were fleeing creditors, others were on the run from the law. Some were heading west hoping to get rich. Many were land speculators who had established farms in Indiana, Illinois, or Iowa, then sold out. Many were simply fed up with battling the malarial fevers that plagued the bottomlands along the Missouri, the Mississippi, and the Ohio, or with trying to wrest a living from poor soil. Whatever lay in store in Oregon, they figured, it could not be worse than a Missouri dirt farm.

Some were swept up in the notion that colonizing the Oregon Country was the patriotic thing to do. Then there was the sense of adventure. Restless young men who signed on as drovers were offered food and lodging for helping families with wagons and livestock on the trek west. There was, too, the lure of moving to Oregon to be a missionary among the Indians, though, as early as the 1840s, Methodists arriving in the Willamette Valley complained that there were no Indians left to convert.

It is a commonplace assumption that thousands of pioneers rushed to Oregon drawn by the promise of free land—320 virgin acres for each man and woman. But the federal government did not pass the Oregon Donation Land Act until 1850. By the time the act expired fewer than five years later, only 7,437 settlers had filed claim to Oregon land.

There is something wonderfully romantic about this notion of hardy pioneers gathering in the towns along the Missouri River and plunging off into the great unknown. It is true that Francis Parkman, Jr., when setting out on his epic 1846 exploration, lost his way within days of "jumping off." But few starts were this spirited. By 1846, the way west actually was a fairly well-defined path. By 1856, it was more than well defined; it was a virtual highway, as tens of thousands of heavily loaded wagons literally ground the route deep into the landscape.

For later pioneers, the problem was not one of finding a trail across the West—it was dealing with the congestion, the carcasses, the human excrement, the fouled water sources, and the lack of firewood and forage.

Between 1843 and 1863, some 250,000 pioneers crossed the Oregon Trail. As many as 10,000 died en route, mostly from disease or Trail accidents. Fewer than four hundred were killed by Indians. Those who survived each saw a different elephant; each rode the back of that fearsome beast. A multitude of motivations drove emigrants to set out from Missouri; a single inspiration impelled those who completed the mammoth trek. It was the pioneer spirit, that driving force best described by novelist A. B. Guthrie. It was the longing "just to git where I ain't."

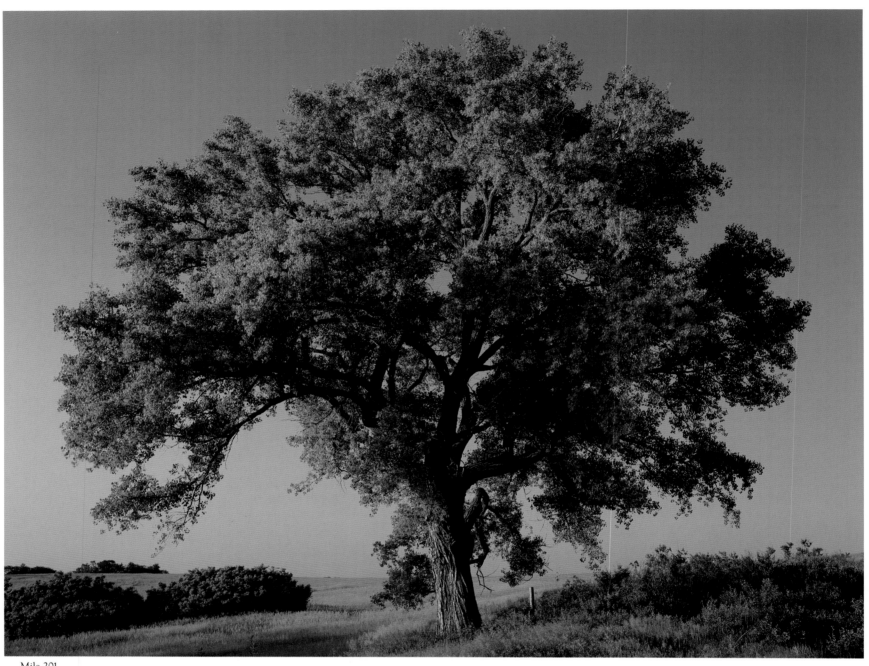

Mile 201

EASTERN COTTONWOOD AT ROCK CREEK STATION, NEBRASKA. The term "pioneer spirit" conjures up images of a single individual struggling to overcome adversity, but Trail crossings hinged on cooperation. Pioneers relied on each other for help in fording streams, rounding up stray cattle—and spreading gossip.

Never have I seen so much hospitality and good feeling anywhere exhibited as since I have been on this route. Let any stranger visit a camp no matter who or where, and the best of everything is brought out, he is fed and caressed almost universally.
Elisha Perkins, 1849

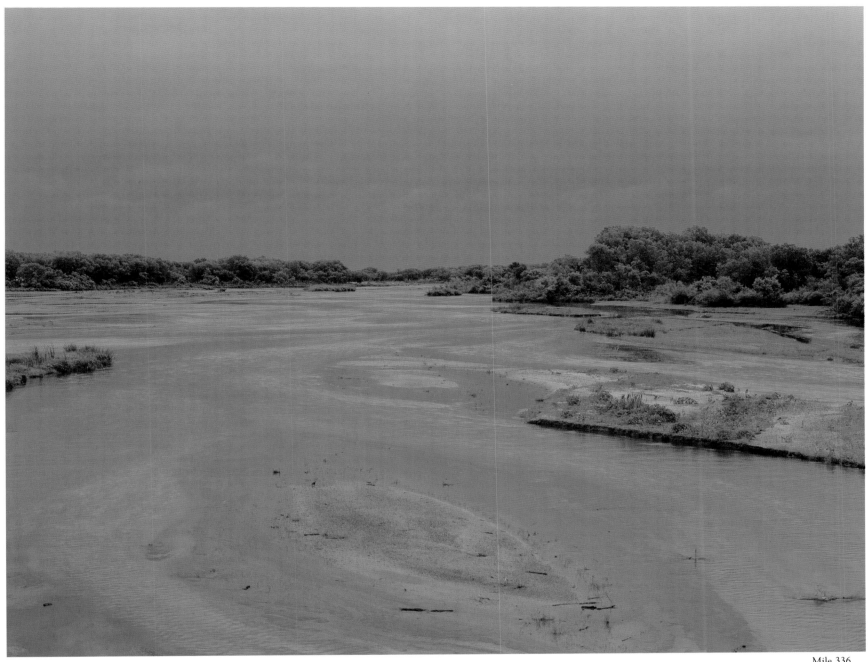

Mile 336

PLATTE RIVER NEAR GARDEN STATION, NEBRASKA. After following the Little Blue out of Kansas, pioneers met the Platte at Fort Kearny. This 1846 Army post was the first established after Uncle Sam was persuaded to patrol the opening of the West. Dragoons posted there were known as the Oregon Battalion.

Houses to us are a novelty and remind one of civilization.
Peter Decker, at Fort Kearny, 1849

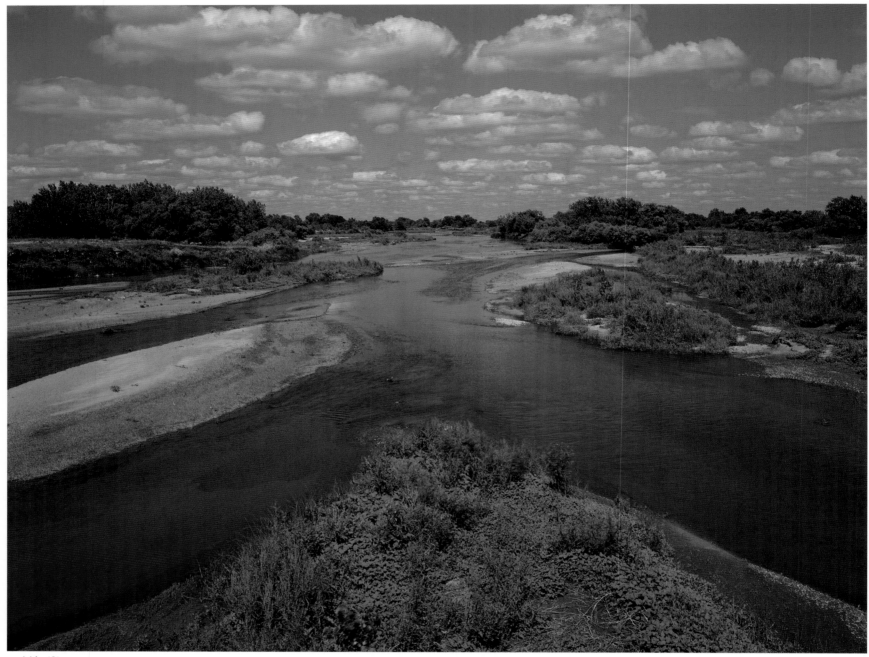

Mile 481

PLATTE RIVER NEAR CALIFORNIA CROSSING, NEBRASKA. One mile west of this spot, pioneers faced their first crossing of the Platte. Though it had a reputation for being "a mile wide and an inch deep," the river proved a daunting challenge. Soft gravel and occasional deep water made the crossing perilous.

We were obliged to double team, making
eight yoke of oxen to each wagon.
Phoebe Judson, 1853

FOREST, ASH HOLLOW, NEBRASKA. Early settlers enjoyed the calm shade and cool springs of this popular rest area, where horror later would unfold. It was here in 1855 that the U.S. Army fought one of its most decisive engagements with the Sioux.

No draught of ruby nectar, quaffed in the height of bacchanalian festivity, ever communicated one half the exhilaration of mind and soul that we obtained that evening.
Matthew Field, 1843

CLEARING STORM, NORTH PLATTE VALLEY, NEBRASKA. Stretching from horizon to horizon, fierce thunderstorms build and break on an almost daily basis across this open prairie. They usually form by midday, and continue, often accompanied by tremendous displays of lightning, late into the evening.

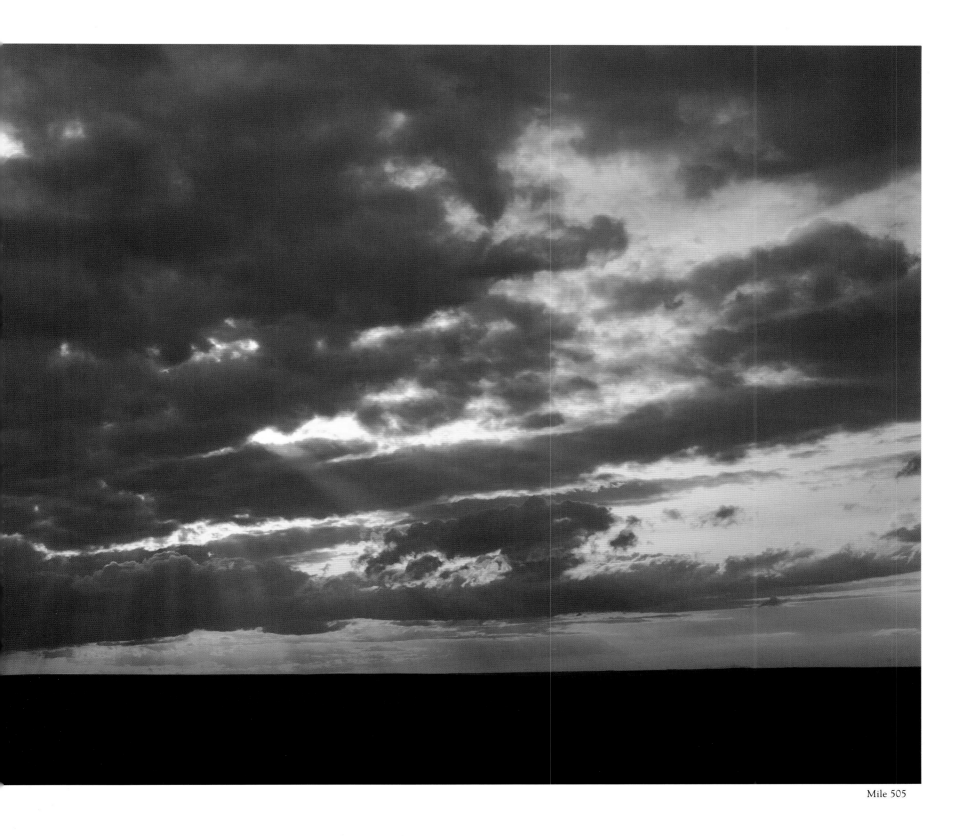

Mile 505

This afternoon it clouded up, and the wind commenced blowing . . . It looks slightly like
freezing to death, now slightly like starving to death, very much like being blowed
away in a hurricane . . . to say nothing of dying for want of tobacco.
E. S. McComas, 1862

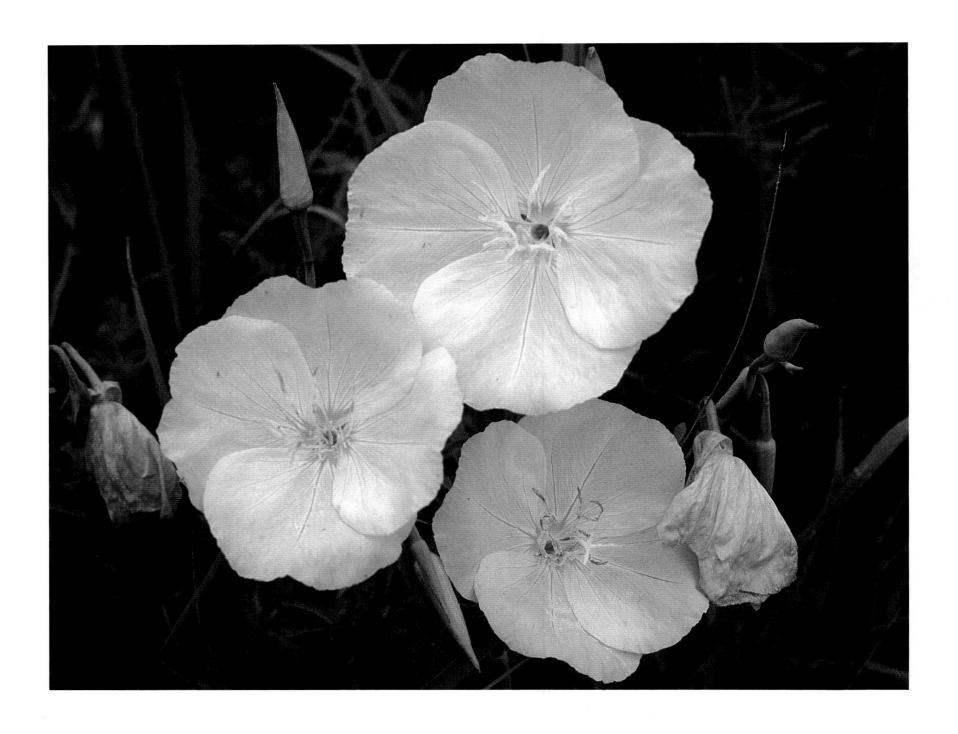

PRIMROSE BLOSSOMS, NEBRASKA. Because there was no official law west of Missouri in the 1840s, each wagon company wrote its own. Before they started out for Oregon, emigrants inked a full catalog of penalties covering a wide range of offenses. Justice generally was administered soon after sentencing.

A sad affair took place last evening: a man murdered by one of his men that he was taking to California. He cut his throat, he had his trial, and was hung the next day. He was swung off a mule under the gallows. He killed the man for about 150 dollars.
George Belshaw, 1853

Mile 507

THUNDERSTORM APPROACHING THE NORTH PLATTE RIVER, NEBRASKA. Most men took to the Trail armed to the teeth, ready—even eager—to fight Indians. For most emigrants, however, the most dangerous people between Missouri and Oregon turned out to be inexperienced companions with weapons.

A young man by the name of Shotwell, while in the act of taking a gun out of the wagon,
drew up the muzzle toward him in such a manner that it went off and shot him in the
heart. He lived about an hour and died in the full possession of his senses.
John Bidwell, 1841

21

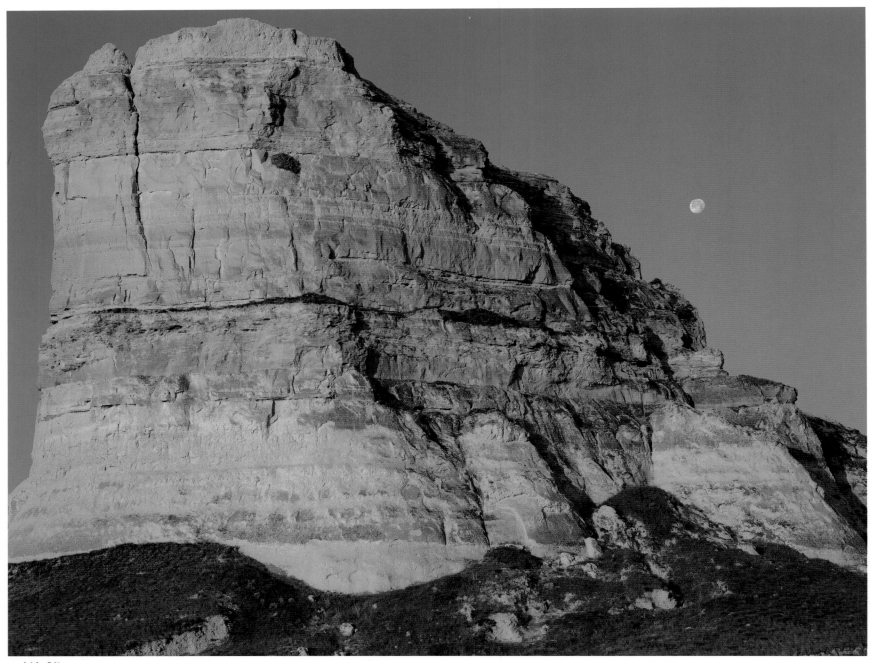

Mile 561

JAIL ROCK BENEATH A SETTING MOON, NEBRASKA. Pioneers spared no poetic effort in naming the remarkable rock formations they followed up the valley of the North Platte. Although this rock does not really resemble a jail, it does stand right next to the rock pioneers dubbed The Courthouse.

The moon, I think, must have been near the full . . . at all events
we leveled off a space and one man played the fiddle
and we danced into the night.
John Minto, 1844

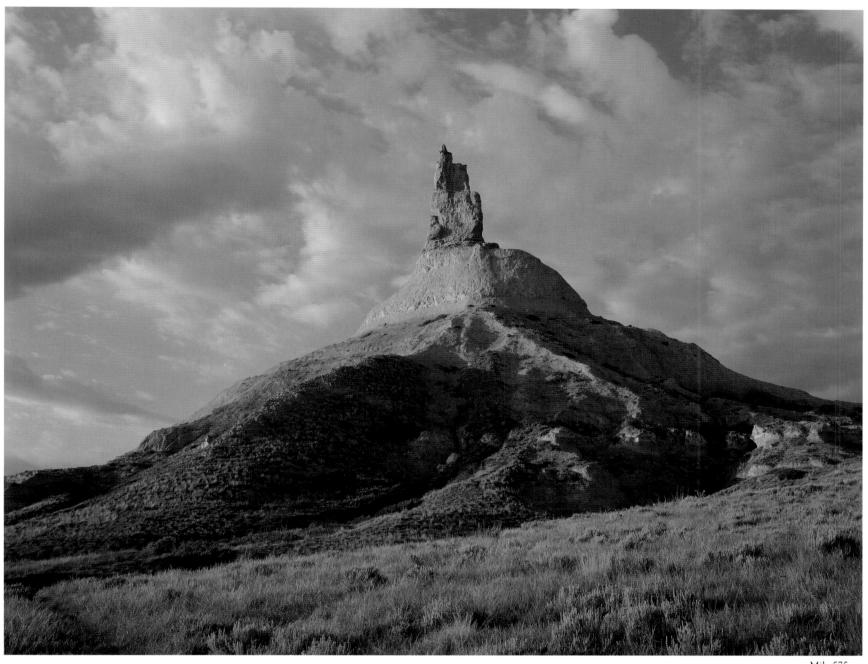

Mile 575

CHIMNEY ROCK, NEBRASKA. The most famous landmark on the Trail, Chimney Rock was visible for days as emigrants toiled up the Platte Valley. Few could resist the temptation to abandon their wagons and hike the few miles south to explore the sandstone tower dubbed the "Eighth Wonder of the World."

I took off my boots and climbed to the top of this wonderful rock.
Elijah P. Howell, 1849

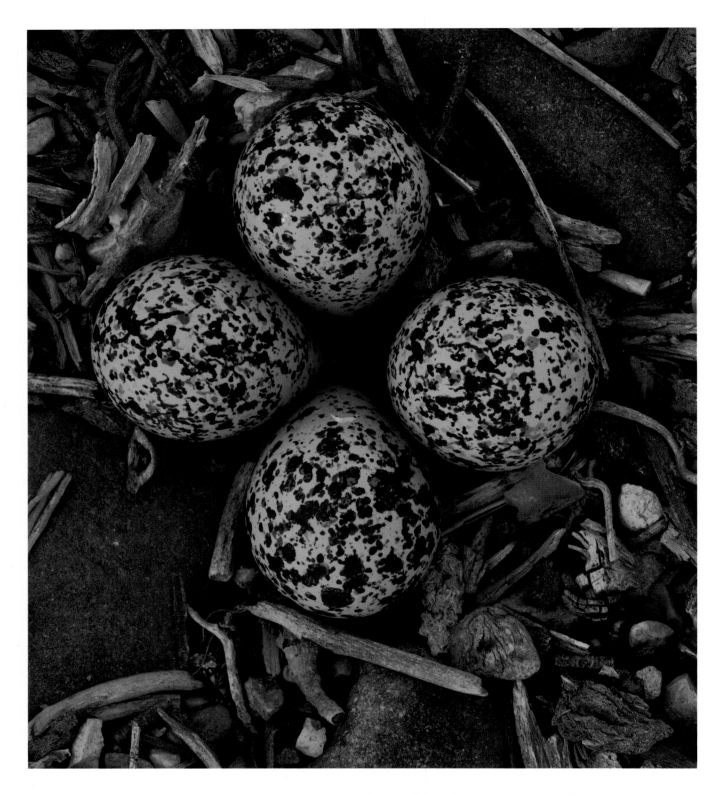

KILLDEER EGGS, NEBRASKA. The careful camouflage of nature's beauty could not conceal the silent enemy never far from the Trail. During gold rush days, overcrowding of campsites and the almost total lack of sanitation caused cholera to run rampant.

Glorious day—twenty-two cases of cholera.
John Benson, 1849

Crossing the Great Divide

To the nineteenth-century traveler, the Rockies appeared as an almost impenetrable wall, an endless range of snowbound summits that stretched to stroke the sky. Yet there was in these mountains a long, low windswept saddle where the thunder moaned, the coyotes howled, and spring water flowed in a most remarkable way . . . toward both the Atlantic and the Pacific.

On October 23, 1812, Robert Stuart, a young Scot working for the Pacific Fur Trading Company, found himself camped in the upper valley of the Green River. Stuart had traveled almost one thousand miles from his lonely station, the trading post at Astoria on the Pacific shore. Spurred by the determination of a man who was heading home, Stuart set out that morning to climb the western slopes of the Rocky Mountains. That very afternoon, he found himself going down the other side.

Here, then, it was: an easy route across the Continental Divide. At the time of Stuart's crossing, the British were laying claim to much of the Great Northwest Territory. There was little surprise there; in 1812 the British were laying claim to much of the known world—and much of the unknown, too.

A considerable amount already was known about America's western coast. Seafaring explorers had been buffeted along this shoreline for at least three centuries. They came searching for the fabled Northwest Passage, a European gateway to oriental trade. There were Spaniards: Bartolome Ferrelo in 1543 and, two hundred years later, Bruno de Hezeta. There were Englishmen: James Cook and George Vancouver. There were a Dane, Vitus Bering, and a Russian, Aleksey Chirikov, who sailed across the North Pacific. And there were Yankee traders, John Kendrick and Robert Gray. In 1792, it was Gray, pursuing the profits of the sea otter trade, who braved the bar and steered his good ship *Columbia* into the mouth of the great river of the West.

Twelve years later, it was down this very river that the two emissaries dispatched by President Thomas Jefferson brought their canoes. The degree of contact with the White man prior to the Lewis and Clark Expedition is suggested by the fact that they found many Indians at the mouth of the Columbia River suffering from imported smallpox and venereal disease. They found, too, evidence of trade items including weapons, clothing, and kettles.

The two Army captains—outfitted with such munitions as needles, handkerchiefs, beads, brass wire, silk ribbons, red flannel, fish hooks, and tobacco—had traded their way into uncovering an overland route from the Missouri to the Pacific. Their journey, via the headwaters of the Missouri River, involved wintering near present-day Bismarck,

North Dakota, and required a trek of almost four thousand miles. No wagon train would ever follow in these footsteps.

The dismal story they told of their squall-soaked winter camped on Columbia's shore didn't exactly start a land rush. But the tale they told of beaver-clogged streams lured other men—mountain men—to go West.

Their numbers were small, perhaps six hundred, and their stint on the world's stage was short. City folks' fondness for the beaver top hat, like all fashion trends, proved to be fleeting. But their place in history would endure. Clad in their fringed buckskins, their beards thick with bear grease, tall tales spilling from every sinew, the mountain men quickly earned their enduring place in the mythology of the West. In 1824, two of them, Jedediah Smith and Jim Bridger, retraced Stuart's steps across South Pass and found the crossing pretty much of a stroll.

In 1830, William Sublette, another trapper, decided that though a pack mule of pelts looked pretty darn good, a cartload would look better. He brought his wagon to the Rockies' crest, but did not cross. History hands that honor to Captain Benjamin Bonneville, who led his first expedition west of the Rockies in 1832. Under his command, the first wheels to cross the Continental Divide carried a twelve-pound cannon.

Next came a canon of a different sort. Missionaries went to Oregon to save the souls of the savage. In 1834, Methodist Jason Lee traveled to Oregon with a party of fur traders. Two years later, he understood how bleak were the prospects for his flock: "That the Indians are a scattered, periled, and deserted race, I am . . . convinced; for it does seem that unless the God of heaven undertake their cause, they must perish off the face of the Earth."

Lee was followed in 1835 by Presbyterians Samuel Parker and Marcus Whitman. The following year, Whitman, this time with his new wife, Narcissa, and her companion, missionary bride Eliza Spalding, again made the crossing. These two are recorded by history as the first White women to cross the Rockies. Whitman, founder of the ill-fated mission near present-day Walla Walla, Washington, repeatedly crisscrossed the continent. He was on the Trail again in 1843, helping guide the first major emigrant train to reach Fort Boise. But the work of the missions was soon swept aside by an even more potent force for change.

In 1842, United States Army Lieutenant John Charles Fremont, guided by Kit Carson, led his first major expedition, including a number of wagons, over South Pass. Fremont wrote in his journal that the crossing presented no "toilsome ascents," that it was no more challenging than a carriage ride up Capitol Hill. Word quickly spread that the Promised Land was open even to those who walked west without God on their side.

Storm: Waiting for the Caravan

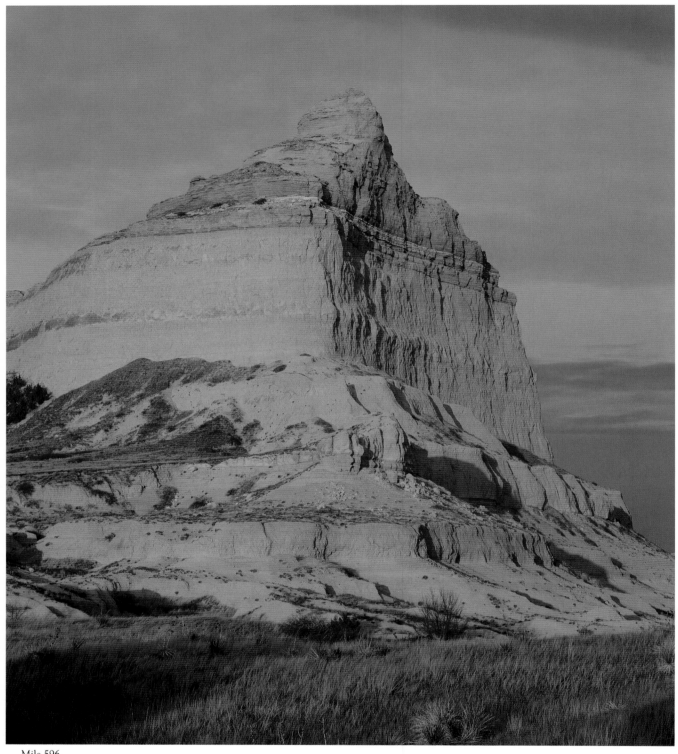

Mile 596

EAGLE ROCK, SCOTTS BLUFF, NEBRASKA. No Trail scenery was more splendid than the sandstone bluffs that line the Platte. But no matter how stoic their appearance, these sentinels never lacked the flirtatious attention of a dance partner—the wind.

Last night my clothes got out of the
wagon and the oxen ate them up.
Cecelia Adams, 1852

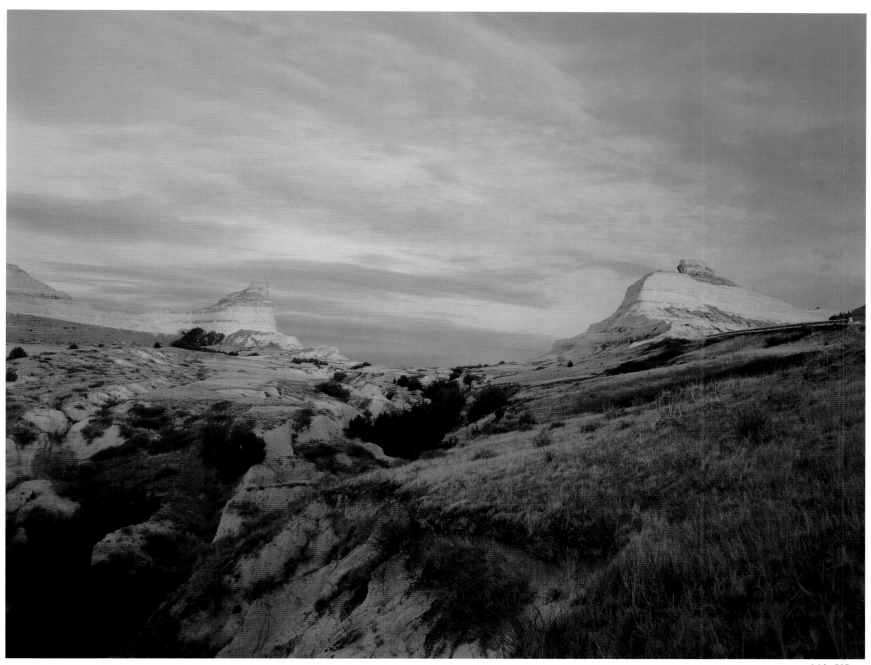

Mile 597

MITCHELL PASS, SCOTTS BLUFF, NEBRASKA. In 1850, Army engineers cleared a road through Mitchell Pass, opening an easier route than pioneers had followed through Robidoux Pass a few miles south. More than fifty thousand heavily laden wagons passed this way in 1852, carving swales fully eight feet deep.

The marching down along the Platte River was indescribably beautiful. The days were tranquil, and ahead of us there seemed to be old castles, ruined cities, and vast cathedrals strung along the route.
Eugene Ware, 1864

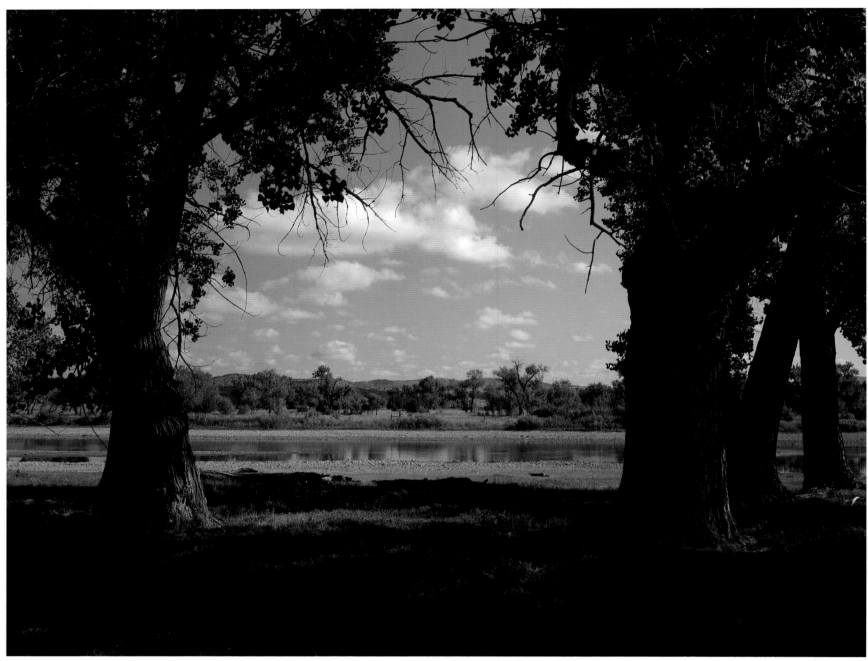

Mile 659

NORTH PLATTE RIVER AT REGISTER CLIFF, WYOMING. Traveling the Trail each day, it was men who gave the marching orders, barking at livestock, mosquitoes, and each other. Each evening, however, they came to the realization that others in the company might be better suited to taking charge.

In camp and the women ruled.
George Belshaw, 1853

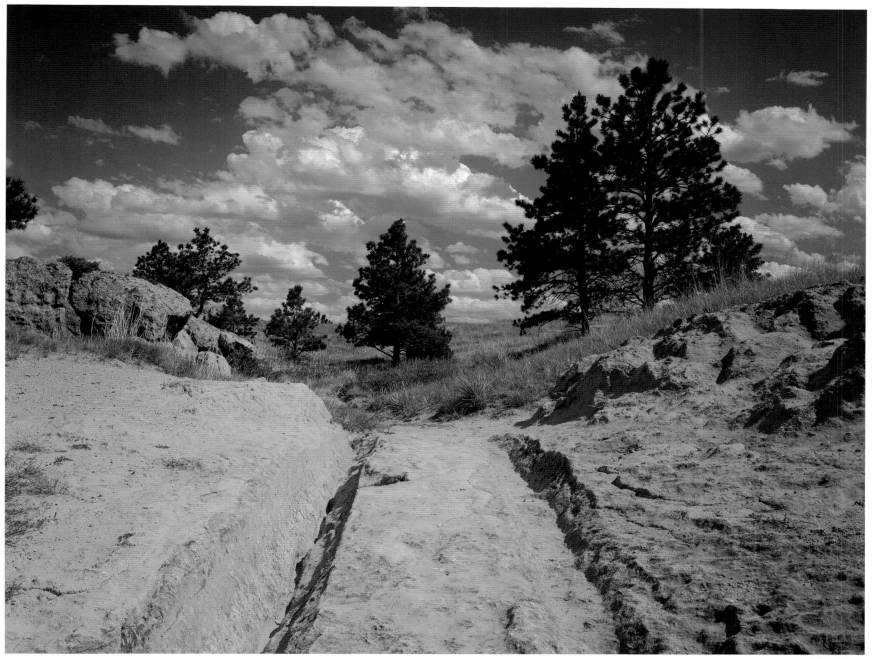

Mile 660

WHEEL RUTS IN SANDSTONE, GUERNSEY, WYOMING. There was much rivalry among the destinations striving to lure emigrants across the various trails west. Lansford Hastings traveled to California and produced a guidebook that included his opinion of those choosing the route to the Willamette Valley.

And I may add that the Oregon emigrants are, as a general thing, of a superior order to those of our people . . . They are not the indolent, dissolute, ignorant, and vicious, but they are generally the enterprising, orderly, intelligent, and virtuous.
Lansford Hastings, 1842

29

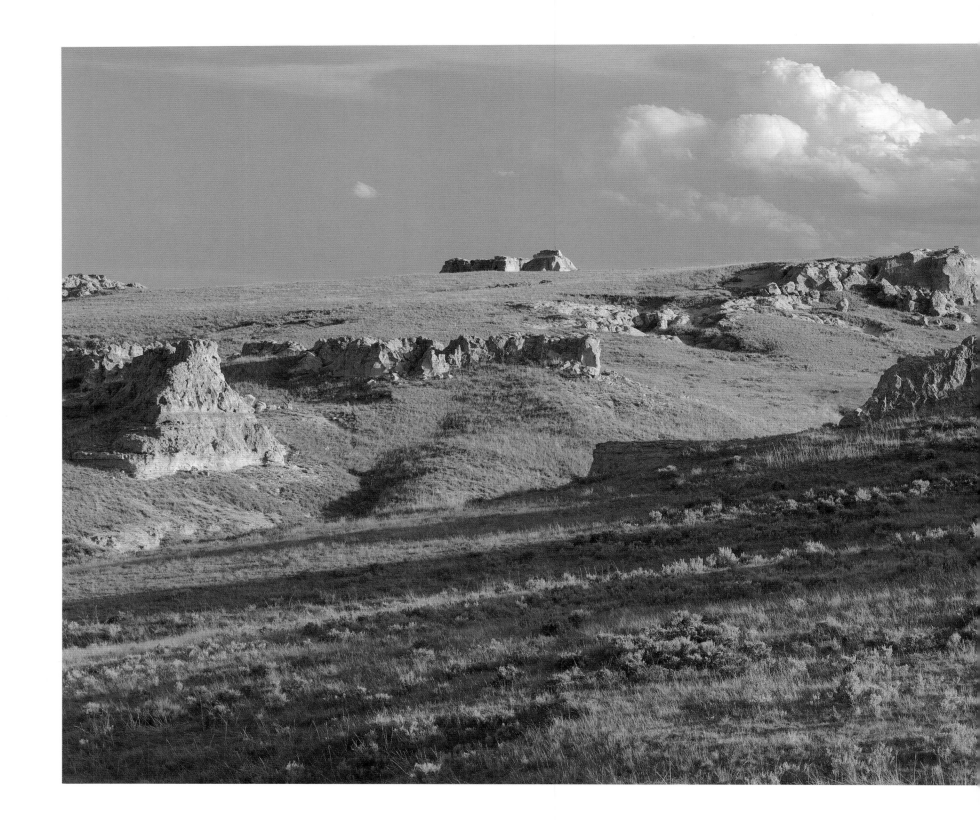

THE VIEW SOUTH FROM RIFLE PIT HILL, WYOMING. The pioneer path west was forged between trails explored by much earlier adventurers. In 1608, French explorer Samuel de Champlain founded Quebec. Two years later, the Spanish were in Santa Fe. Wagon ruts still were two hundred years from South Pass.

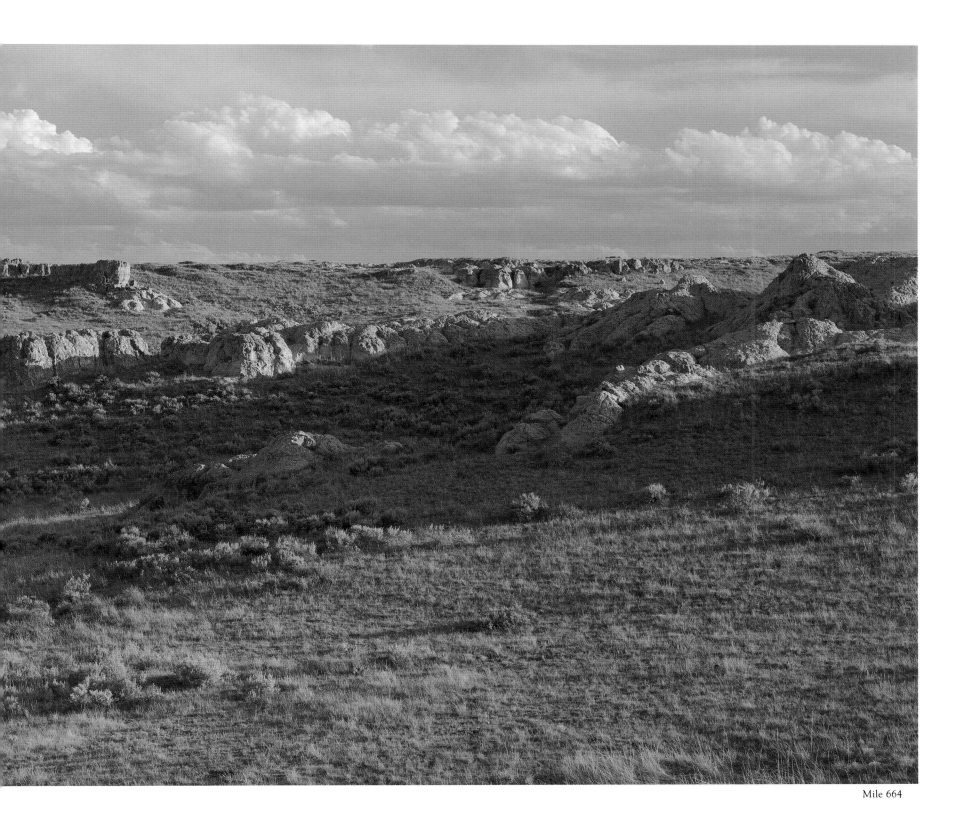

Mile 664

Above you rise in sublime confusion mass upon mass of shattered cliffs . . . below you spreads
far and wide the burnt and arid desert, whose solemn silence is seldom broken by the
tread of any other animal than the wolf or the starved and thirsty horse . . .
Thomas J. Farnham, 1839

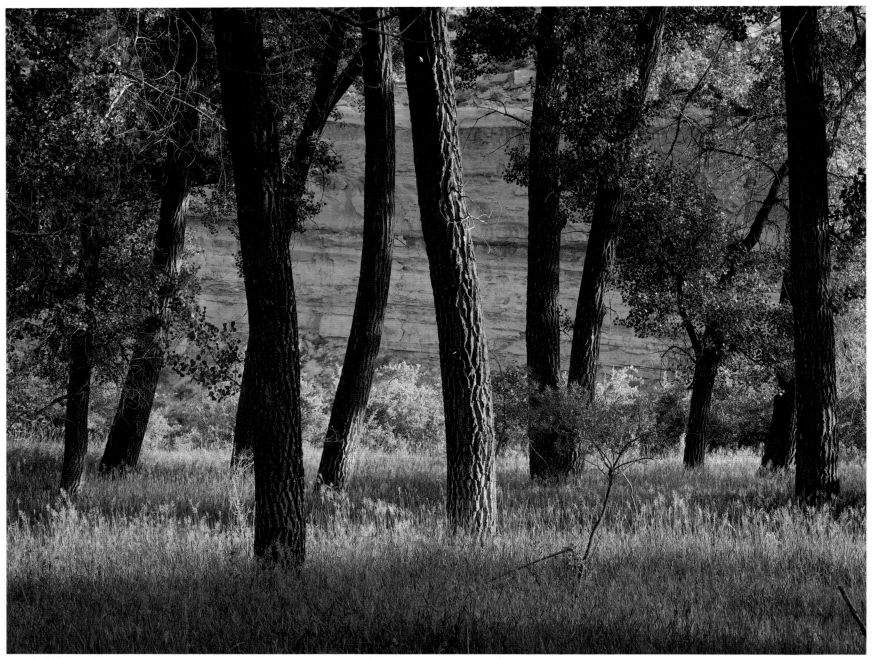

Mile 708

COTTONWOODS AND CLIFF NEAR LA BONTE CABIN, WYOMING. Few trading posts existed along the Oregon Trail during the 1840s. Pioneers had to husband their food supplies carefully. Game was far less plentiful along the road than many had anticipated, putting any ailing emigrant cow at risk.

Today we killed a beef for supper, or I should say tried to. Pa and the boys
shot at it about fifty times before they got it right. Yes, those Indians
had better think twice before attacking this dangerous group.
Maria Shrode, 1850

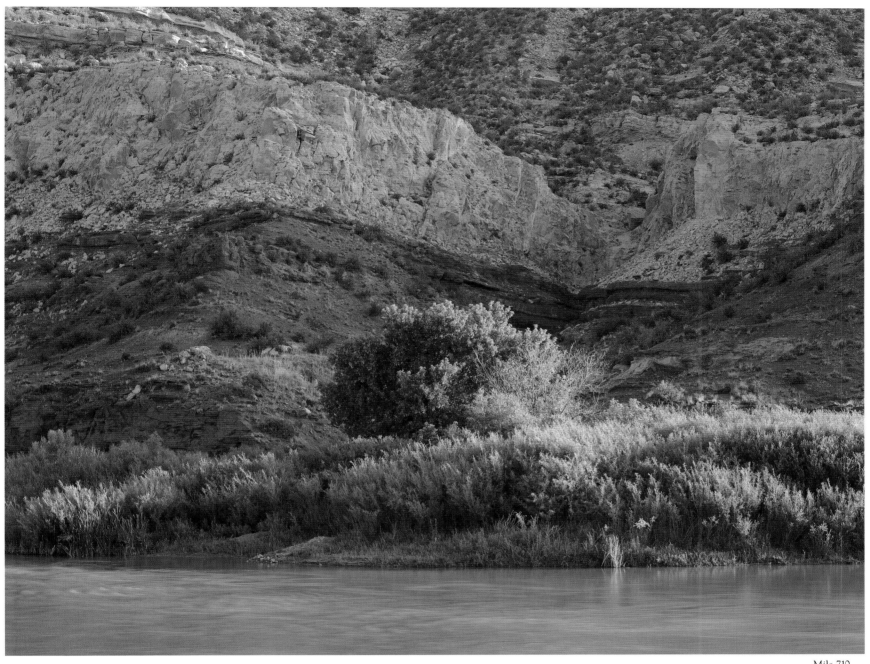

Mile 710

RED EARTH CLIFFS AND THE NORTH PLATTE RIVER, WYOMING. By this stage of the journey west, the heady excitement of "jumping off" had given way to the arduous business of coping with the details, and drudgery, of a scheduled six-month stint as people struggled to walk some twenty miles each day.

Laid over to wash. I don't believe I was ever so tired in all my life.
I am so sore all over I can hardly move.
Martha Moore, 1859

Mile 724

PIONEER CAMPSITE NEAR AYERS NATURAL BRIDGE, WYOMING. Many were lured a few miles from their path by reports of restful glades where a family could escape for some hours the tumult of the emigrant road. On the Trail, one company rarely was far distant from another. Sometimes this was a blessing.

I carried a little motherless babe five hundred miles, whose mother had died, and when we would camp I would go from camp to camp in search of some good, kind motherly women to let it nurse, and no one ever refused when I presented it to them.
Margaret Inman, 1852

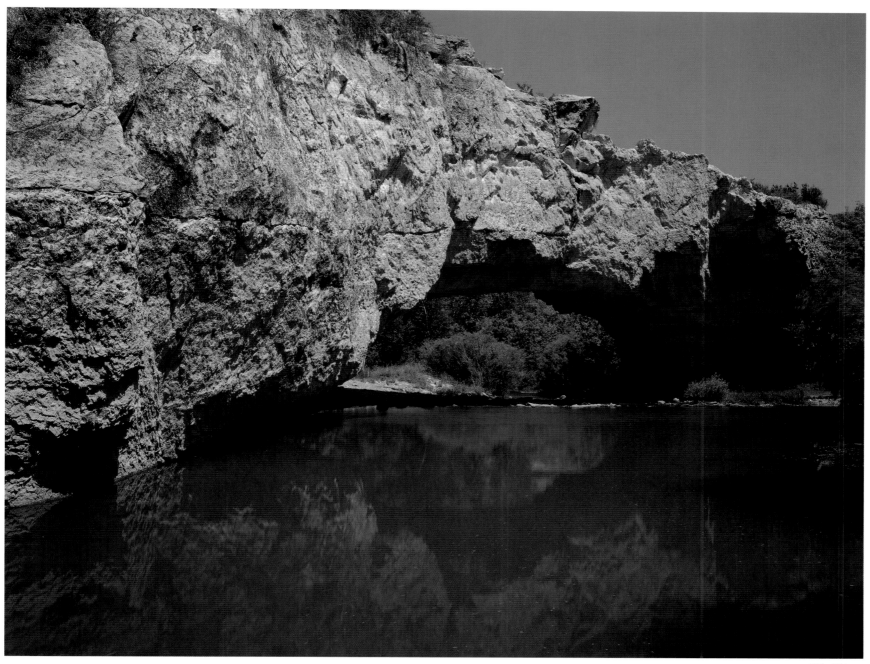

Mile 724

AYERS NATURAL BRIDGE, WYOMING. The Spanish and French first pushed west into this world of wonder, but through the seventeenth century their power was on the wane. On the rise was Britannia, eager to blaze a trail to the Pacific shore. Her ambition would be thwarted by a young revolutionary country.

*The wagon train is divided into two parties. One lot fiddles and dances at night
and the other party holds prayer services. My mother believes that
the fiddle is a invention of the devil to lure people to hell.
Joseph C. Wooley, 1853*

35

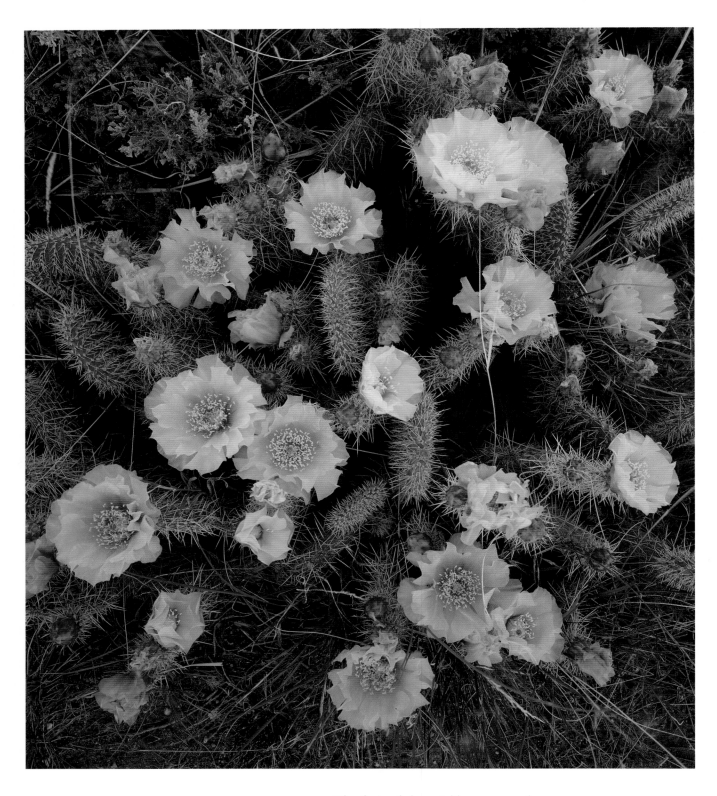

PRICKLY PEAR CACTI, WYOMING. The fruit of the prickly pear may be eaten raw or boiled down into a syrup. The fleshy pads, with the spines removed, were fed to thirsty livestock. Finding cactus flesh, however, rarely sent anyone scurrying to her diary.

Tonight the wagons are decorated with slices of meat dangling from strings,
fastened to ropes that reach from front to back, along the side of
the wagon, looking very much like coarse red fringe.
Helen Carpenter, 1856

Don't Go West, Young Man

It was not war, nor famine; not pestilence, nor plague. No tidal tragedy or mass upheaval drove the wave of humanity that washed in the middle of the nineteenth century toward the Pacific shore. So what did prompt hundreds of thousands of people suddenly to up and abandon family, friends, and farmsteads, to strike out for an unknown future in an unknown land?

Commentators in the 1840s came up with a very simple answer. It was Manifest Destiny, the idea that the nation was preordained to expand, and that white people—subjugating Indians as they extended their empire—were divinely called to this task.

This notion must have had a certain appeal, since it prospered for more than one hundred years. But it really was nonsense. There was something much more compelling, and much more human-scaled, that propelled this massive peacetime migration. People were talked into it.

Talk started early and spread rapidly. In the tradition of human discourse, much of it was done by those who knew little of what they spoke. As early as 1813, the *Missouri Gazette* in St. Louis began encouraging pioneers to head west to colonize Oregon. The journey, they insisted, would be a cakewalk, since there was "no obstruction in the whole route that any person would dare to call a mountain." There is no evidence any *Gazette* journalist ever set foot west of Nebraska's Fort Kearny.

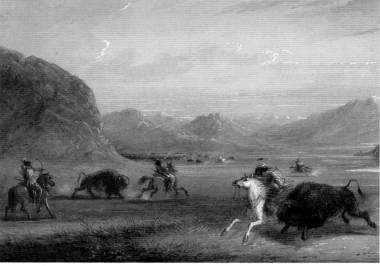

Meanwhile, the British newspapers, protecting the crown's imperial interests along America's North Pacific coast, still were insisting that Britannia's traders had nothing whatsoever to fear. As late as 1843, the very year the first major wagon train brought more than nine hundred settlers to Oregon, the *Edinburgh Review* delighted in deriding the "howling wilderness" and "hopeless sterility" of the American West. "Oregon," trumpeted the pride of Scotland, "will never be colonized overland from the Eastern states."

Not all this anti-expansionist talk came from the comfy confines of gentlemen's clubs in Britain. Two months to the day after the 1843 emigrants "jumped off," Horace Greeley, editor of the New York *Daily Tribune*, insisted their expedition wore "the aspect of insanity" and predicted that ninety percent of them would perish.

Similar sentiments came, too, from the frontier. Dr. John McLoughlin, chief factor of Britain's fur-trading Hudson's Bay Company outpost at Fort Vancouver, assured his home office that American pioneers would "reach the moon" before they reached Oregon.

But reach Oregon they did, for these were people in pursuit of a promise. What had been promised was a piece of paradise. And it was peddled to them by a carefully choreographed public relations campaign. Some of those urging citizens to paint their wagons were political pundits eager to boost the cause of Western expansion. Some were speculators, looking forward to making a killing from the commerce that would sprout from freshly settled soil. In 1831, Hall J. Kelley, an agent of the Boston-based American Society for Encouraging the Settlement of the Oregon Territory, published an eighty-page pamphlet: "A General Circular to all Persons of Good Character who wish to emigrate to the Oregon Territory."

In his booklet, Kelley waxed more than lyrical about the bountiful character of the Oregon Country and included some prescient prose on its potential as a portal for Pacific Rim trade. The society sought to raise a capital stock of two hundred thousand dollars, to be divided into one-hundred-dollar shares, each entitling the owner to 160 acres of land.

That land, of course, was to be taken from the Indians. But any potential investor could rest assured. The society was committed to "the benevolent work of enlightening and civilizing that rude and suffering people." They all would be kindly treated "on the back lots in the sea port town, where they can be instructed, and encouraged in cultivating garden grounds. . . ."

Then there were the missionaries.

By the 1830s, a considerable number of Christian shepherds had visited the Oregon Country. One of them, Marcus Whitman, played a key role in unlocking the gate to the Oregon Trail. He first settled among the Cayuse tribe near present-day Walla Walla, Washington, and quickly was convinced by the Reverend Jason Lee, missionary to the Willamette Valley Indians, that success in spreading the Word would hinge on first securing the land by fostering settlement. Whitman, on one of his subsequent recruiting missions through the East, took with him two Native American Chinook boys. They spoke—with what we can safely assume was carefully coached eloquence—of the hunger of their people for the teaching of the white man's God. Eager-beaver missionaries hurried westward with their bags and Bibles.

In the makeshift campsites that sprawled for miles along the bank of the Missouri River, there assembled a truly astonishing collection of characters: bullwhackers and blacksmiths, crooks and con men, tinkers and tailors, gold diggers and land developers, preachers and pioneers. They were joined by hunters from France, botanists from Germany, journalists from England, and an assortment of hangers-on. By 1845, the editor of the Independence *Expositor* had a simple message for them all: "Whoo ha! Go it boys! We're in a perfect Oregon fever!"

Buffalo Hunting near Independence Rock

Mile 773

ESCARPMENT NEAR BESSEMER BEND, WYOMING. Here the Trail passed on its way to Bessemer Bend and an ending, at last, to the long, tiresome journey up the Platte River. Some of the valley's more persistent residents would not soon be missed by pioneers.

Mosquitoes are more abundant than I have ever seen before.
They swarm about in millions, making the air black.
Charlotte Pengra, 1853

Mile 784

LICHENS, ROCK AVENUE, WYOMING. In tandem, beauty and tragedy walked the Trail. In 1849 and 1850, Uncle Sam sold guns and ammunition at discount rates to civilians heading west. Not coincidentally, these were the years of greatest self-inflicted bloodshed.

And now Oh God comes the saddest record of my life for this
day my husband accidentally shot himself . . . if I had no
children how gladly would I lay me down with my dead.
Mary Ringo, 1864, pregnant with her sixth child.

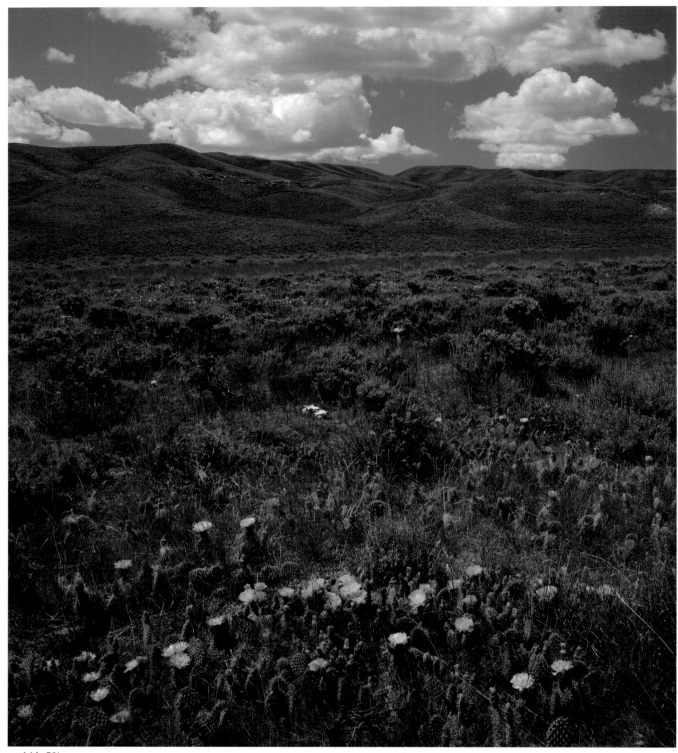

Mile 791

CACTI AND SAGE, WILLOW SPRINGS, WYOMING. The paths followed by pioneers were a series of pushes from watering hole to watering hole. This meant livestock had to be driven hard, while emigrants continued to pay constant attention to their well-being.

Drove twenty miles, good roads, poor soil. My cattle is getting
lame, I have to shoe them with leather.
George Belshaw, 1853

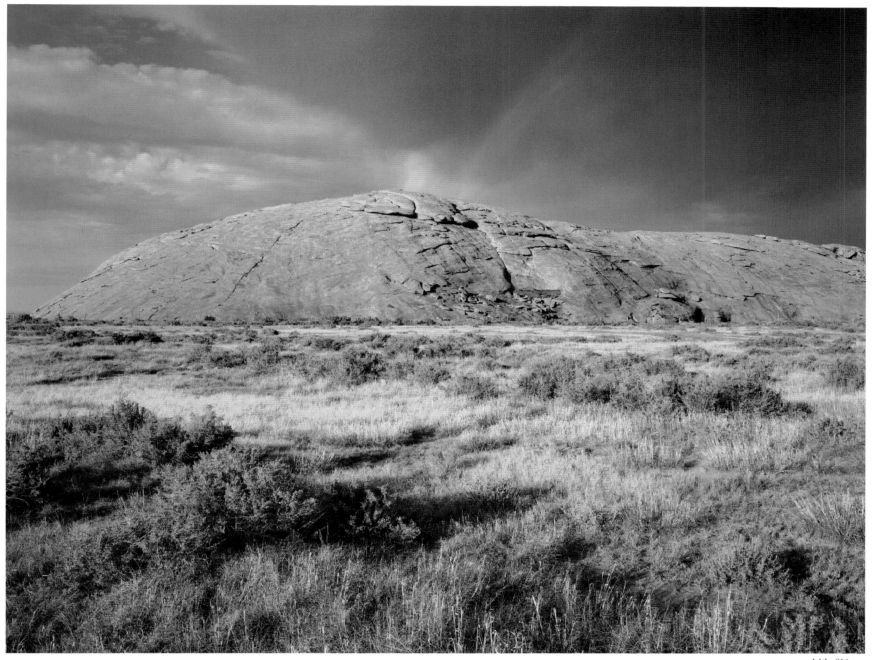

CLEARING STORM, INDEPENDENCE ROCK, WYOMING. Widely circulated, and often wildly inaccurate, pioneer guidebooks suggested that if emigrants hurried to reach this campsite by the Fourth of July, they likely would be in time to cross over Oregon's Cascade Mountains before the onset of early snowstorms.

Made twenty miles, we passed eight fresh graves.
Abigail Jane Scott, 1852

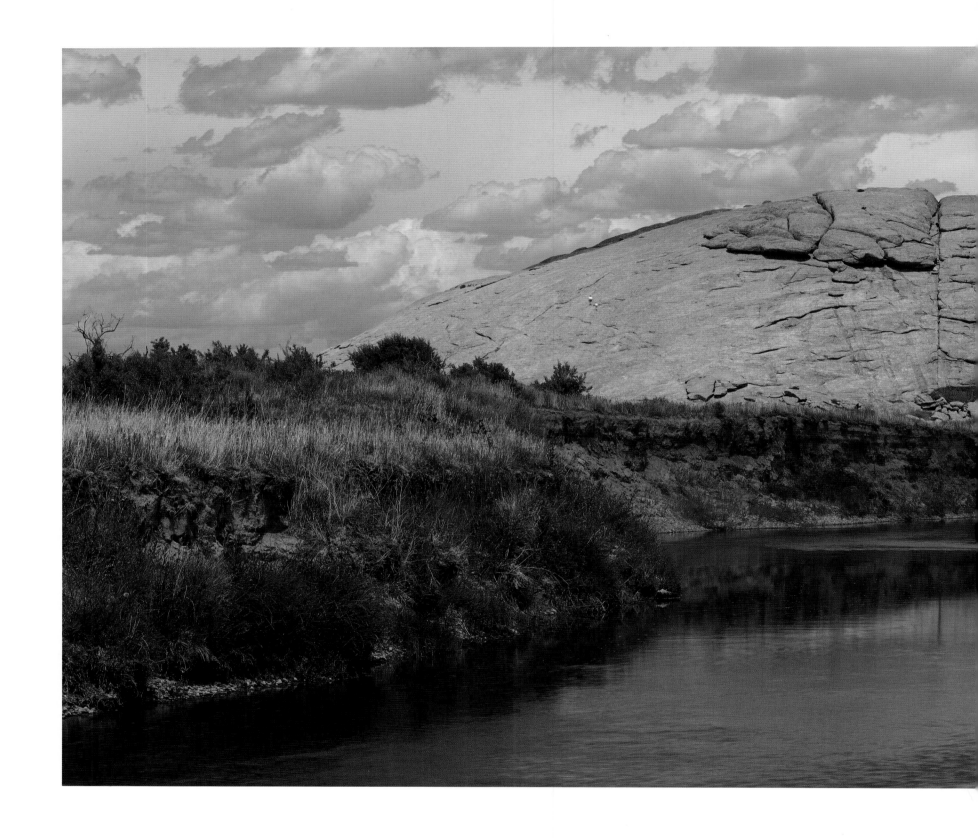

INDEPENDENCE ROCK AND THE SWEETWATER RIVER, WYOMING. Pioneers pressed forward to camp close to Independence Rock, one of the most important landmarks on the Trail. In the busiest years, so many pioneers circled their wagons near here that the surrounding prairie seemed an ocean of canvas.

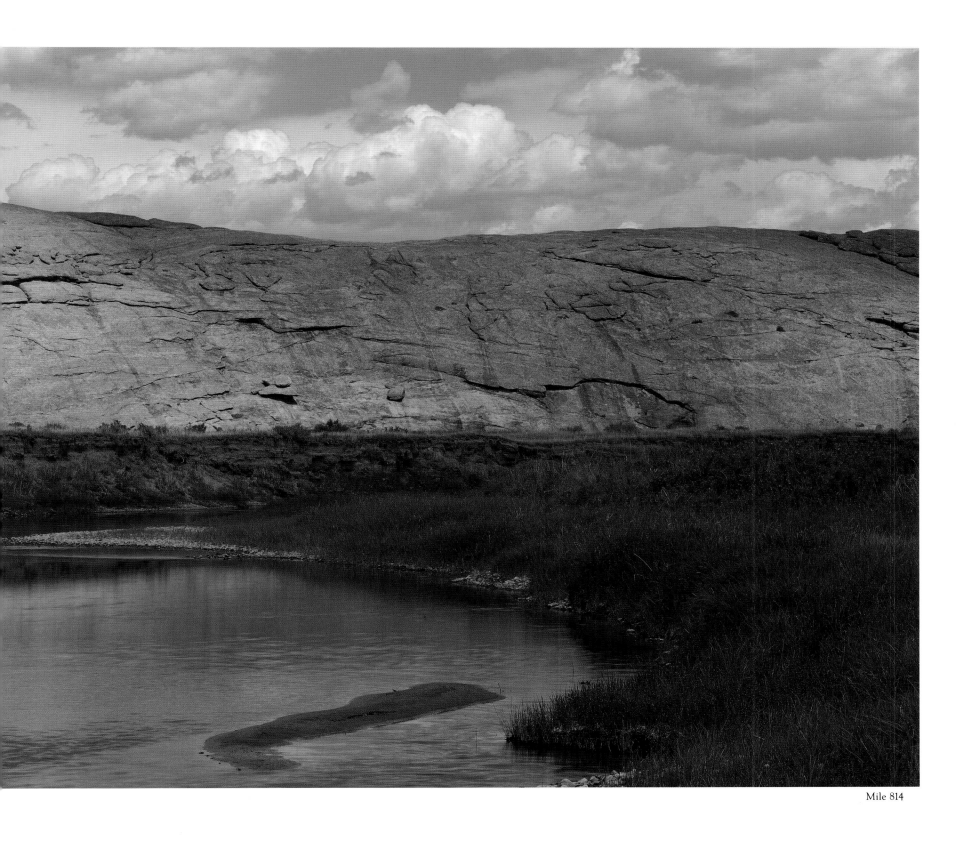

Mile 814

Independence Rock at a distance looks like a huge whale. It is painted and marked
every way, all over, with names, dates, initials, etc., so that it was
with difficulty I could find a place to inscribe on it.
J. Goldsborough Bruff, 1849

43

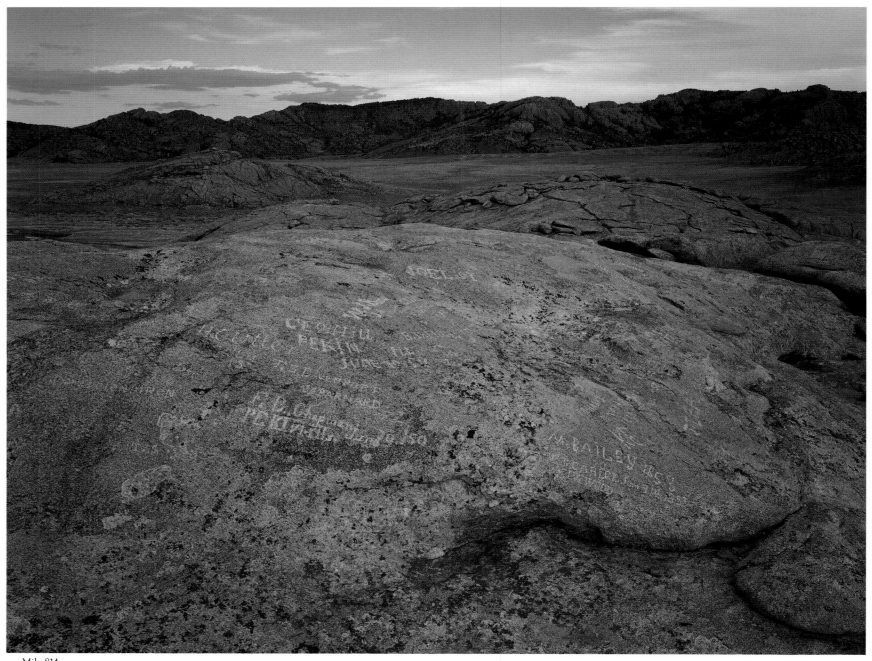

Mile 814

PIONEER INSCRIPTIONS, THE SUMMIT OF INDEPENDENCE ROCK, WYOMING. In 1845, a company generally spent about 170 days, or almost six months, traveling from Missouri to Oregon. Just ten years later, the opening of shortcuts and the development of bridges and ferries shortened the journey to 140 days.

Our crowd is so large, it seems like a village whenever we stop.
James Pratt, 1849

Mile 814

FLOWER GARDEN, TOP OF INDEPENDENCE ROCK, WYOMING. After climbing high to carve their names on "Guestbook Rock," people found a tranquil world of small pools, birds, mammals, prairie grasses, and flowers—far removed from the harsh reality below.

The road from Independence to Fort Laramie is a graveyard.
Dr. T. McCollom, 1849

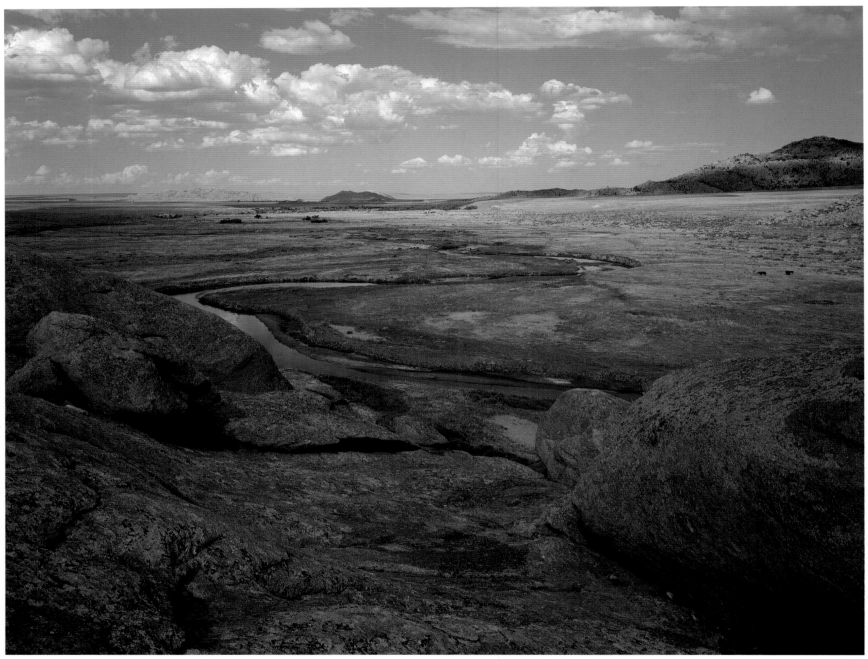

Mile 814

SWEETWATER RIVER, EAST FROM INDEPENDENCE ROCK, WYOMING. Judging by the way they armed themselves for the journey, many believed the road west was under siege by marauding bands of murderous savages. But, especially during the early years, most pioneers found Indians committed to helping them.

The Indians, men, women and children, visited our camp. They are the nicest looking and best behaved Indians we have seen. They had fine splendid banners, four of which were waving all the time . . . They wanted presents of tobacco, powder, lead, etc.
Reverend Edward E. Parrish, 1844

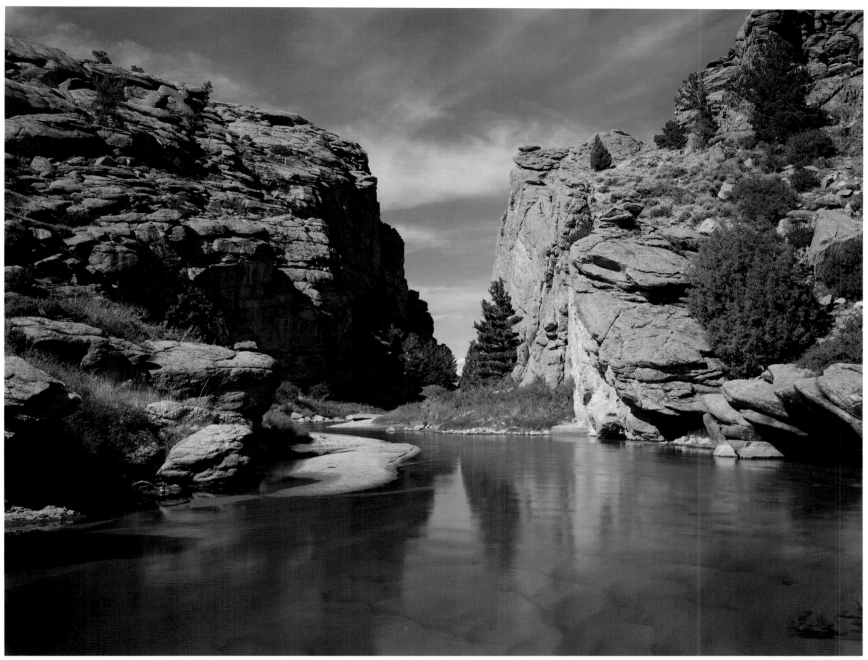

Mile 820

DEVIL'S GATE, WYOMING. Livestock kicked up so much dust that pioneers, who often wore goggles, sometimes could not see from their wagon to the ox team pulling it. From this dramatic gorge of the Sweetwater River, the devil himself enticed dust-caked emigrants to come bathe in clear waters.

Dust . . . if I could just have a bath!
Jane Gould, 1862

47

Mile 821

SPLIT ROCK AT SUNSET, FROM DEVIL'S GATE, WYOMING. There was no such thing as a "typical" pioneer story. The emigrant experience varied greatly from year to year according to such ever-changing factors as weather, disease, crowding, and the constantly deteriorating state of Indian-White relations.

This is Sunday but we observe no Sabbath here. May the heavenly
father remember his erring children in mercy!
Martha Moore, 1859

Oregon Fever

Some Missouri farmers did not waste much time saving money for their Great Migration. They simply dried their fruit, parched their corn, packed up their plows, hitched their oxen to the farm wagon, threw in back all their bacon and beans, and headed down the road. In many ways, these farming families may have been the people best prepared to meet the challenges that lay ahead.

If a man and woman knew their livestock, and treated the animals well; if they were familiar with their firearms, and kept them packed away; if they respected rivers, and did not rush to ford them; if they paced their passage and lightened up their load—they stood an excellent chance of a relatively smooth progress to Oregon.

And then there were the city slickers. These poor souls simply showed up in Independence, St. Joseph, Kanesville, or some other "jump-off" town along the Missouri, figuring folk there would be willing to help them on their way. Willing they were. Waiting along the western edge of American civilization was a keen assortment of wheelers and dealers, hucksters and promoters, outfitters and frontier guides, drifters and ne'r-do-wells. Even insurance salesmen joined the throng.

In 1843, many of those who arrived in Independence already owning oxen, a wagon, and a full complement of supplies completed their journey west without spending a single penny. For those who bought their supplies from Missouri companies ready and willing to fully equip raw recruits, the going rate might reach as much as three hundred dollars per outfit.

Having bought a decent rig and loaded it with 200 pounds of flour, 150 pounds of bacon packed in bran, 10 pounds of coffee, 20 pounds of sugar, 10 pounds of salt, 2 bushels of dried fruit, and a small barrel of pickles, an 1843 emigrant family might find no further use for a dollar within two thousand miles.

Just ten years later, the proliferation of ferry and bridge tolls, and the irresistible lure of a trading post every twenty or thirty miles, prompted the average pioneer family to spend an additional $200 during their six months on the Trail.

For those who simply showed up in Independence hoping to be able to buy a ticket to Oregon, the range of options was considerable. Salesmanship in the middle of the nineteenth century, as in the middle of the twentieth, was longer on style than substance. Travel agents did not just say Paradise was waiting at the end of the Trail; they said getting there would be half the fun.

No sooner had the first wagons crossed the Rockies than some Missouri entrepreneurs were peddling the opportunity to make the

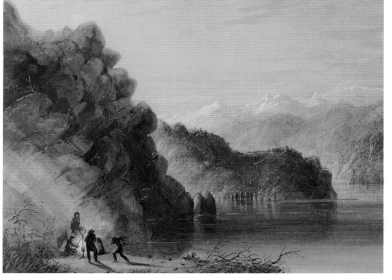

Lake Scene—Rocky Mountains

journey west in style. Brochures promised pioneers a fully-catered service: six passengers per comfortable wagon, sixty days from start to finish.

Passengers soon learned, however, that mules had not been consulted by the copywriters. A comfortable ride quickly gave way to tearing the wagon from the mud, to rafting swollen rivers, to collecting buffalo chips for fuel, to helping bury the dead.

Still, word of this sort of misfortune spread more slowly than gossip of great success. Some prospective emigrants were even convinced the journey was so easy they could make it pulling a handcart, or pushing a wheelbarrow. Many wagon travelers recorded in their diaries passing these hardy souls as they struggled across the prairie.

The sheer spectacle of the open plains produced in some men and women a sense of awe. In others it produced a sense of knowing there was a buck to be made. By 1846, William Thomas, an inventor in Westport, was busy fabricating what he called a "wind wagon," complete with mast and sails. This "see-worthy" prairie schooner was supposed to whip passengers out to the coast at fifteen miles per hour.

In 1849, Rufus Porter, the founder of *Scientific American* magazine, drew up plans for an "Aerial Locomotive," a thousand-foot-long, propeller-driven balloon that was supposed to float to San Francisco in three days. The fare: fifty dollars, wines included.

No aerial locomotive ever pulled out of a Missouri station, but progress did come to the Trail. Sir Richard Burton, the intrepid British author and explorer, traveled to Salt Lake in 1860 by stage coach. He paid $175 for his ticket. The sailing may not have been exactly smooth, but at least it was cozy. The Butterfield Overland Express, which ran "Concord Coaches" clear through to San Francisco, packed as many as nine passengers inside, with a further nine clinging to the roof.

And so it went, a trickle at first, then a river, and finally a flood. The vast majority of men, women, and children crossed the continent by walking, for the unsprung, jolting wagon was far too uncomfortable to ride. Armed with their dreams and determination; wrapped in the warm hope that, whatever the Trail threw at them, they would rise to overcome it; eager, and together, they stepped forward in search of a better tomorrow.

In 1850, two years after gold was discovered in California, as more than 50,000 pioneers poured across the prairie, some Indian tribes began to think they had seen enough. A journalist, Matt Field, wrote that tribes were starting to talk of moving east. Chiefs were convinced there could be hardly any Whites left on the far side of the Missouri River.

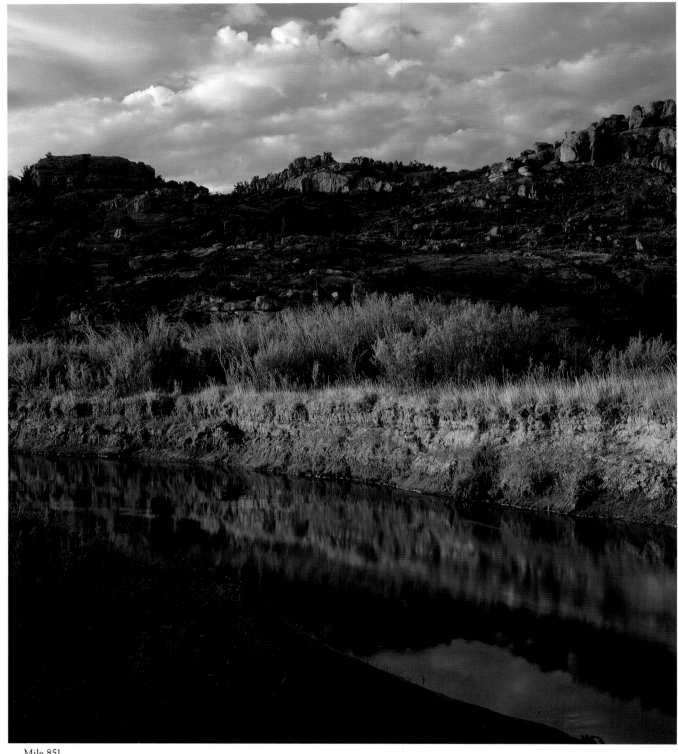

Mile 851

SWEETWATER RIVER NEAR THREE CROSSINGS, WYOMING. In the sixty-mile stretch between Independence Rock and St. Mary's Station, many wagon companies forded the Sweetwater River eight times. Each crossing put an enormous strain on the livestock.

I think I had as good a team as travels the plains. I had eight yoke
of cattle and I worked six yoke at a time.
George Belshaw, 1853

Mile 851

GRANITE, THE DEEP SANDY ROUTE, WYOMING. That wagons were able to move at all in some terrain was a marvel. Swollen rivers, in particular, could cause long delays. One 1844 company spent seventeen days struggling to cross a single creek. It took two months instead of the usual ten days to get two hundred miles.

In order to avoid crossing the Sweetwater three times we took the old trail . . . The hauling
was heavier through deep sand than any we have ever had yet. Nooned on a barren
hill where each sprig of grass seemed separated some feet from its neighbor.
Bennett C. Clark, 1849

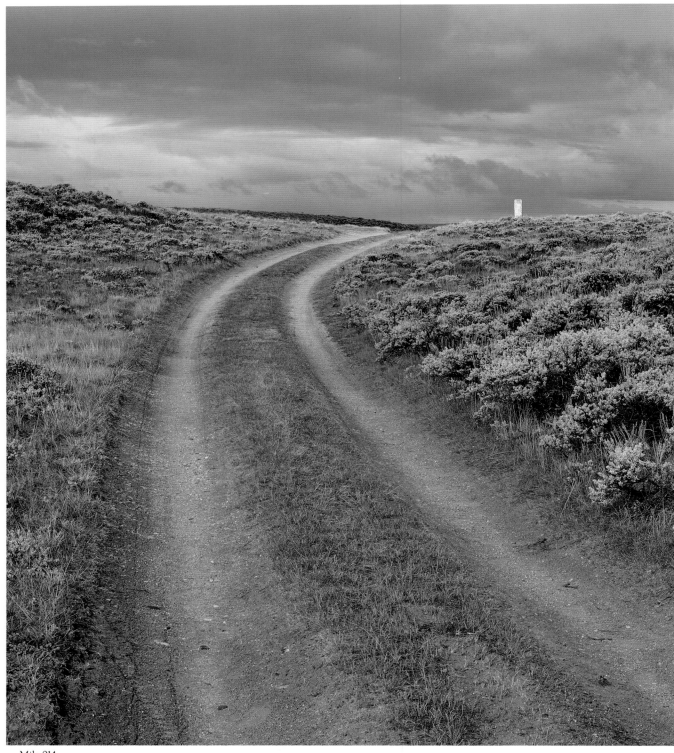

Mile 914

SOUTH PASS, WYOMING. The Rockies confined most cholera east of the mountains, but pioneers could not confine it to their campsites. The disease spread among Indian tribes, including the Osage, Konza, Kickapoo, Shawnee, Pawnee, Cheyenne, and Sioux.

The road, from morning till night, is crowded like Pearl Street or Broadway.
Franklin Langworthy, at South Pass, 1850

52

Mile 916

PACIFIC SPRINGS AND THE WIND RIVER RANGE, WYOMING. Two miles west of South Pass, pioneers found the first Pacific-bound water they would drink. A series of springs formed a quaking bog, which was interlaced with rivulets of icy water. Pioneers rejoiced: their journey was half done.

Atlantic water forever gone and Pacific water to be our future drink.
Reverend Edward E. Parrish, 1844

PLUME ROCKS, WYOMING. In this long stretch of flat, high plains country, this eroded sandstone outcrop, a few hundred yards north of the Oregon Trail, lured many pioneers from their path. They dubbed this landmark Plume Rocks after ostrich plumes, the height of fashion "back in the States."

Mile 926

A drowsiness has fallen apparently on man and beast; teamsters drop asleep on their perches and even when walking by their teams, and the words of command are now addressed to the slowly creeping oxen in the softened tenor of women or the piping treble of children.
Jesse Applegate, 1843

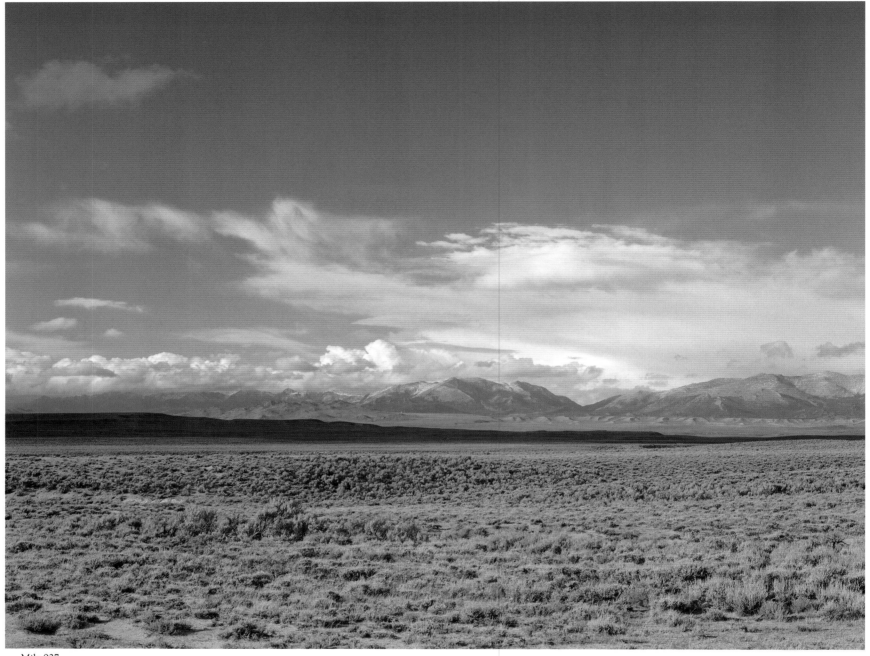

Mile 927

WIND RIVER RANGE FROM DRY SANDY CROSSING, WYOMING. Some of the Trail's blessings turned out to be curses in disguise. Pioneers rejoiced when heavy spring rain provided abundant grazing for livestock. But that same rain could swell streams, making river crossings the most perilous of all Trail activities.

. . . today we have used a cart, having cut our
wagon in two places to make it lighter.
Elizabeth Julia Goltra, 1853

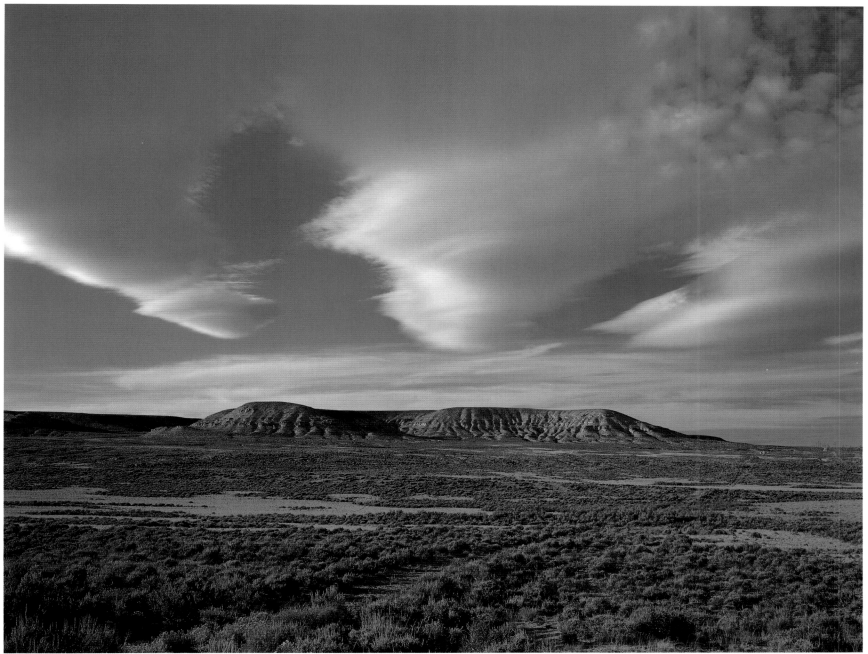

Sublette Cutoff Mile 987

NAMES HILL, SUBLETTE CUTOFF, WYOMING. In 1830, William Sublette took his wagons to the fur traders' rendezvous at South Pass, pioneering wagon travel to the crest of the Rockies. Among the signatures carved on nearby Names Hill is one that must have been etched for the illiterate "James Bridger, Trapper."

I had now under my care twenty-six wagons and forty-three men,
which kept me wide awake all the time.
George Belshaw, 1853

57

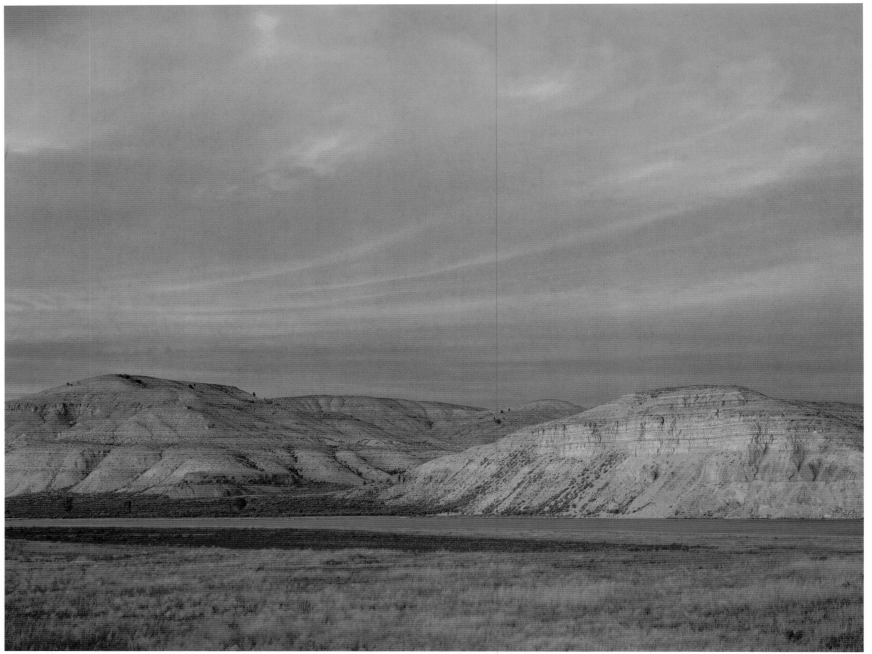

Mile 988 Sublette Cutoff

GREEN RIVER NEAR NAMES HILL, WYOMING. Fresh meat always was scarce. Emigrants constantly were on the lookout for deer, elk, buffalo, waterfowl—even the occasional squirrel. This diet was supplemented by berries, nuts, and roots; and when all else failed, by the old standbys—bread, beans, and bacon.

The horses are well worn out, and with grass, wood and water in plenty we lay in camp.
The location is pleasant, in fact the Green River is the only pleasant
locality we have seen since leaving the Platte River.
Lemuel Clarke McKeeby, 1850

58

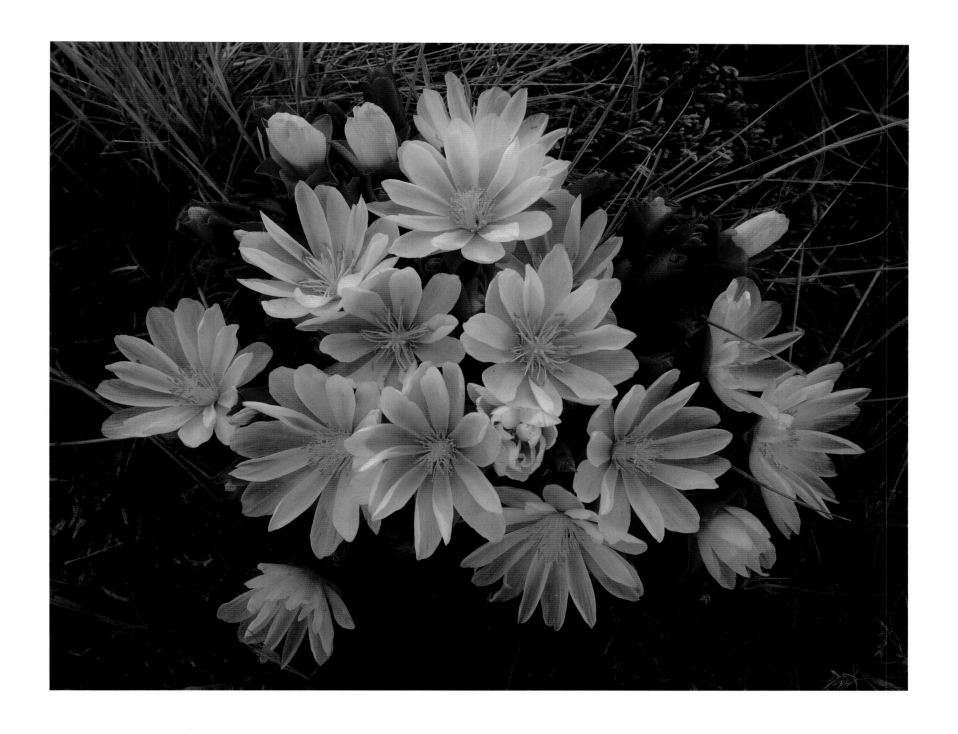

BITTERROOT PLANT, WYOMING. Bitterroot or rock rose was an important food to all Indian tribes of the West. The root, once separated from its bitter sheath and dried, could be stored indefinitely. In early spring, the leaves are insignificant narrow strips that shrivel before the plant produces its stunning flowers.

Yesterday, some Indians gave us some edible roots which we ate in abundance
in our hunger—whether it was the plant or the amount I ate I am
not sure but suffered horrible pains and diarrhea.
Heinrich Lienhard, 1846

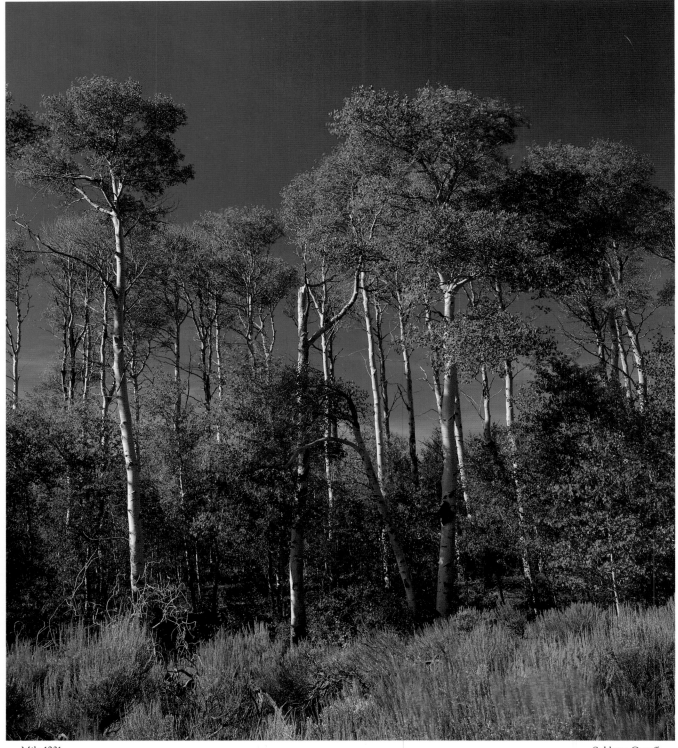

Mile 1031

ASPENS AT EMIGRANT SPRINGS ON THE SUBLETTE CUTOFF, WYOMING. From the forested summit of the Dempsey Ridge, the shortcut plunged down to the Bear River. Hungry pioneers rejoined the main trail near the site of present-day Cokeville, Wyoming.

How we do wish for some vegetables. I can really scent them cooking sometimes. One does like a change and about the only change we have from bread and bacon is bacon and bread.
Helen Carpenter, 1857

Jumping Off

The pioneers who left Independence in 1843 paid fur trapper John Gantt one dollar per head to lead them as far as Fort Hall, and he did exactly that. This made the 1843 wagon train highly unusual—it ended with the leader it started with.

In the early years along the Trail, most emigrants traveled in the company of trappers and their fur-trading caravans. The pioneers took their cues from these experienced veterans.

In later years, as the Trail became better defined, pioneers thought these expert guides no longer were needed, and trouble frequently set in. Men such as Gantt did not just know which road to take; they knew just how to take it. Slowly. Steadily. These men well understood the considerable perils of rushing off at every available opportunity to chase after Indians or buffalos, or to search out imagined shortcuts.

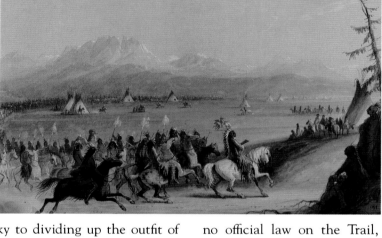

The pioneers sorted themselves into as many kinds of traveling companies as ingenuity could contrive. Some set off in caravans of more than 100 wagons. In 1843, Jesse Applegate's train of sixty wagons divided into fifteen platoons of four wagons each. No sooner had this been accomplished than outfits began to disintegrate, and to comingle. The most efficient trains seem to have been made up of about twenty wagons, with three or four men to each wagon.

Each company generally drew up a constitution designed to govern its progress. Bylaws covered everything from taboos against gambling and whisky to dividing up the outfit of anyone who died. Joel Palmer's 1845 train decided that murderers would be hanged—from a hastily raised wagon tongue were no convenient tree available. Rapists would receive thirty-nine lashes for three days in succession. Some companies even opted for military-style uniforms. All this was planned in the confines of some Missouri camp. Dissension and defections usually set in as soon as the wagons rolled. Later trains learned not to elect officers until they had been on the Trail for some time.

What did pioneers quarrel about? In short, everything. Some trains had sworn never to travel on the Sabbath. This worked fine until the first Sunday, when some pioneers saw themselves being passed by heathens hurrying toward a campsite with plenty of firewood. There was nothing in the Scriptures saying, "Blessed are those who go to bed cold."

Other emigrants insisted companies halt when wagons needed repair, when animals were exhausted, when rivers were in flood . . . not on every seventh day. Still, those who maintained this strict regimen, and thus gave regular rest to man and beast, may have made the steadiest progress.

People quarreled, too, about the various animals that accompanied their wagons. Horses fared poorly on the dry prairie grasses, but were useful for the occasional buffalo hunt. Mules were cheaper and tougher, but stubborn. Oxen did most of the work on the Trail. Perhaps sixty percent of pioneers harnessed them to the yoke. As their cloven iron shoes wore out, and hooves became cracked and crippled, pioneers daubed each ox's feet with boiling tar or fashioned crude moccasins from buffalo hide. Oxen were strong, reliable, and had one other considerable advantage over mules and horses—when dead, they tasted better.

Then there was the question of the cows. Those who had brought along these laggardly creatures regularly incurred the wrath of those who did not. It was just such a dispute that prompted Applegate's company to split in two.

Pioneers who took care of their livestock could profit considerably, for there was money to be made at the Trail's end. In 1852, an ox bought in Missouri for $30 sold in Portland for $120. A $100 horse fetched $500. Most profitable were milking cows. A $12 heifer might be worth $150 by the time she reached the Willamette Valley.

If pioneers ever tired of quarreling about campsites, animals, organization or trail dust, there was always sex. The exposure to the vast ruggedness of the landscape, and the stepping away from societal bonds, prompted in some men and women a sense of passion that did not go unrequited. When they were not burying, preachers kept busy marrying. As for illicit affairs, since there was no official law on the Trail, the Emigrant Road became the scene of numerous impromptu firing squads.

Others who incurred the wrath of their traveling companions found themselves banished, and off they wandered, hoping to hitch the fortunes of their wagon to another company's star. They frequently found the welcome cool, for an extensive, informal telegraph network operated along the Trail. News traveled quickly because the varying rates of progress meant that companies constantly were passing each other. In addition, there was a regular flow of folks heading East. Some were what the pioneers called "gobacks," people abandoning the quest. Others were adventurers and speculators, fur-traders and military men, returning from the West.

And so it went, day after endless twenty-mile, dust-caked day. As dawn's trumpet blasted, pioneers scurried to round up the livestock, which might have wandered miles in search of grazing. Families walked all morning, rested, walked again until dark, ate another meal of beans and bacon, fell asleep again beneath the stars.

Some evenings an old man played the fiddle. Some evenings a young girl sang a hymn. Then, at dawn, once more, the trumpet called anew.

Cavalcade

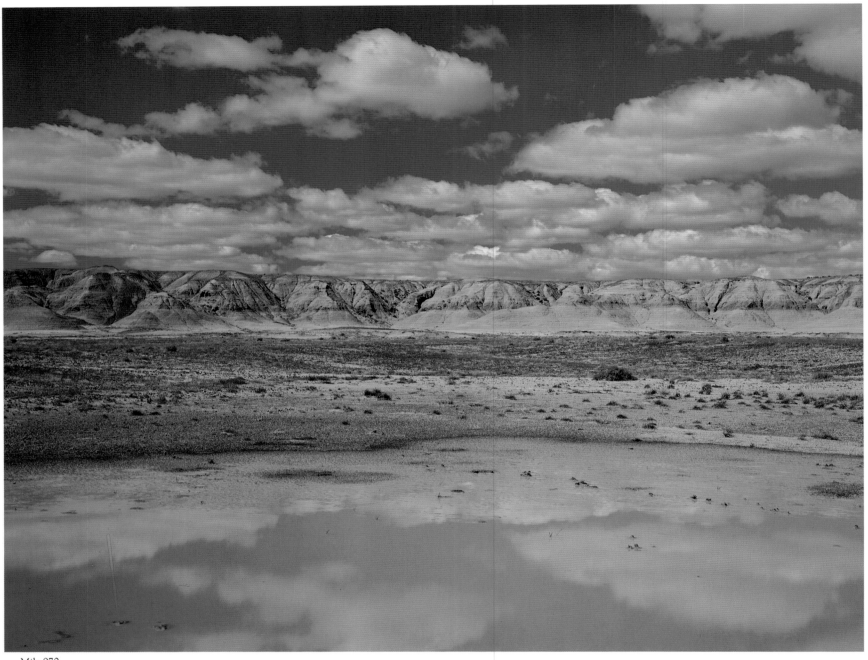

Mile 970

LITTLE COLORADO DESERT, WYOMING. As the Oregon Trail unfolded, it presented to pioneers an unrelenting series of barren landscapes, obstacles that seemed guaranteed to bring out the very worst in a man. The road west might have been designed to uncover emotions a man thought forever buried.

If there is any meanness in a man, it makes no difference
how well he has it covered, the plains is the
place that will bring it out.
E. W. Conyers, 1852

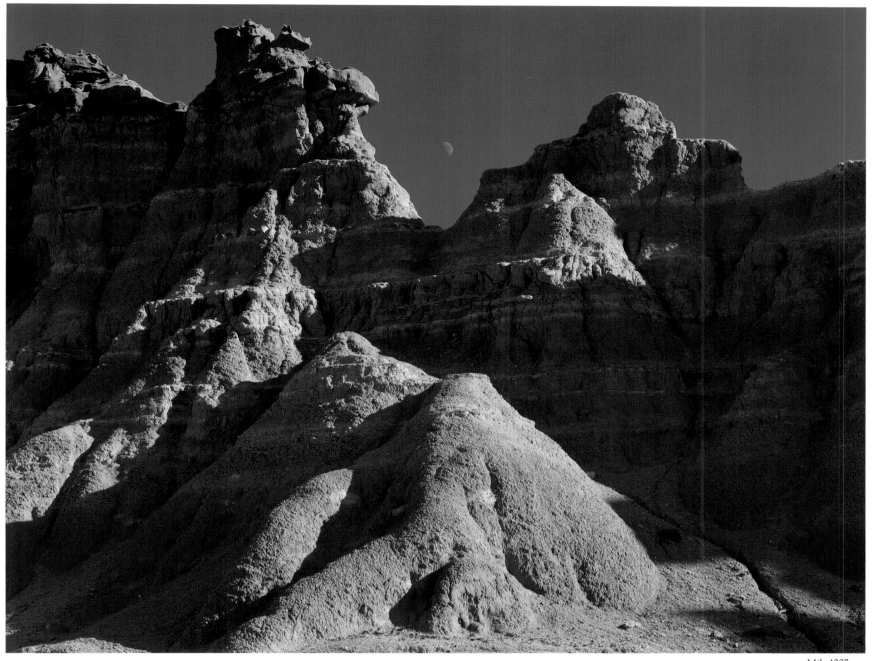

Mile 1007

SOLOMON'S TEMPLE, WYOMING. Though many planned to conserve supplies by living off the land, game proved elusive. Water had to be carried across barren stretches, sometimes for days. By the 1850s, the Mormons developed a "half-way house," furnishing everything from respite to fresh oxen and hot baths.

Our drinking water is living . . . that is it is composed of one third
green fine moss, one third pollywogs, and one third embryo
mosquitoes . . . we strain through our teeth.
W. B. Evans, 1852

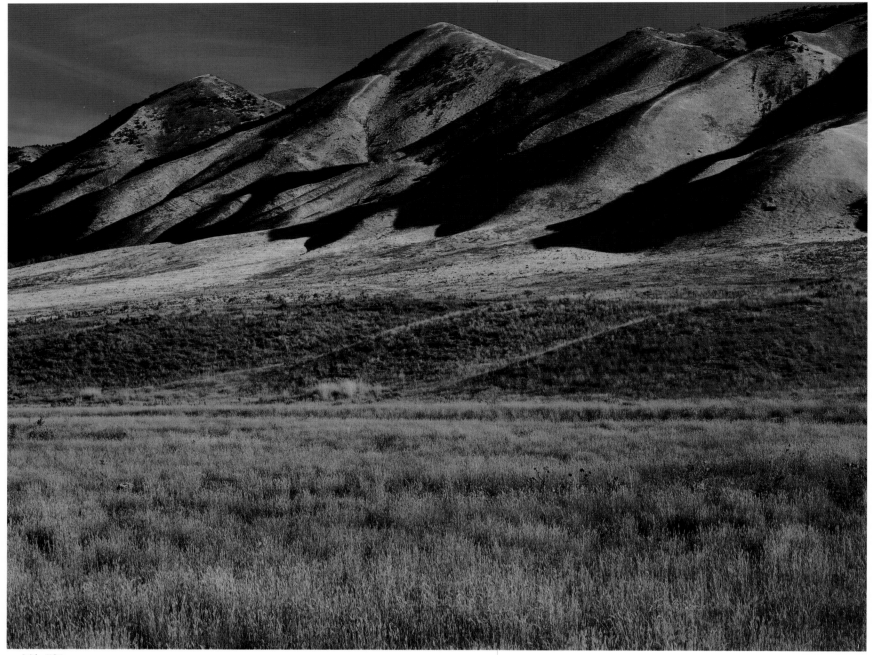

Mile 1104

THE SUBLETTE RANGE, WYOMING. The furious challenge of forging a path into untamed country, and the heady excitement of stepping away from their so-called "civilized" world—a society stuffed full of inhibiting airs and graces—unleashed in more than a few men and women a hitherto unrecognized passion.

Love is hotter here than anywhere that I have seen,
when they love here they love with all their
might and some times a little harder.
John Lewis, 1852

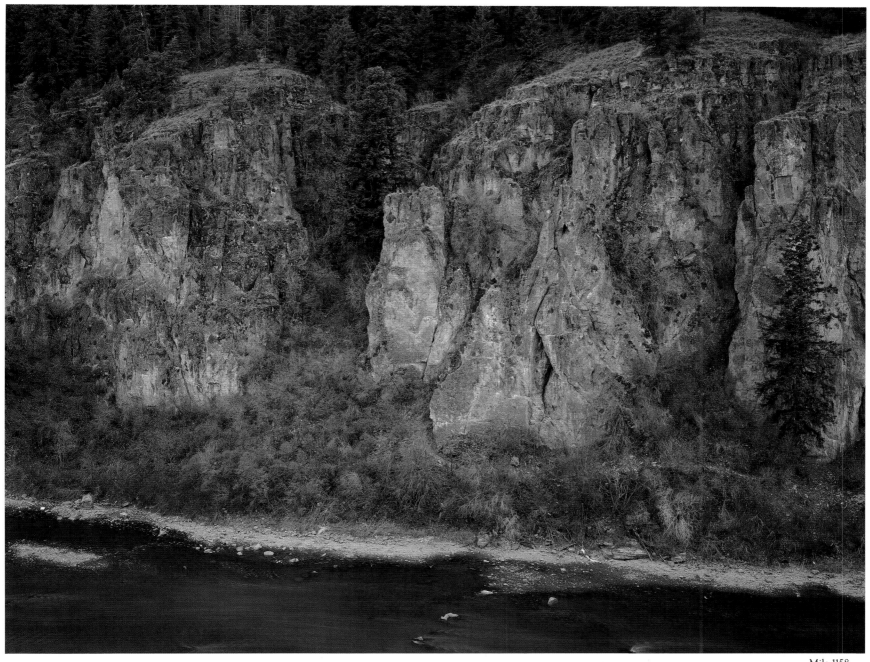

Mile 1158

SHEEP ROCK, IDAHO. In 1841, this is where the Bidwell-Bartleson Company, the first to travel without experienced mountain men, wheeled toward California. It turned out to be a tortuous route through desert. Despite the ongoing difficulties, pioneers still found the time for those unbridled passions to bear fruit.

Wife's old love affair with . . . the tailor seems to have
started all over again . . . I beat him so his eyes
were blackened and his right arm lamed.
Hans Hoth, 1854

65

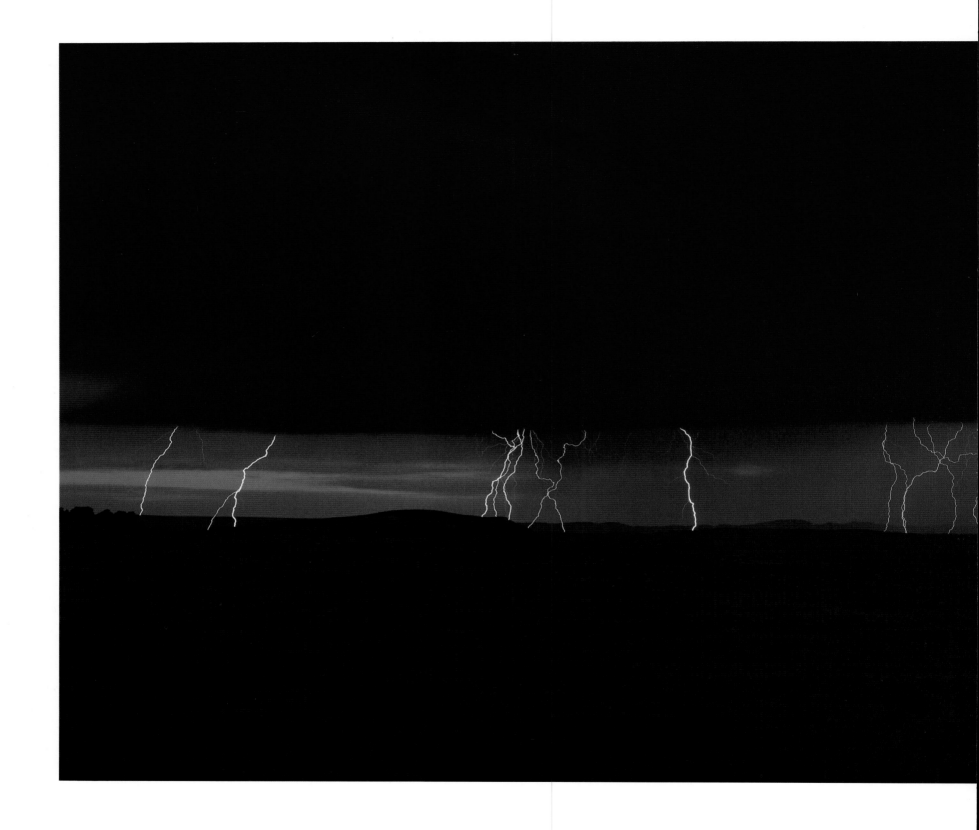

LIGHTNING NEAR AMERICAN FALLS, IDAHO. Beneath a restless sky, the Great Migration brought people together: young and old, rich and poor, all religions, all walks of life, all places of birth. The Oregon Trail was a cradle for democracy; it played a key role in weaving the threads that form the fabric of the West.

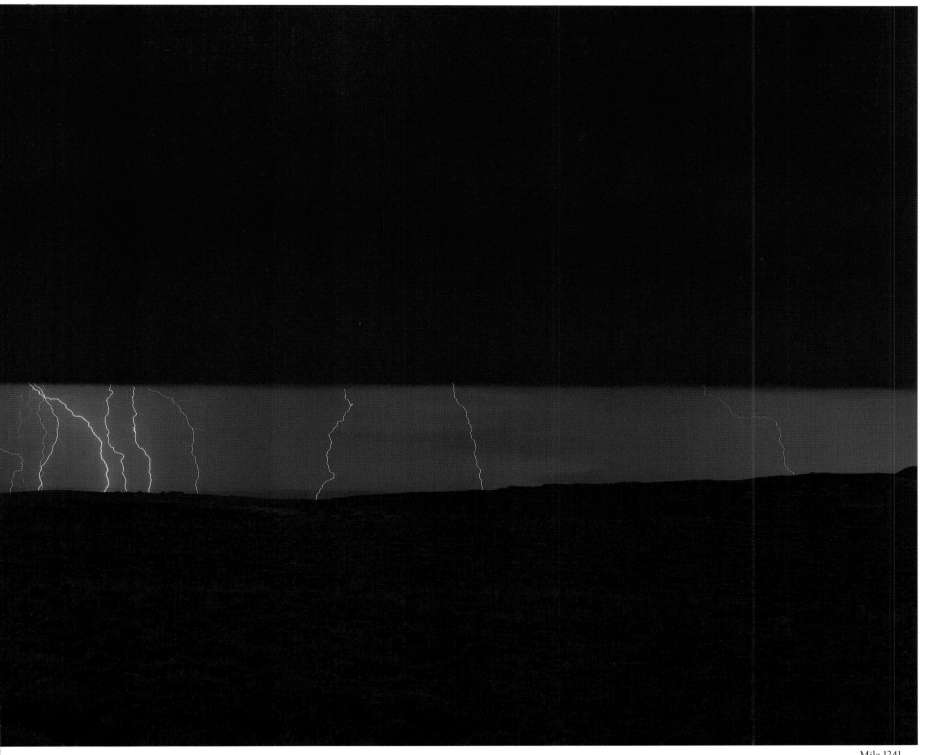

Mile 1241

*The sides of the heavens warred like contending batteries in deadly conflict. The rain
came in floods; and our tent, not being ditched around, was flooded soon after the
commencement of the storm, and ourselves and baggage thoroughly drenched.*
Thomas J. Farnham, 1839

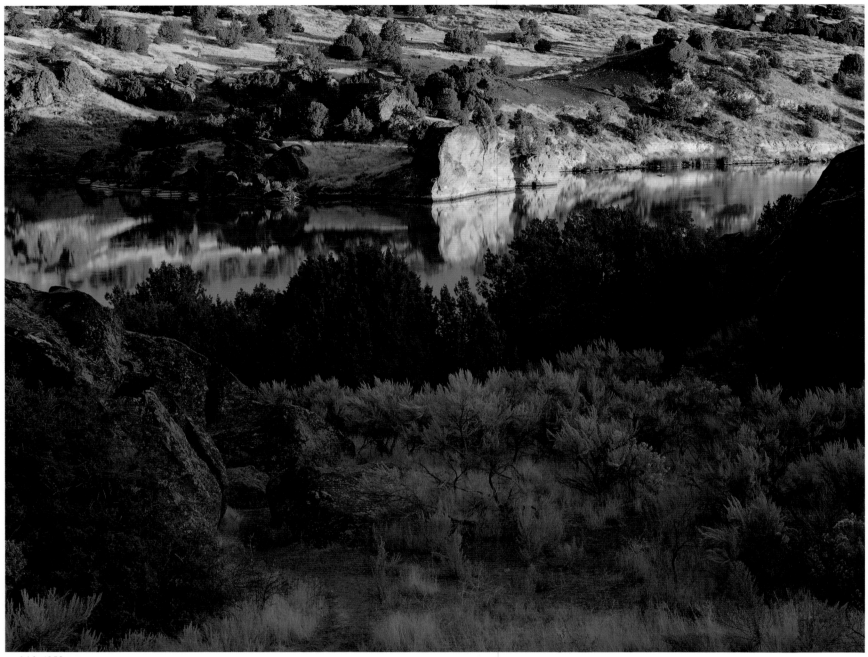

Mile 1250

DEVIL'S GARDEN, IDAHO. The Oregon Trail met the Snake near Fort Hall, then followed the river's course for more than three hundred miles. As emigrant wagons inched their way around inhibiting mounds of rock, pioneers became convinced only the devil could have created a garden quite like this.

We never passed a single company without being made welcome to such supplies as could be spared from their scanty stores, which speaks well for the noble, free-hearted souls that crossed the plains in forty-nine.
Reuben Shaw, 1849

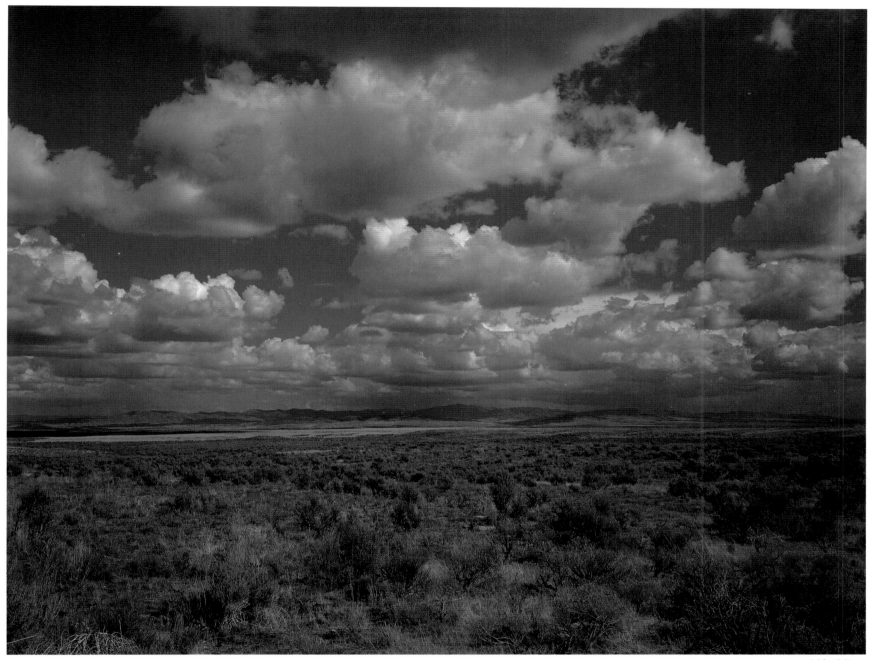

Mile 1261

NEAR THE CALIFORNIA JUNCTION AT RAFT RIVER, IDAHO. According to Oregon lore, two signs marked this early parting of the ways. On one road was a pile of rocks painted gold. On the other was a sign saying, "To Oregon." Those wanting riches turned left; those who could read went to Oregon.

We arrived late in camp last night. We had thought that some
of our profane men were bad enough, but the Californians
are so much worse that there is no comparison.
Mary Stuart Bailey, 1852

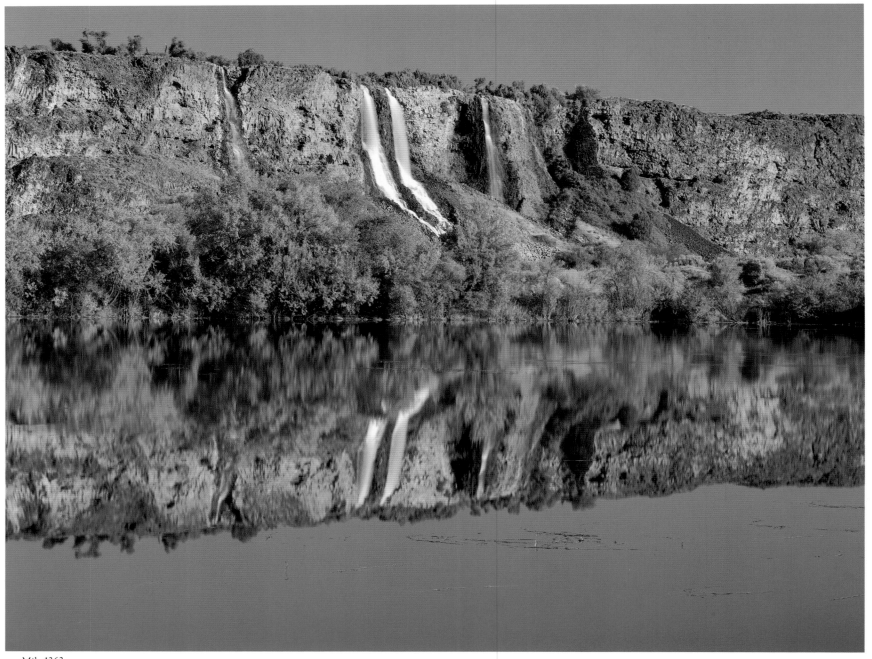

Mile 1363

THOUSAND SPRINGS, IDAHO. Along the bank of the Snake River, tumultuous springs burst from between layers of volcanic rock to cascade to the river below. Pioneers marveled at the spectacle of Thousand Springs and feasted upon the huge fish that cavorted close by their spawning grounds.

. . . I lay on the bank of the river, where I could scarcely sleep for the Indians, who sung
all night in a very curious manner . . . the salmon also kept a great noise,
jumping and splashing about in the water.
Joseph Williams, 1843

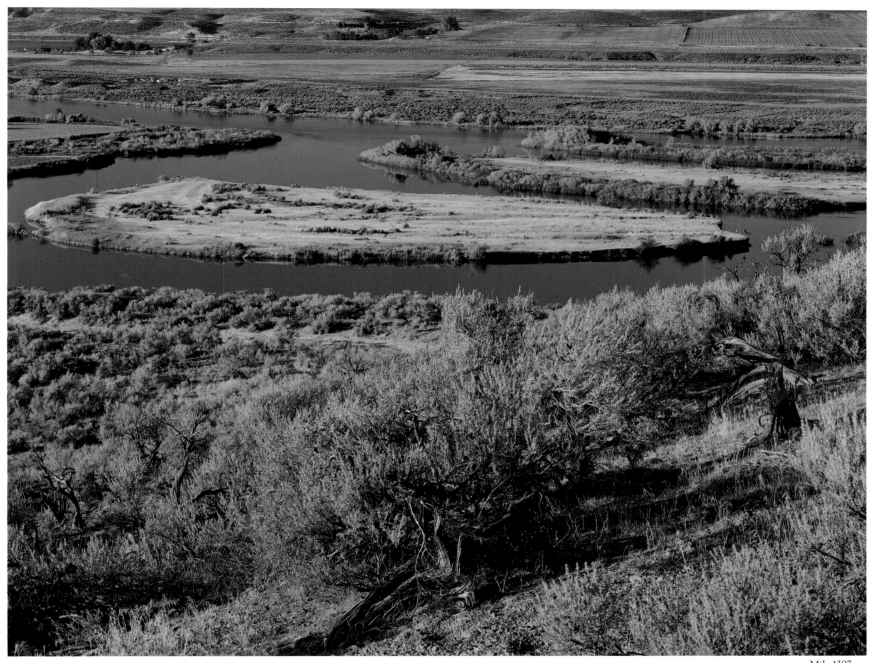

Mile 1397

THREE ISLAND CROSSING, IDAHO. In years when the water was low, pioneers crossed the Snake here to avoid the dry, rocky route along the south bank, rejoining the main Trail near present-day Nyssa, Oregon. Pioneer wagons etched a trail across two of these islands as emigrants made their way to the north bank.

You must hire an Indian to pilot you at the crossings of Snake River,
it being dangerous if not perfectly understood.
J. M. Shively, 1846

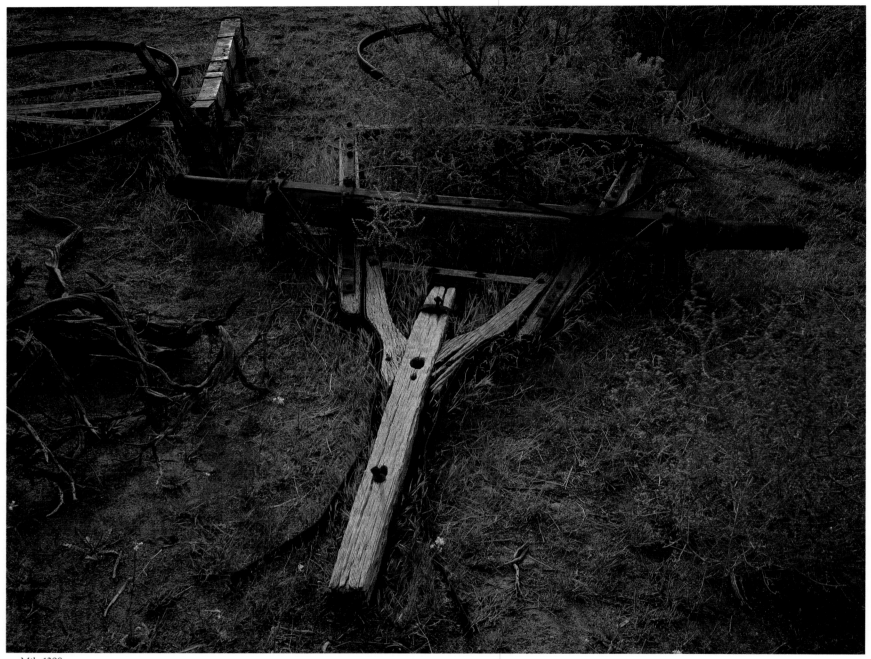

Mile 1398

WAGON DEBRIS AT THREE ISLAND CROSSING, IDAHO. As the Trail west seemed to grow ever more difficult and livestock became ever more exhausted, the pioneers faced continuing demands to lighten their loads. Great heartache was caused by abandoning cherished items that had been hauled so far.

The road has been strewn with articles . . . large blacksmith's anvils and bellows, crow-bars, drills, augurs, gold-washers, chisels, axes, lead, trunks, spades, ploughs, large grindstones, baking-ovens, cooking-stoves . . . barrels, harness, clothing, bacon and beans.
Capt. Howard Stansbury, 1849, en route to the Great Salt Lake

A Woodstove, a Washtub, an Old Rocking Chair

The typical pioneer wagon was small; its hickory bed measured ten feet long by four feet wide, with sideboards two feet high. The canvas top generally was gaily painted with a slogan: *Oregon or Bust*. It was lined inside with pockets. The wagon bed, caulked for ferrying across rivers, frequently had a false bottom, beneath which were compartments opening from the outside. Into this wagon, to be drawn by six or eight oxen, a family crammed one ton of dreams.

Spring can be a glorious season along the Platte River. It can also be a wet one. Storms roll like great bowling balls across this landscape. The rain comes in fast and hard. It turns the earth into a deep and grasping mud. The journey west marked, for some of the pioneers, their first experience working with livestock. The journey west marked, for some of the mules, their first experience working with wagons.

This marriage was made somewhere other than in heaven. Many of the rookie rigs crossed over into Kansas hopelessly overloaded. The emigrants had "jumped off," determined to carry with them everything under the sun.

Under the sun was where many items soon found themselves. Rocking chairs and linen chests. Flatirons and crowbars. Woodstoves and washtubs. Mattresses and mirrors. Grindstones and gold-washers. Barrels and bellows. Baking ovens and bacon "piled up like cordwood." It would have made a great garage sale, but nobody was buying.

For many emigrants, it took but a few weeks of travel before the Oregon Trail turned into a dumping ground. This cruel business of having to lighten the load continued all along the Trail, as mountains grew taller, as rivers ran deeper, as livestock became exhausted, as the elephant appeared more often.

One family went so far as to trim the fat from all its bacon. One minister brought his beloved library as far west as the Boise River. There, finally, his livestock exhausted, he had to ease their burden by stacking his prized volumes at the side of the road.

Nothing was sacred when it came time to count essentials. Pioneers found themselves dumping family heirlooms, a box of children's toys, fine china. Many an Indian put together a striking new outfit from clothing left by the wayside. One 1847 emigrant recalled his Salmon Falls camp being visited by an old Indian sporting a tall silk hat and vest—and absolutely nothing else.

For years, old-timers in Portland talked of taking shovels to stalk the treasures left buried near Mount Hood. There, according to a legend far bigger than any cache, many pioneers had been forced to ease their burdens before descending the dreaded Laurel Hill. Everything buried

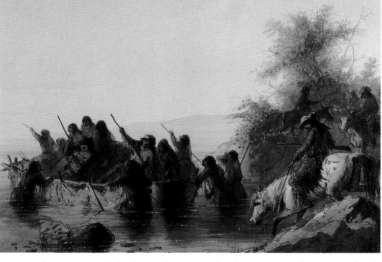

Bull Boating

among those timberline meadows, it was said, must be valuable, because by that stage of their long journey the only things still in wagons were possessions held most dear.

There were, too, those pioneers who had planned with great care precisely which items would fill every last square inch of their wagon beds. In 1847, Henderson Luelling filled one wagon with a mixture of charcoal and rich Iowa soil, then packed aboard seven hundred young fruit trees, vines and shrubs. He sold his stock to settlers in the Willamette Valley.

Casting off prized possessions must have been particularly painful for all those—especially pregnant women and children—who were unwilling participants in this great adventure. Dragged along by the binding ties of family and circumstance, they found little in their long journey west to persuade them that Paradise might be close at hand.

Unloading what had only so recently been carefully packed was not the only hardship pioneers faced within days of "jumping off." After weeks of waiting, packing, repacking, and waiting again, it took but a few days for the euphoria of finally getting underway to settle into the harsh reality of life on the Trail. The shakedown cruise often was both difficult and dangerous. Many pioneers suffered serious injury, or worse, before mastering the art of handling a wagon and team. And then there was that other question that now had to be settled—who would be in charge? Frequently the fellows who had looked best qualified to make decisions around the campsites in Independence looked less reliable once the wolf of wilderness was at camp's door.

Then there was the question of firearms. For the typical pioneer, the journey west was his first experience with weapons. For hundreds, it also was the last.

Men—few women carried guns—killed themselves in all sorts of ways. In 1841, the year the first major train moved west, came the first casualty of accidental gunfire. His name was William Shotwell. The most frequent accident involved an excited pioneer reaching for a gun from his wagon and pulling it muzzle first from beneath its covers. Then there were those who tripped and fell, triggering a pistol tucked into a waistband. There were, too, the quarrels that often boiled over into bloodshed.

No wonder one company, less than a week from the Missouri, paused to debate whether the smart thing to do might be to halt and found a colony right there. Of course, they did not; for despite the relentless monotony, growing hardship, and an ever-rising death toll, pioneers pressed forward, lured by the promise of the Paradise that waited beneath the setting sun.

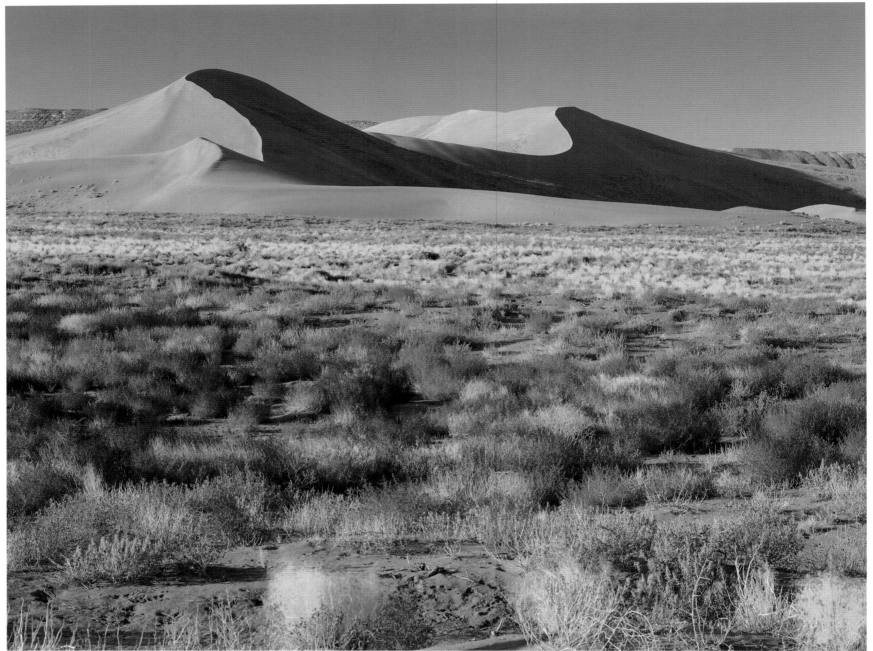

Mile 1419 South Alternate Route

BRUNEAU DUNES, SOUTH ALTERNATE ROUTE, IDAHO. These sand dunes, reported to be the tallest in North America, stand a few miles south of the main Trail. Like sentinels, they seemed to watch, and to warn, that though much of the Trail was behind them, pioneers still faced much that would test them.

We met several going back who said that all their animals had died, and all they wanted
was to get back alive. There is more suffering on this trip than one
can well imagine, and how it is to end God only knows.
Dabney Carr, 1850

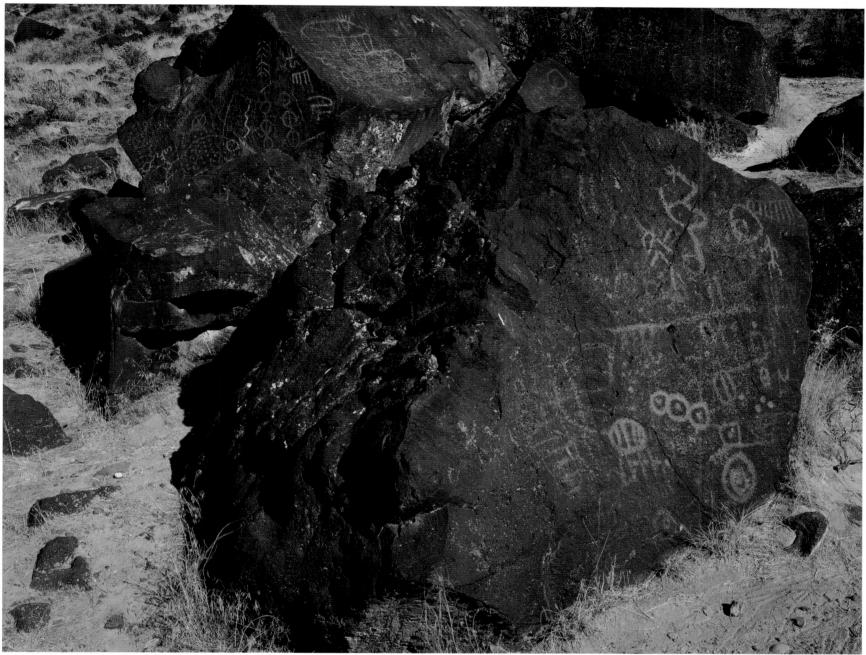

South Alternate Route Mile 1482

MAP ROCKS, SOUTH ALTERNATE ROUTE, IDAHO. The rock art that occurs throughout the West poses many unanswered questions. Who made these figures? What do they mean? How old are they? The artists have long since vanished, leaving only these enigmatic symbols to echo through time.

The Indians have visited us every day and brought us
fish. They appear perfectly friendly.
Martha S. Read, 1852

Mile 1400

HILLS NORTH OF THREE ISLAND CROSSING, IDAHO. Beyond the planning, the organization, the execution—and the luck—there was something else critical to each pioneer's success. It was that singular determination, in spite of all the Trail threw at them, to keep putting one foot in front of the other.

Travel, travel, travel—nothing else will take you to the end of your journey;
nothing is wise that does not help you along; nothing is good
for you that causes a moment's delay.
Marcus Whitman, 1843

Mile 1435

GRANITE BOULDERS AND GIBBOUS MOON, IDAHO. The Oregon Trail passes below many of these granite outcroppings as it wends its way between Rattlesnake Station and Bonneville Point. Many pioneers climbed to places such as this from which the view—and the road ahead—seemed to go on forever.

Oh when shall I see once more a verdant landscape!
One thousand miles of naked rocks.
Riley Root, 1848

GRANITE BOULDERS AT SUNSET, IDAHO. As emigrants gazed into the distance, they must have felt Trail's end still was hopelessly distant. Within days, they would leave the Snake River Plain; then climb the Blue Mountains, the imposing barrier separating them from the great river of the West, the Columbia.

Mile 1435

While we were in the midst of a funeral service, the coyotes were on a knoll
about sixty rods from us, fighting and howling so dismally
it was difficult to hear the preacher.
David Cartwright, 1852

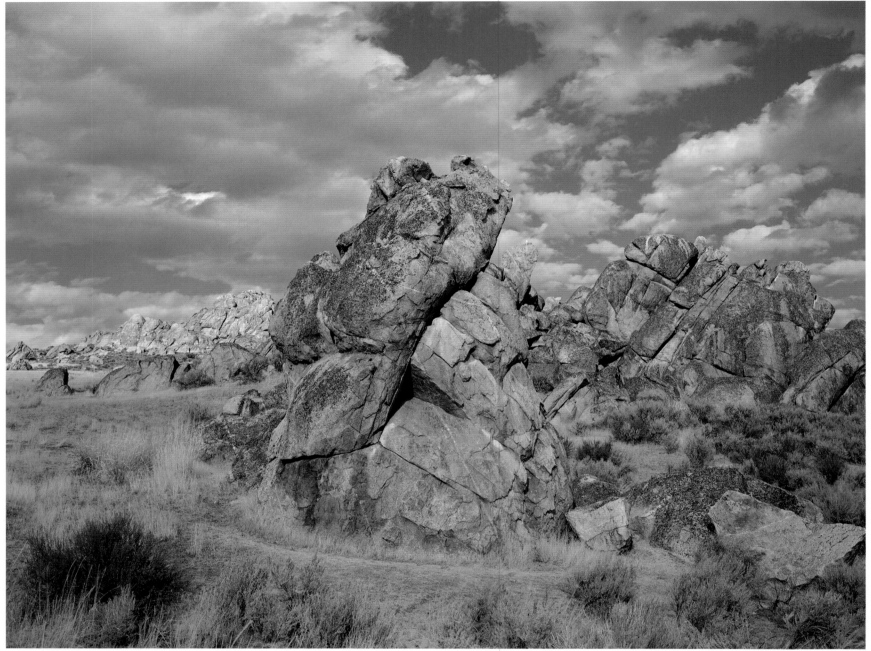

Mile 1438

INSCRIPTION ROCK, IDAHO. Pioneers would not be thwarted in their determination to leave something more than ruts across the sage. Hard rocks such as these defied the pioneers' efforts with chisels. Instead, to satisfy their urge to immortalize their names, emigrants daubed autographs on the rocks with wagon tar.

This day traveled nine miles. One boy fell and two wheels run over one leg and the other foot,
nearly cutting the leg off while breaking the bone. Lay in camp and cut off
the thigh of the boy—he died in the hands of the operator.
Nicholas Carriger, 1846

Mile 1452

SUNRISE FROM BONNEVILLE POINT, IDAHO. In 1833, Captain B. L. E. Bonneville first gazed from this spot upon the trees in the valley of "La Riveriere Boise." The shade and the firewood offered by the trees were a welcome sight both to the soldiers and to all the pioneers who followed in their footsteps.

When we arrived at the top we got a grand view of the Boise River valley. It is
filled or covered with dry grass and a few trees immediately along
the bank, the first we have seen for more than a month.
Cecelia Adams, 1852

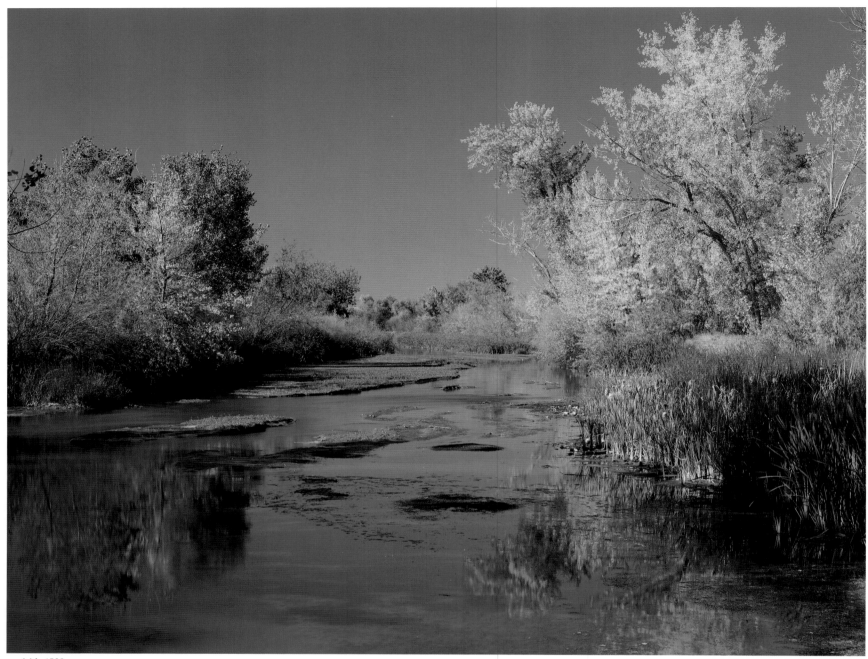

Mile 1509

OWYHEE RIVER, OREGON. Near here, after crossing the sluggish Owyhee River, the South Alternate Route continued on its way to join the main Trail a few miles north, near present-day Nyssa, Oregon. In August, with temperatures up to 100 degrees, even doing the laundry might seem like welcome relief.

This was our manner of washing and ironing. We used cold water, had a washboard, and did our washing in the evening and, when dry, folded the clothes and put heavy weights on them or just wore them as they dried . . . We wore bloomers all the way . . .
Jane D. Kellogg, 1852

Mile 1510

THE SITE OF FORT BOISE, IDAHO. Oxen and mules were not the only animals pioneers brought with them. From fort to fort, pioneers herded cattle, sheep, horses, goats, and turkeys. As anyone who has herded three turkeys across a barnyard knows, herding three hundred across a continent was a herculean task.

It took me one hour to choose camping ground
on account of the grass being eat off.
George Belshaw, 1853

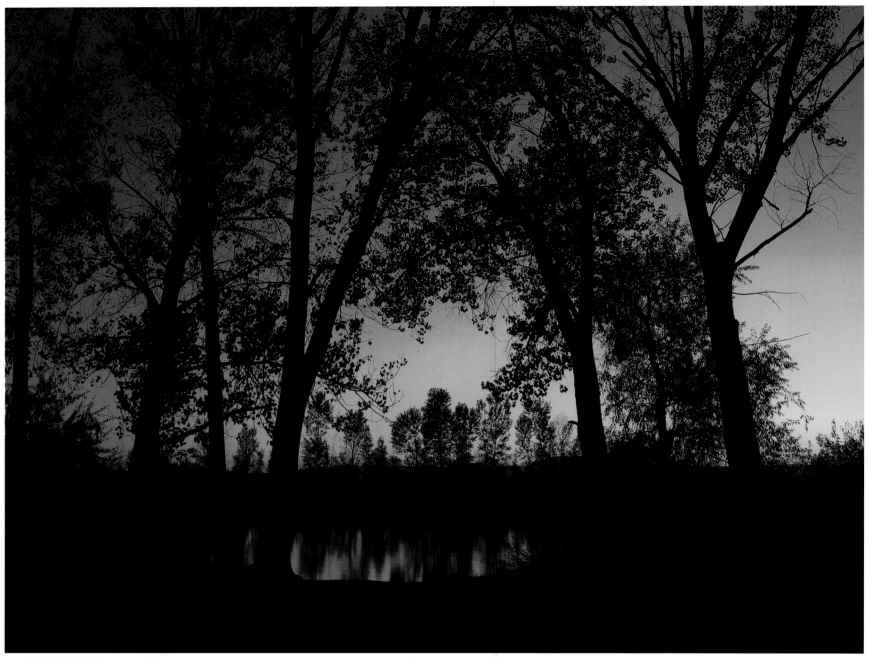

Mile 1510

AFTER SUNSET, THE MIDDLE CROSSING AT FORT BOISE, IDAHO. This swale still reveals the spot where pioneers put their wagons and rafts into the water and crossed the river via a series of small islands. In later years, a ferry, which was operated by Jonathan Keeney, was established just upstream.

In the dusk of the evening, the women went downstream for a dip in the river . . .
Increasing darkness was sufficient protection against any "Peeping Thomas."
The sensation on stepping into the stream was one never to be forgotten.
Helen Carpenter, 1857

The World's Longest Graveyard

It came first by sailing ship, from the Far East to New Orleans. It continued by steamboat, up the Missouri River, spilling into the docklands, spreading through the towns. When pioneers set off along the Oregon Trail, they took it with them.

Asiatic cholera was a killer unlike anything people had encountered. It was quiet. And quick. A man might work all morning, be stricken at noon, and enter darkness before the evening sky. Festering in the unsanitary conditions so characteristic of the Trail's crowded campsites, the disease raged through entire companies—though children usually were not affected.

Cholera was by far the biggest killer on the Trail. It far outstripped the next most frequent causes of death—drowning and the accidental discharge of firearms. In the peak years of the epidemic, when many companies lost people each and every day, the road along the Platte began to look like the world's longest graveyard.

The scene was terrible, but by no means exclusive to the Trail. Death rate statistics are difficult to estimate, but, almost certainly, more people were stricken in the places the emigrants were leaving than were perishing on their way out to the Oregon Country.

Cholera's first significant sweep along the Trail came in 1849, the first year of the California gold rush, when the number of emigrants soared. Perhaps two thousand pioneers fell to the disease that year, and a similar number the next. By 1851, the epidemic seemed to have passed, but in 1852, the busiest of all years on the Trail with some sixty thousand pioneers "jumping off," cholera returned with a vengeance.

Diaries are replete with terrible stories: of a couple dying, leaving seven children orphaned on the prairie; of emigrants so desperate to keep pushing on toward Oregon—and away from the plague—that grave diggers walked behind the wagons, shovels at the ready. Ezra Meeker's reminiscence includes the tale of one returning train with all eleven wagons driven by women. Cholera had taken every man in the company.

Not everyone who contracted the disease—usually signaled by the onset of vomiting and diarrhea—succumbed. Each wagon included a medicine chest. In 1847, Elizabeth Dixon Smith's included "a box of castor oil, a quart of best rum, and a vial of peppermint essence." In 1849, Catherine Haun added quinine for malaria, citric acid for scurvy, and opium for aches the cause of which she could not quite determine.

That same year, Dr. Israel Lord had found considerable success in the treatment of the dreaded cholera with "a single dose of laudanum, with pepper, camphor, musk, ammonia, peppermint or other spirits."

Many of the larger trains made sure to have a physician among their number. Still, surgeons were not always the most popular of pioneers. Helen Carpenter, whose 1856 diary is one of the most sensitive accounts of Trail life, was appalled to see that a certain Dr. J. Nobles had taken to advertising his services by painting his name in red letters on grave markers.

In the weeks to come, Carpenter would confide to her diary concern that the desensitization caused by conditions along the Trail might spill over into life in the promised land.

During the early weeks along the Platte River, companies paused to give each corpse a decent burial. But the ensuing lack of timber put an end to the practice of making coffins just as surely as the ensuing months of hardship put an end to compassion. By the time pioneers reached the Little Colorado Desert, bodies were being tossed into the shallow sand.

Countless pioneer grave sites were disturbed by wolves and coyotes, which left horrifying remains along the Trail. There were reports of Indians robbing graves. But by the 1850s tribes seem to have decided, from fear of disease, to leave grave sites well alone. Still, some emigrants took to rolling wagons back and forth over fresh burial sites, hoping to erase all trace of those who fell so far from any place they could call home.

People were not the only ones who perished, but for the livestock there would be no graves. Bullwhackers worked their beasts mercilessly, and oxen died by the thousand. Along certain sections of the Trail, the stench from animal carcasses was far clearer than any signpost marking the way west.

The Oregon Trail saw few pioneers with the fabled Conestoga wagons. Those bigger, heavier vehicles were mainly used to haul military supplies or freight along the smoother Santa Fe Trail. Still, the typical pioneer wagon, though small and weighing little more than two thousand pounds when fully loaded, was notoriously difficult to maneuver across the rugged landscape of the West.

The rigs had to be high-wheeled to clear the tall underbrush. When piled high with all manner of pioneer property, they were hopelessly top-heavy. This meant that any effort to negotiate a sideways route across even the most gentle slope could result in the wagon rolling over, snapping an axle, cracking a wagon tongue, or breaking a wheel. Because of this, much of the route taken by pioneers looks baffling. It seems as though, across much of its winding course, the Oregon Trail very deliberately followed the toughest route of all, going straight up and straight down each and every ridge. It often did precisely that.

Pawnee Indians Watching the Caravan

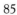

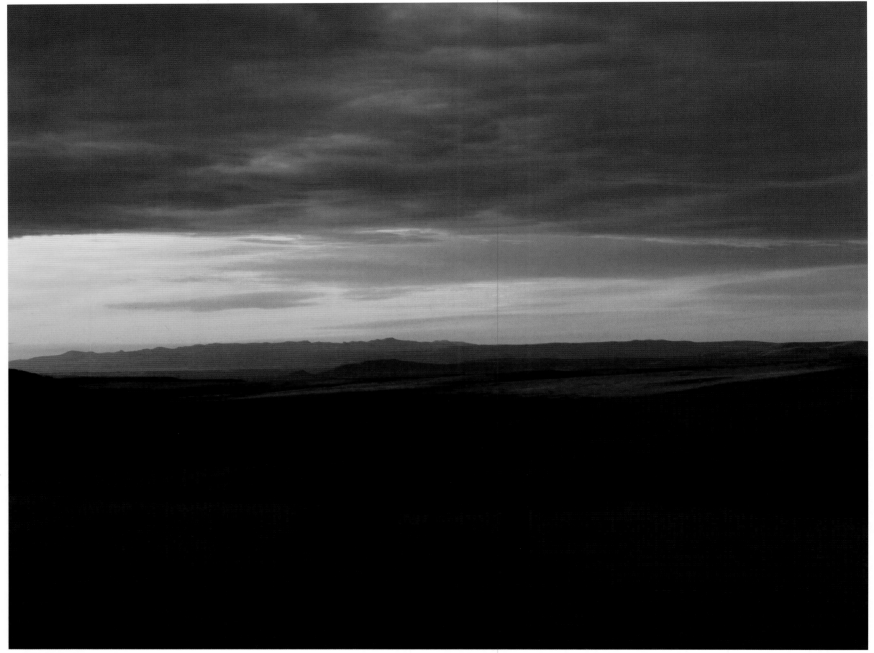

Mile 1521

AT SUNRISE, VIEW SOUTH FROM KEENEY PASS, OREGON. In 1843, a view such as this showed no one living along the Trail. By 1853, pioneers found settlements springing up around an endless string of trading posts, bridges, forts, and stagecoach stations. There was a constant stream of traffic going both ways.

Here we left unknowingly our Lucy behind, not a soul had missed her until
we had gone some miles, when we stopped awhile to rest the cattle;
just then another train drove up behind us with Lucy.
Amelia Stewart Knight, 1853

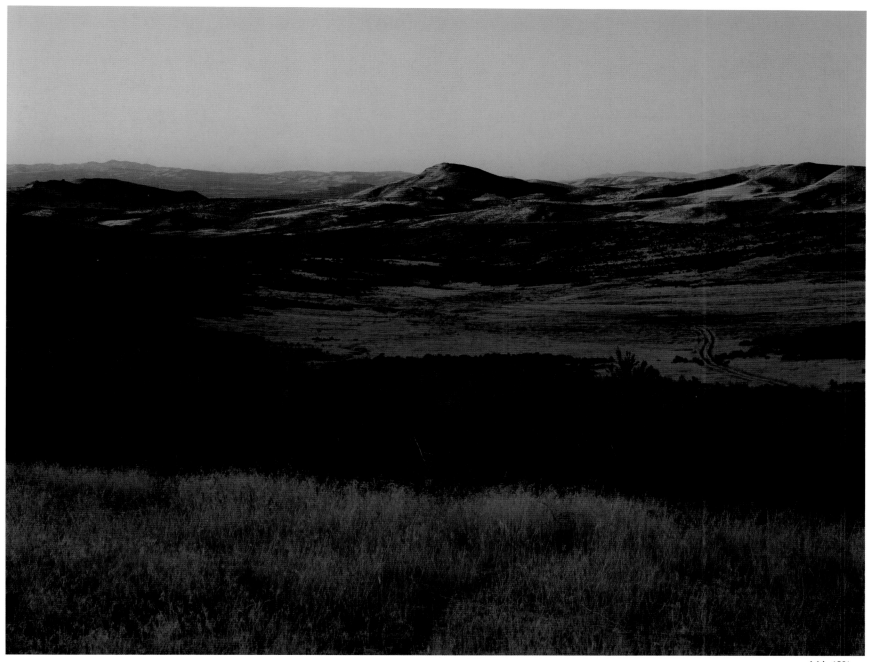

Mile 1521

AT SUNSET, VIEW NORTH FROM KEENEY PASS, OREGON. It was important for pioneers to heed the land, to listen to its rhythms. Today it is possible to overpower the landscape, to use the motorcar, or the jet plane to bludgeon the landscape into submission. Raw ego teamed with ox power was not up to that task.

Drove fourteen miles. Hard day's travel on account of the wind.
It blew so hard that the cattle's eyes was full of sand.
Had hard work to make them face it.
George Belshaw, 1853

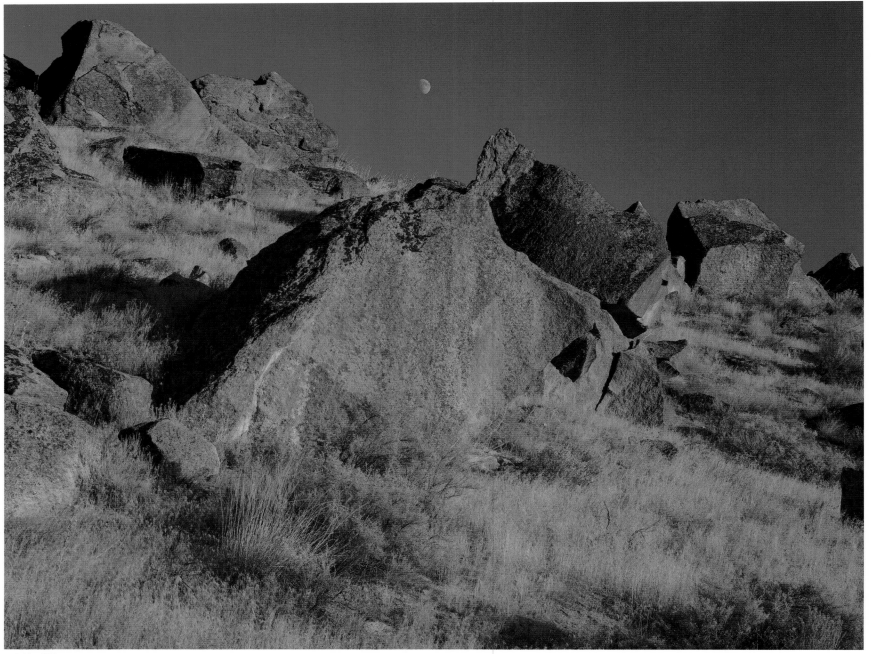

Mile 1527

ROCKS AND MOON AT THE HENDERSON GRAVE SITE, OREGON. A plaque near here proclaims that a pioneer named Henderson, not realizing the Malheur River was nearby, died here of thirst. But the river is visible from miles around. What passes for history began as a fictional essay by a third-grade student.

Only yesterday he was at our camp, full of life and vigor, with as
bright hope for the future as any of us! He was taken ill
at dark and now he lies in the cold embrace of death.
Esther Belle McMillan Hanna, 1852

Mile 1538

DRY GULCH NEAR TUB SPRINGS, OREGON. Many companies set out with great decorum, maintaining social proprieties from dinner parties to funerals. Each dust-caked day brought a hardening some feared might be as tough to shake as it had been to acquire.

Not until the next morning did we see that the camp fire was on a grave . . .
but it was not moved, I have mentioned our growing indifference . . .
It is to be hoped we will not be permanently changed.
Helen Carpenter, 1856

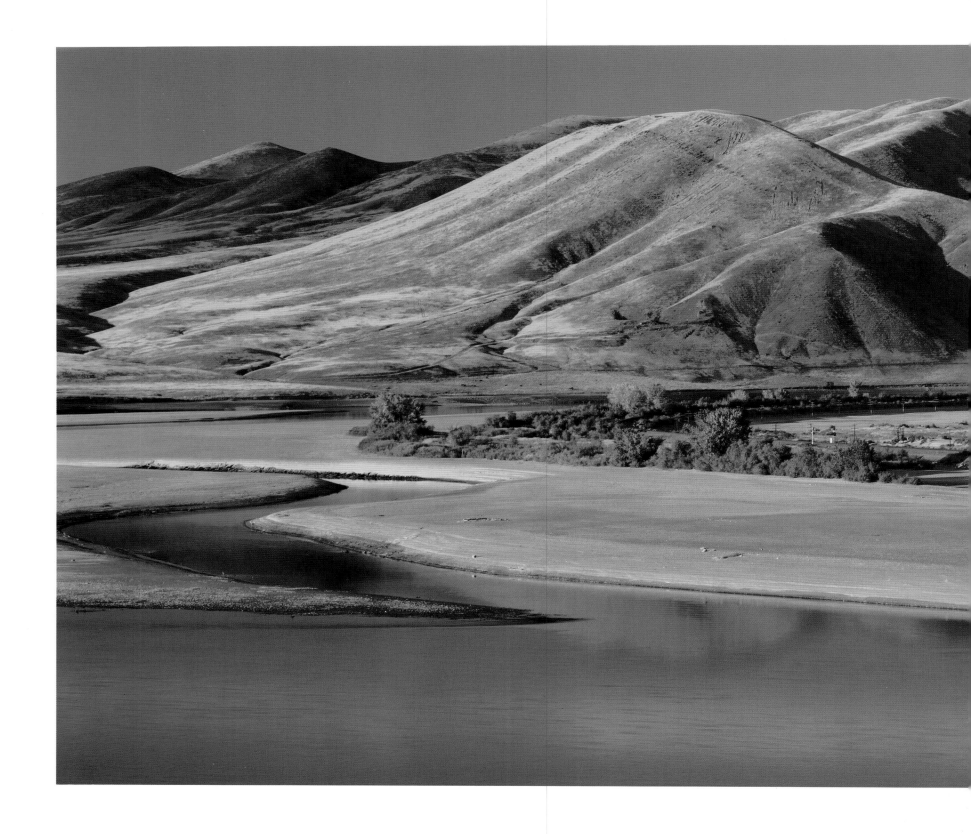

FAREWELL BEND, OREGON. History has bequeathed us a lasting image of the brave pioneer battling to cross an impenetrable landscape. But the landscape was, in fact, a series of portals. The ribbon of rivers— the Platte, the Sweetwater, the Snake, and the Columbia—formed a natural highway to the West.

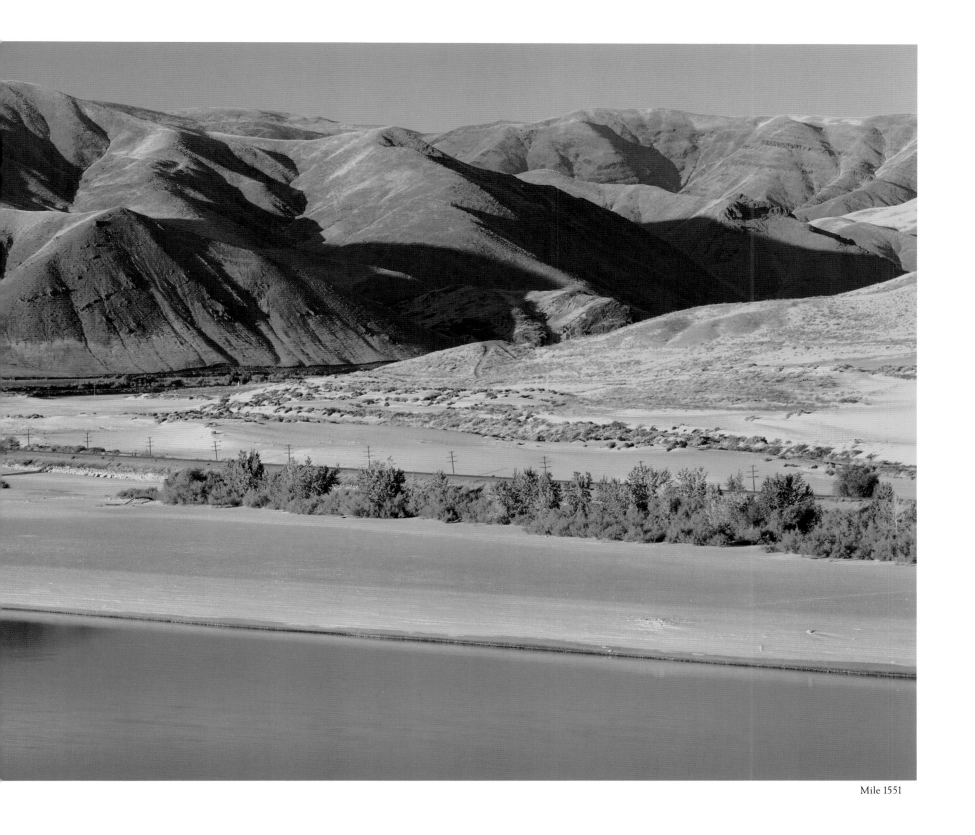

Mile 1551

Here we bade adieu to Snake River, which is said henceforth to pursue
its course amongst impracticable mountains where is no
possibility of traveling with animals.
William J. Watson, 1849

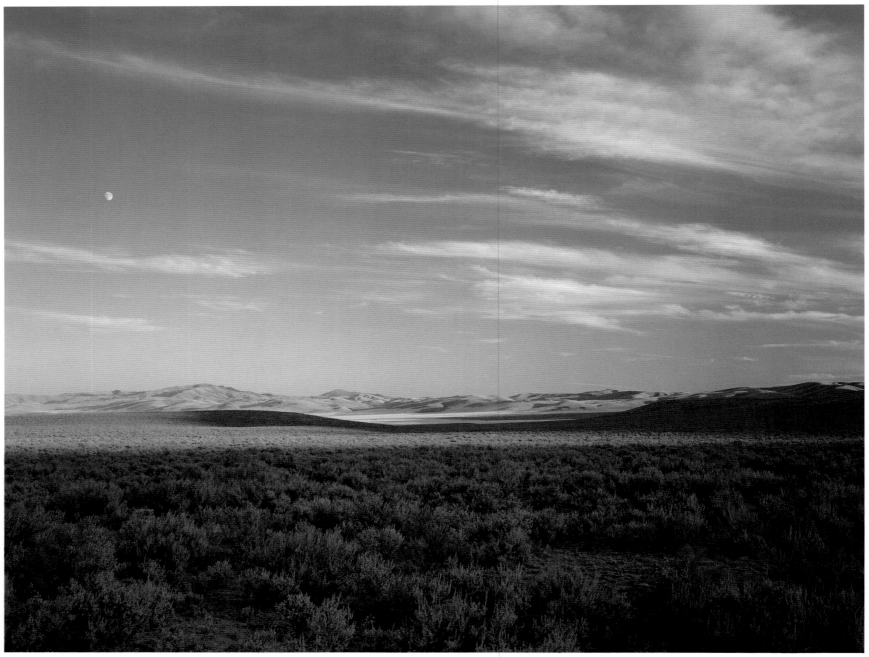

Mile 1600

VIRTUE FLAT FROM FLAGSTAFF HILL, OREGON. The views east and west from Flagstaff Hill are among the most celebrated of all Oregon Trail panoramas. Virtue Flat is named not for the high moral standing of those who pioneered a trail to the West, but for a family that later ranched in this area.

At our camp, we were visited by an Indian chief of the tribe Cayuse, accompanied by his son. He was of a friendly disposition; his object in visiting us was principally to barter for cattle; he had in his possession thirty or more horses.
Joel Palmer, 1845

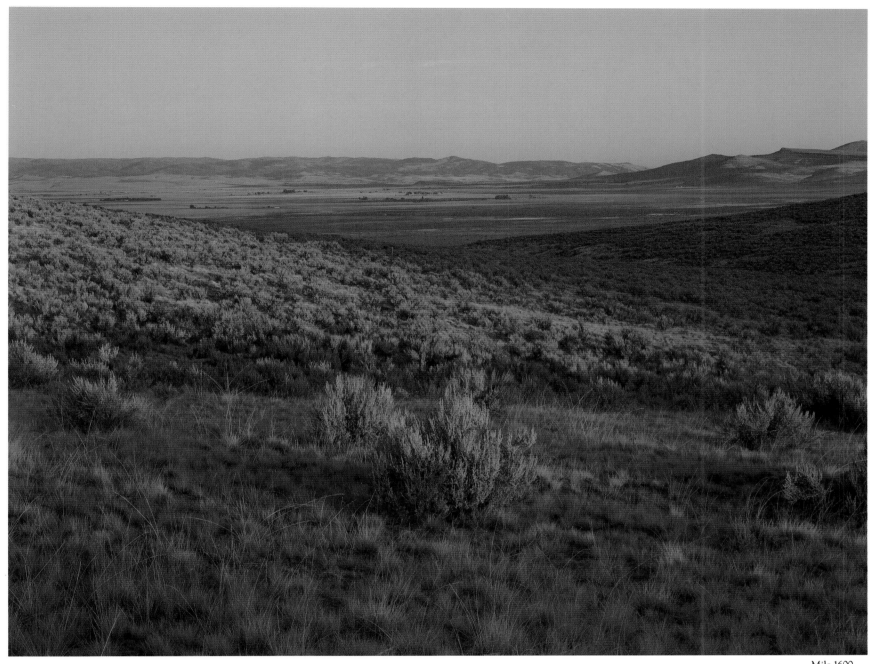

Mile 1600

BAKER VALLEY FROM FLAGSTAFF HILL, OREGON. On this windswept hill, in 1992, Oregon opened a major Oregon Trail Interpretive Center, the first in a series of centers to be constructed in the state. Pioneers paused near here to gaze into the Baker Valley, hoping to see the celebrated "Lone Pine."

The tree is a large pine standing in the midst of an immense plain entirely alone.
It presented a truly singular appearance and I believe is respected
by every traveler through this almost treeless country.
Medorem Crawford, 1842

Mile 1603

LONE PINE CAMPSITE, BAKER VALLEY, OREGON. For more than twenty years, mountain men and missionaries traveling through this country had made camp beneath the shade of the single large tree that grew on the valley's floor. John Fremont looked forward to reaching this landmark as he approached in 1843.

On arriving at the river, we found a fine tall pine stretched on the ground, which had been felled by some inconsiderate emigrant axe. It had been a beacon on this road for many years past.
John Fremont, 1843

ELKHORN RANGE FROM BAKER VALLEY, OREGON. Pioneers were not great spellers, not even when painting the customary slogan that adorned a canvas stretched across each wagon. One gold-rusher may not have been schooled, but he was realistic: "Brest for doze dat spect noting for dey will not be disappointed."

Looney's wagon turned over this morning, soon after
leaving camp . . . Snow, that fell the night before
last on the mountains, in sight all day.
James Nesmith, 1843

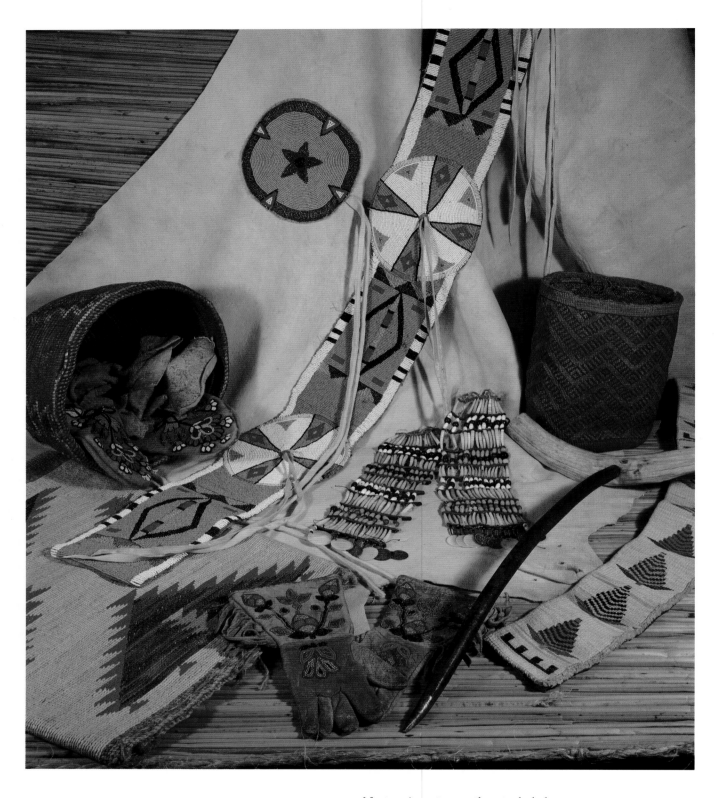

ARTWORKS, WARM SPRINGS, OREGON. Native American tribes included intricate designs even in familiar, everyday objects. These belong to the Confederated Tribes of the Warm Springs Reservation. Artifacts courtesy the Museum at Warm Springs.

We are continually hearing of the depredations of the
Indians, but we have not seen one yet.
Caroline Richardson, 1851

Be Brave and Always Tell the Truth

On the outskirts of the small town of Lingle, Wyoming, there is a field where soldier rows of sweet corn march toward the banks of the North Platte River. Each summer, they shade the bloodstains that color this ground.

There were as many as four thousand Sioux Indians, mostly Oglala and Brulé Lakotas, camped by the river that day. The young men were getting impatient. The trading, the dancing, the drumming was done. It was time to be off doing what young Sioux men were supposed to do: chase buffalo and steal horses from the Crows. But under the terms of the treaty some bands had signed three years earlier, the Sioux had been promised annuities every summer for fifty-five years.

And so the tribes lingered, waiting. They received more than they had bargained for. The Indian camp lay hard by the Oregon Trail, seven and a half miles southeast of the clutter of old trading posts and trapper stations slowly segueing into Fort Laramie. It was along this road that, on August 17, 1854, a Danish Mormon convert, who was straggling behind his companions, came herding his lame and tired cow.

The cow took fright and ran into the heart of the Indian village. The pioneer took fright and ran into the heart of the fort. Before nightfall, the cow— or, more precisely, the choicest cut thereof—was in the belly of a young Minneconjou Sioux named Straight Foretop, who was visiting the Brulé. This man had little time for the Indians he called Loaf-About-the-Forts, men who had sold their tongues to the Whites. The next day, when word reached the camp the pioneer was demanding that soldiers rescue his cow, Straight Foretop declined the invitation of Brulé Chief Conquering Bear to turn himself in to the White man's justice. The pioneer, in turn, declined Conquering Bear's offer of one of his finest ponies for the life of the cow. The next morning, August 19, 1854, Lieutenant John L. Grattan rode out from Fort Laramie to seek restitution. Grattan's company that morning included a belligerent interpreter long detested by the Brulé, twenty-eight men, and a pair of small field cannons.

On reaching the Indian camp, Grattan was adamant. He wanted the cow or the culprit. Neither was available. Then, the young officer, in what surely must have been one of the dumbest strategic moves of any military career, opened fire, mortally wounding Conquering Bear. In seconds, one thousand Indians were upon him, hacking him and his force to pieces. Watching the horror unfold was a twelve-year-old Sioux. His name was Crazy Horse. For the next twenty-three years, he would know war.

Coincidentally, it was the very next day, twenty-five miles east of Fort Boise, that a small group of Snake River Indians tried to steal a horse from a company of five wagons. The thief was shot, and eighteen settlers, including women and children, were wiped out in the ensuing battle.

It had not always been this way. The first strangers, many of them French trappers, were welcomed by the tribes, who gave them help, guidance, and wives. Hospitality, too, was extended to the first pioneers, many of whom would not have found game, river crossings, or routes across the mountains without their Indian guides. There were many reasons why relations deteriorated. One was that the United States government—which, in a landmark 1787 decision, had promised that "The utmost good faith shall always be observed toward the Indians"— systematically accommodated settlers' lust for Indian land and resources.

Chief Joseph of the Nez Perce gave his people a simple admonition: "Be brave and tell the truth." In their relationship with the Indians tribes, few White men managed to approach either valor or veracity.

The Whites kept coming, bringing change that destroyed much of Native American civilization: whisky, plows, barbed wire, and the notion of Indians having no fee-simple title to their land, as mere wanderers on the Earth.

Sioux historian Mari Sandoz recalls that Indians marveled at a "lengthening village of the Whites" passing by each summer, wondering why they never came back. "Yet they must be the same ones each year, for there could not be that many people on all the Earth."

This assault on Indian civilization frequently has been forgiven as an inevitable outcome of the tenor of nineteenth-century times. But there were voices, many of them, raised on behalf of Indians. In his pamphlet, *A Plea for the Indians*, John Beeson, who traveled to Southern Oregon in 1853, issued an eloquent call for protection of the rights of his new neighbors. Beeson was driven out of Oregon by Rogue River Valley settlers outraged by the radical nature of his views.

The Eden Seekers were harkening to other—and louder—voices. In 1854, Portland's newspaper, the *Weekly Oregonian*, positively chortled over reports of rampant disease, famine, and squabbling among the Indians along the Rogue River. "It will save the Whites the trouble of exterminating them." Extermination, thought editor T. J. Dryer, offered the best hope for what he called an "everlasting treaty" with Oregon Indians.

One hundred forty years after Dryer's rantings, the Umatilla Indians drew up plans to build an Interpretive Center on their reservation near Pendleton, Oregon. They decided to tell the tale of the Oregon Trail from the perspective of the Indian tribes. The architect might have included a large, empty room, as a symbol of all that had been lost.

Indian Women: Swimming

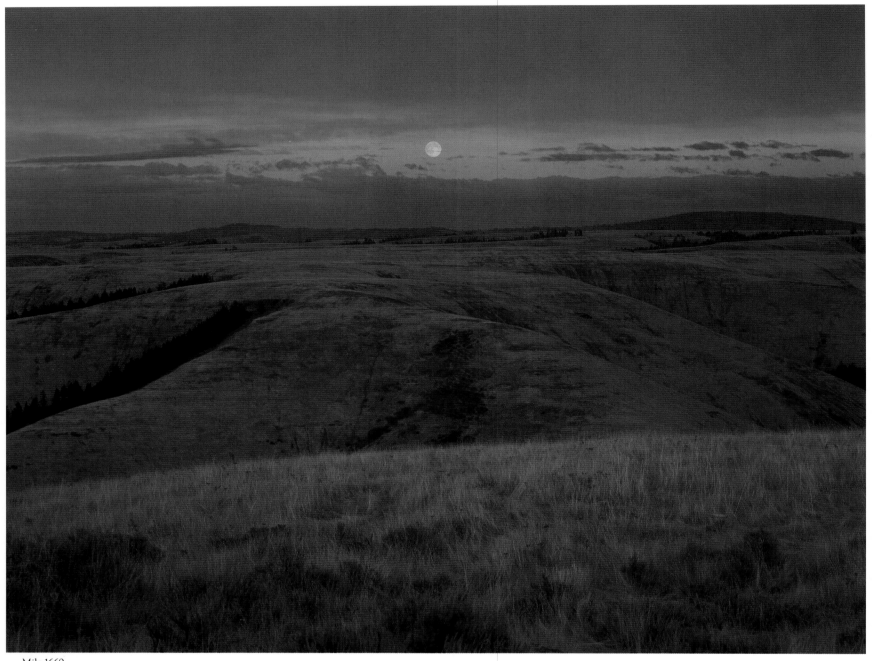

Mile 1669

MOONRISE FROM THE SUMMIT OF THE BLUE MOUNTAINS, OREGON. The Blues lived up to their reputation, taxing every bit of strength remaining in weary ox teams. From the ridge, pioneers gazed back, perhaps wistfully, before continuing down the precipitous Cabbage Hill toward the Umatilla River.

*Cold and windy. We made a fire of a little wood that we carried all day
yesterday. Made a bite to eat. Our cattle ran off in search
of water, which hindered us till late. Made four miles.*
Elizabeth Dixon Smith, 1847

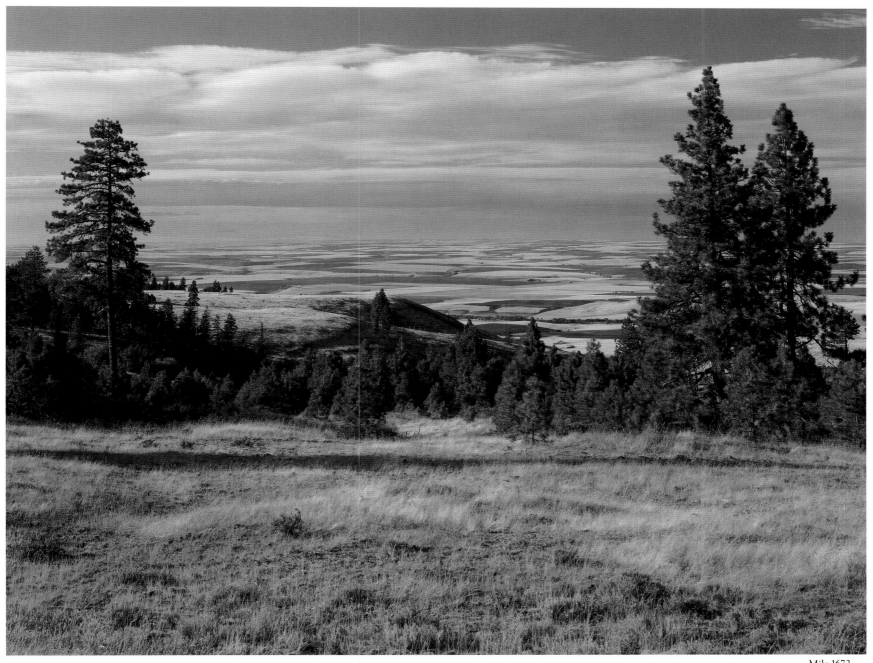

Mile 1672

UMATILLA VALLEY FROM DEADMAN PASS, OREGON. From the foot of this hill, early pioneers, often running out of supplies, made another of the decisions that faced them: whether to detour north to seek help from the mission established at Waiilatpu by the Whitmans, or continue on the shorter main Trail.

Prospects seem to darken entirely around us a good deal, for some families are already entirely out of bread and many more will be in the course of one or two weeks.
Cecelia Adams and Parthenia Blank, 1852

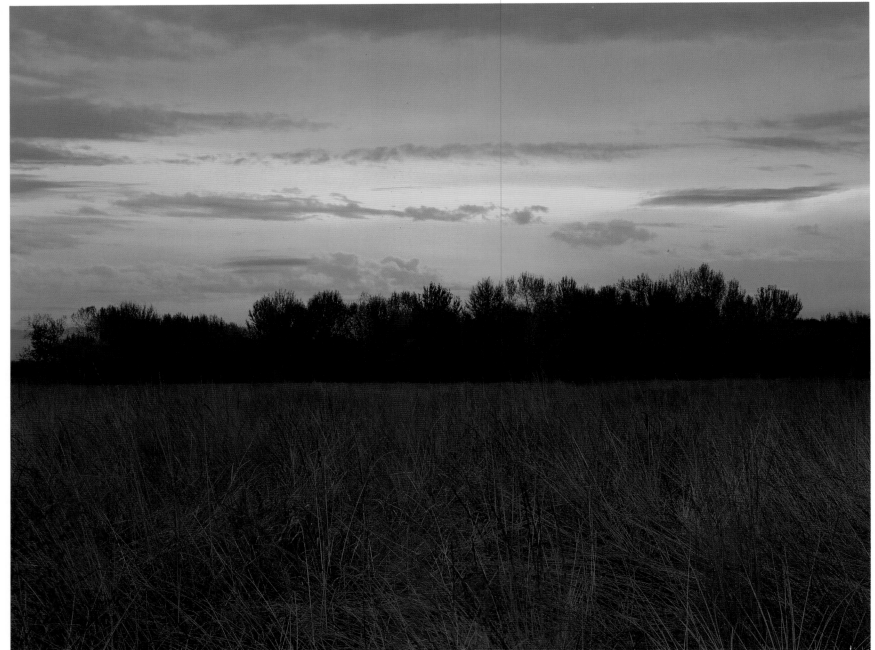

Mile 1709

WHITMAN MISSION, WAIILATPU, WASHINGTON. Dr. Marcus and Narcissa Whitman built a mission here in 1836, at the place named for the tall grasses that still adorn this landscape. It was here, at what was then the bed of the Walla Walla River, that their daughter, Alice Clarissa, drowned in 1839.

Left the fort for Walla Walla . . . we easily found a canoe made of rushes and willows on which we placed ourselves and our saddles when two Indians on horseback with each a rope attached to the canoe towed us over.
Narcissa Whitman, 1836

COTTONWOODS AT WALLULA, WASHINGTON. The Hudson's Bay Company had established Fort Walla Walla near this spot, where the Walla Walla River flows into the Columbia. Here, the emigrants had the choice of an overland trek on the south bank of the river, or a river journey by raft or Hudson's Bay boat.

These boats are very light, yet strong. They are open, about forty feet long, five feet wide,
and three feet deep . . . They are made in this manner so that they
may be carried around the falls of the Columbia.
Peter Hardeman Burnett, 1843

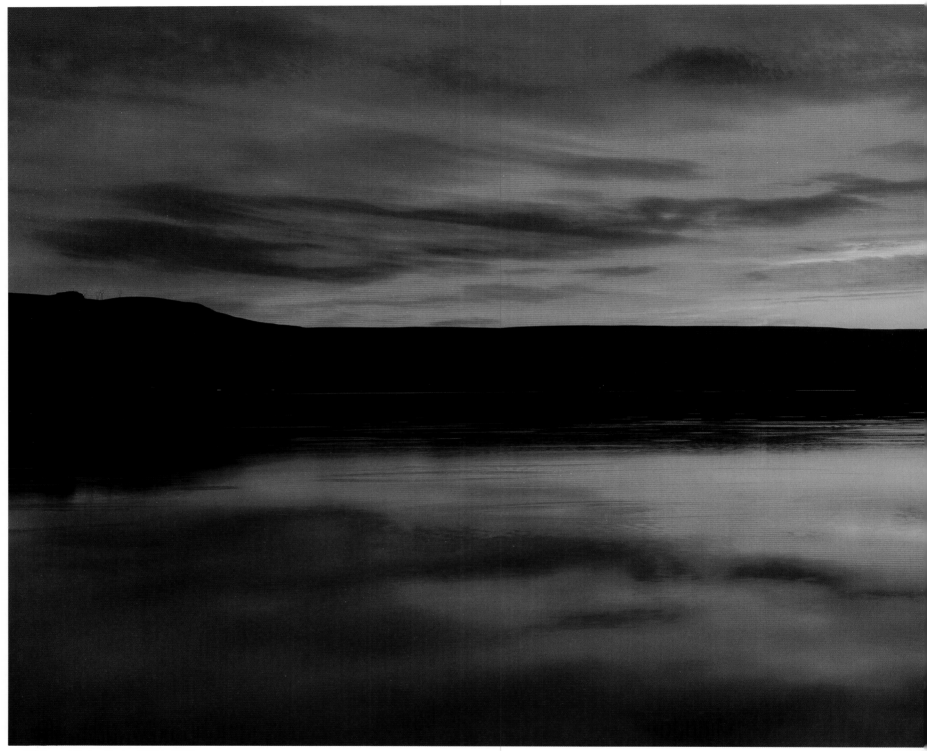

Whitman Mission Route—1843 to 1847

MOUNT HOOD FROM BIGGS, OREGON. Often aided by Indian boatmen, pioneers traveling down the Columbia River gazed from this spot, for the first time, upon Mount Hood. Those who later chose to leave the river at The Dalles crossed Sam Barlow's road over this mountain, risking an encounter with early snow.

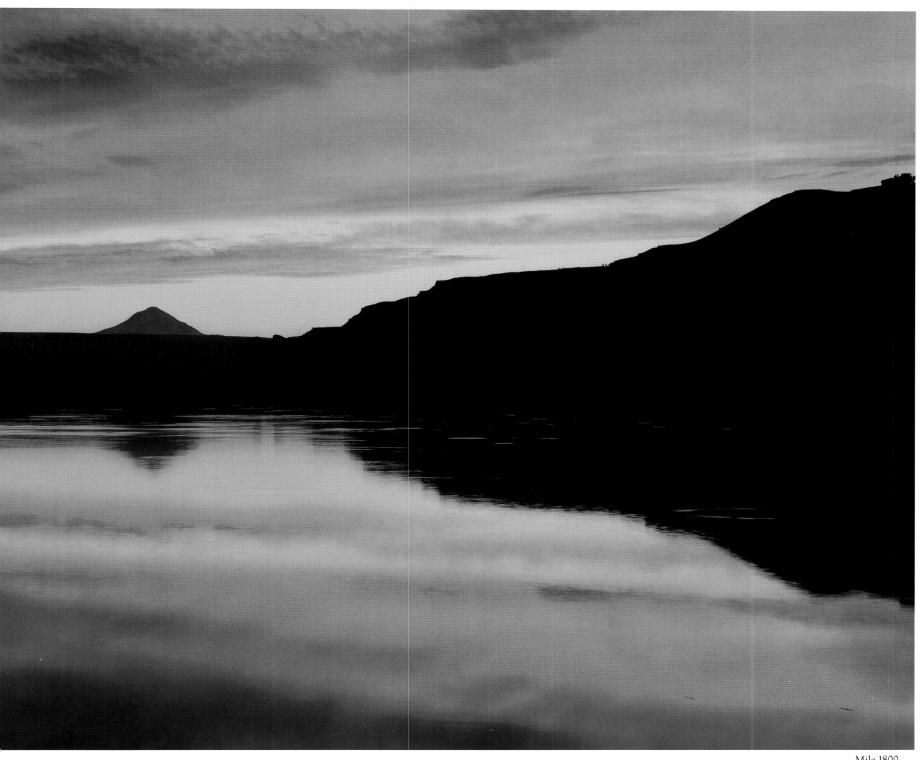

Mile 1800

*Anybody in preparing to come to this country should make up some calico shirts to trade to
the Indians. In cases of necessity, you will have to hire them to pilot you across rivers.
Against we got here, my folks were about stripped of shirts, trousers, jackets . . .*
Elizabeth Dixon Smith, 1847

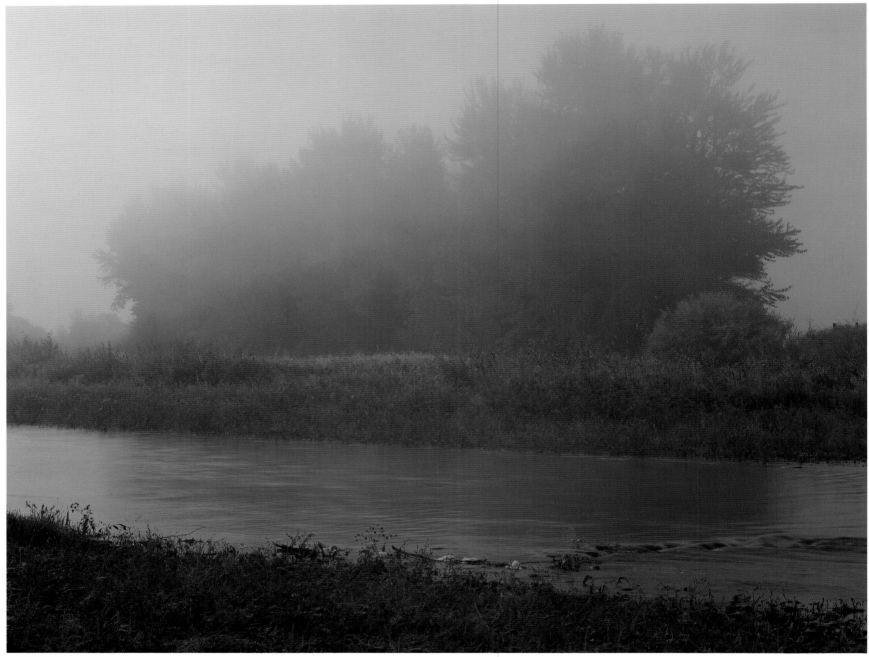

Mile 1712

CROSSING OF THE UMATILLA RIVER AT ECHO, OREGON. According to historian John D. Unruh, Jr., about 4 percent of those who traveled along the Oregon Trail died during the journey. Only about 4 percent of all those who died were killed by Indians. Cholera and drowning killed far more than arrow or bullet.

Feel very unwell today. Am almost worn down with the fatigue
of the constant travel. Our way seems endless!
Esther Belle McMillan Hanna, 1852

Mile 1757

SWALES AT FOURMILE CANYON, OREGON. The passing of thousands of wagons carved deep ruts, but during the 1850s, only one-third of all emigrants crossed South Pass. Other routes were the Santa Fe Trail; sailing around Cape Horn; and passage to Panama, then across the Isthmus, before sailing for California.

On rising the highlands from the creek, the wind increased to a gale. We had to hold our wagons from upsetting. We drove into a ravine and there lay until the wind lowered, then traveled about six miles and camped; no wood nor water.
Loren B. Hastings, 1847

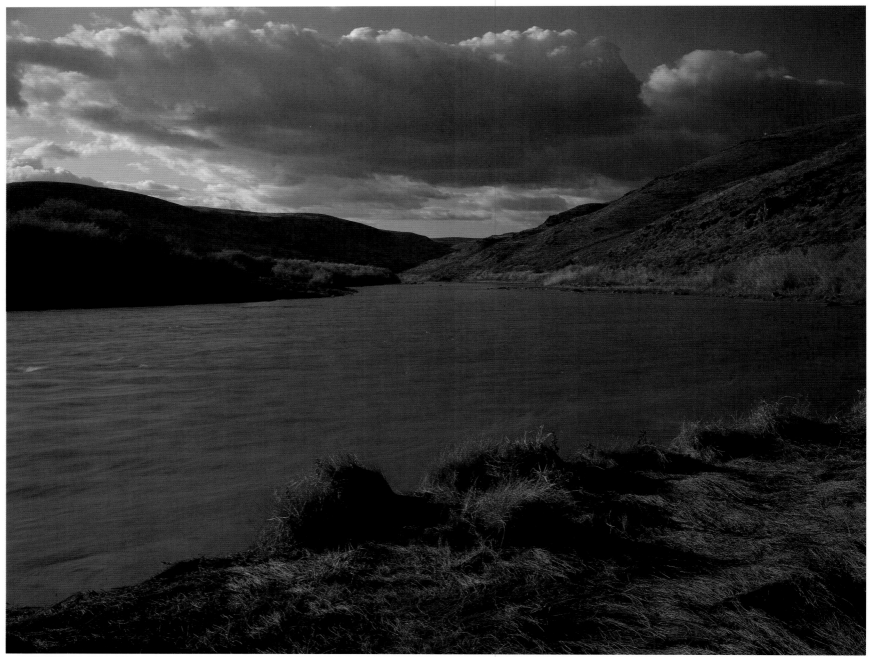

Mile 1775

McDONALD FORD OF THE JOHN DAY RIVER, OREGON. In 1849, a ship took two hundred days to round Cape Horn and reach San Francisco. Passage cost three hundred dollars. The six-week trip from New York to San Francisco across Panama cost five hundred dollars. The poor crossed mountains and forded rivers.

This is the best and most beautiful place we have seen on the whole road or, in fact,
in our lives, and is said to be a fair specimen of western Oregon.
If so, our expectations will be more than filled.
John Tully Kerns, 1852

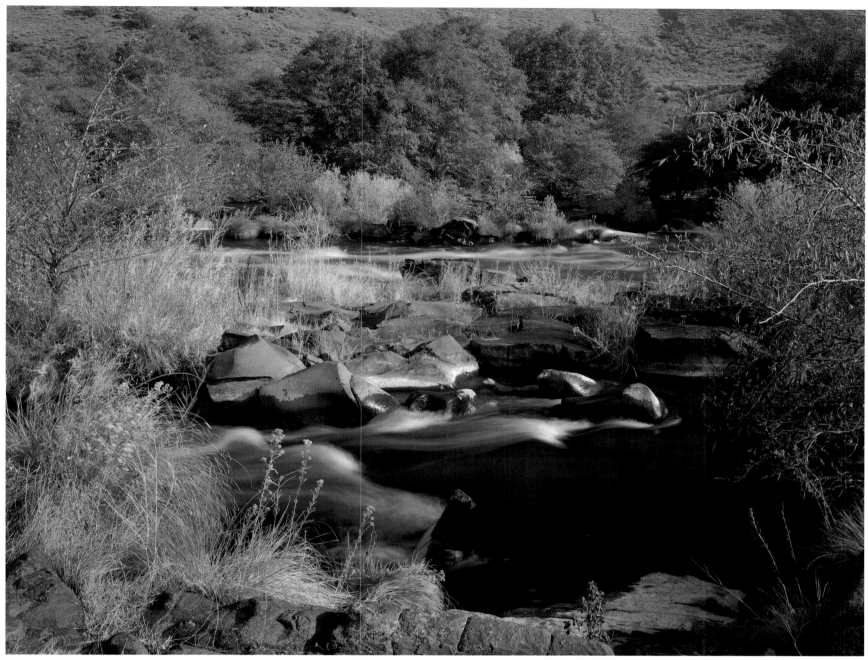

Mile 1804

THE DESCHUTES RIVER, OREGON. Pioneers assumed Indians came to beg and to steal. Some emigrants found them a great inconvenience; a few found them a real threat; most found them helpful with tasks from foraging to fording rivers. In twenty-five years, fewer than four hundred pioneers were killed by Indians.

We reached Deschutes River . . . The Indians soon came and helped us over, and
swam our horses across by the side of their little tottering canoes, for which
we gave them some tobacco, and continued our journey in the rain.
Joseph Williams, 1842

THE TOOLS OF THE TRADE. Governor Joseph Lane's sword and Lieutenant Patrick Cronin's rifle echo the role of Uncle Sam, who explored new routes, built roads, carried mail, subjugated Indians, and offered assistance from encouragement to extra beans.

Why don't the government do something immediately
that will be of practical utility to the emigrant
or traveler across our own territory?
T. H. Jefferson, 1849

Blue Coats and Long Knives

He helped lure them from their homes, prodding them in the notion that pioneering was a patriotic act. He helped support them in their travels, furnishing en route everything from emergency supplies to the succor of seeing his sabre glisten in the sun. He helped revitalize them when their spirits flagged, for the last thing he wanted was droves of them lingering about his camps. If the net result of all his efforts was less than some had hoped for, one thing is beyond question: without him far fewer would have braved the Oregon Trail.

His name was Uncle Sam.

The way west was a path of pioneer expansion. It also was a military road. The earliest Army expeditions to the West had made clear efforts to impress native tribes with their military power. In 1835, when Colonel Henry Dodge rode toward the Rockies with 120 dragoons, his mission was to warn Indians to behave as Whites passed through their territory.

In 1844, Major Clifton Wharton led a much larger force up the Platte, taking along a pair of twelve-pound cannons that he used for demonstration whenever Indians failed to comprehend the urgency of the Army's admonition.

But the role of Uncle Sam went far beyond displays of military might. The work of Army surveyors did much to convince citizens that a path was open to the Oregon Country. The widely circulated reports by John Charles Fremont, who represented the Army's Corps of Topographical Engineers, did much in the early 1840s to encourage emigrants. Perhaps not coincidentally, Fremont was the son-in-law of Missouri Senator Thomas Hart Benton, an arch exponent of western expansionism.

Uncle Sam's guest appearances in the West finally turned, in 1846, into a full-time role. That year, Congress appropriated $81,500 to raise a regiment for the West and set in motion the campaign to establish a series of military installations. In 1849, the United States Army dispatched the Mounted Riflemen along the Oregon Trail, dropping off dragoons as each new outpost was established. Fort Kearny guarded the gateway to the Platte. The celebrated fur-trading post at Fort Laramie became an Army encampment, as did the Hudson's Bay Company post at Fort Hall. Toward the end of the Trail the company split, some descending the Columbia River to Fort Vancouver, others taking the heavy supply wagons over the Barlow Road. When these troops became bogged down in the swamps west of Summit Meadows, they cached their load at what became Government Camp before pressing forward to winter at Oregon City and Astoria. Thereafter, there were many fits and starts for the federal role in the West, but there was no going back.

Interior of Fort Laramie

Many problems derived from the fact that the government paid scant attention to events west of the Missouri. There were few policies clearly articulated; and too many decisions—which often turned out to be bad ones—were left to officers in the field. Conflict with Indians was fomented by miners, settlers, newspaper editors and militaristic forays of self-styled "volunteers." Into this morass, the Army frequently found itself marching to separate the combatants and to mop up. Finally, as conflict between the Army and Indian tribes intensified through the 1850s, field officers frequently found themselves at odds with policies being promoted by the government's Indian agents and commissioners.

Military campaigns oscillated between sorties seeking to buy favors and punitive expeditions seeking retribution for occasional Indian atrocities. One year after Lieutenant John L. Grattan was killed over his foolish pursuit of a single stray cow, General William S. Harney led a major expedition against the Sioux. The 1855 Battle of Ash Hollow was a victory for the fire power of the United States Army. Harney lost half a dozen men while killing at least eighty-six Indians.

Some Army commanders clearly understood the tragedy that continued to unfold as settlers and goldseekers spilled all across the Western frontier. In 1860, Major John Owen wrote: "These Indians twelve years ago were the avowed friends of the White Man. Their present hostile attitude can in a great measure be attributed to the treatment that they have received from unprincipled White Men passing through their country."

As more settlers headed west, the incidence of conflict between Whites and Indians increased. Some attacks on pioneer companies were led by renegade White bandits disguised—not very convincingly—as Indians. As early as 1851, the Oregon territorial legislature had sent a message to Congress concerning "bands of marauding and plundering savages led on by out-cast Whites, more brutal still than the Indians."

By 1855, the presence of soldiers along sections of the Trail prompted occasional complaints about the military commandeering ferries or taking up all the good grazing, but for the vast majority of pioneers Uncle Sam was a welcome traveling companion. Army supplies were sold or given to emigrants in need. Army blacksmiths shod many a crippled ox. Army surgeons treated everything from consumption to toothache. The Army's postal service connected pioneers to families left behind. And it was the Army's heavily laden freight wagons that gouged the ruts so clearly marking the way to a better tomorrow. No matter how difficult the road or how cruel its obstacles, the pioneers kept on going. For Uncle Sam was right there with them, pointing the way to rainbow's end.

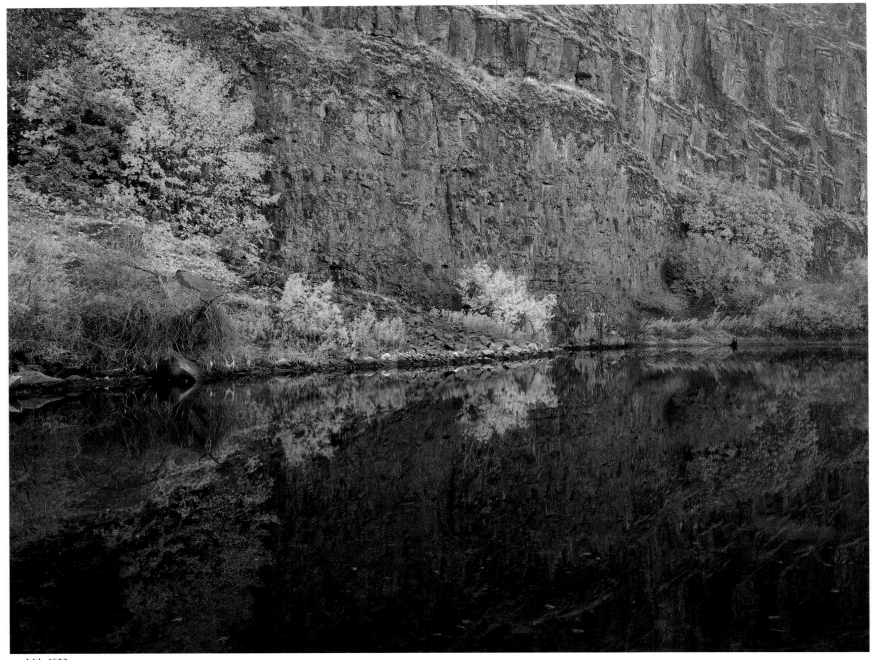

Mile 1823

ROWENA CLIFFS, OVERLAND TRAIL'S END, OREGON. Near-vertical cliffs, tumbling directly to the water's edge, forced pioneers to take to rafts or boats. Ahead lay much cold, much rain—and the churning Cascades of the untamed Columbia River. Indian burial sites along the river were visited by pioneers.

Alas, the poor Indian! Not even his bones are allowed the rest of the grave,
but are knocked about with the utmost contempt, and of the once powerful
tribe of the Cascades but few now remain, the remnant of a mighty race.
Origen Thomson, 1852

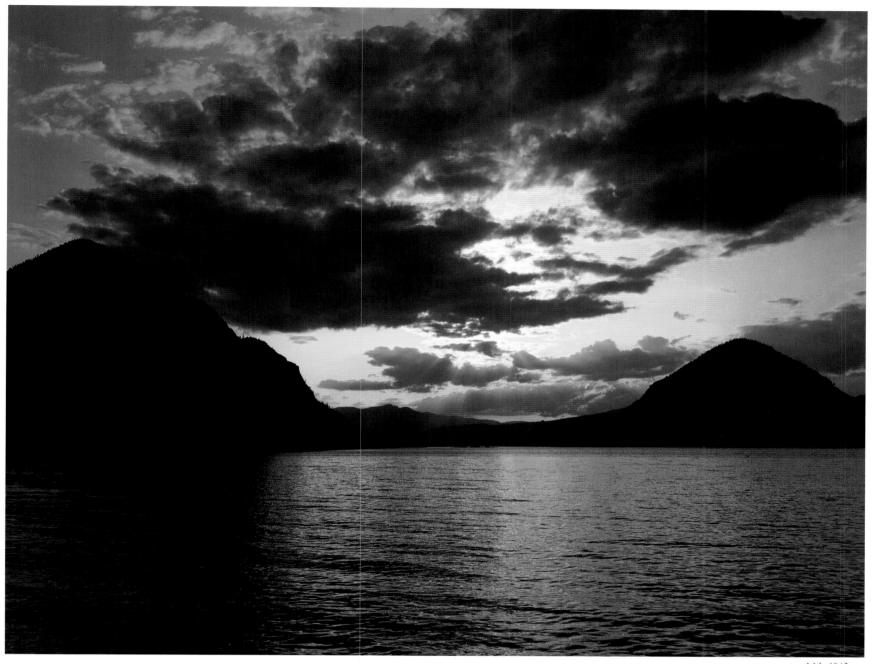

Mile 1840

TWIN GUARDIANS OF THE COLUMBIA, OREGON. Shellrock and Wind mountains stand just west of Hood River. Wind Mountain is well named, for gales sweeping through the narrow Columbia River Gorge seem to emanate from the mountain itself. Many rafters waited days here for autumn storms to calm.

The young men were out of provisions by this time and
ours were far spent. We knew not what to do.
Esther Belle McMillan Hanna, 1852

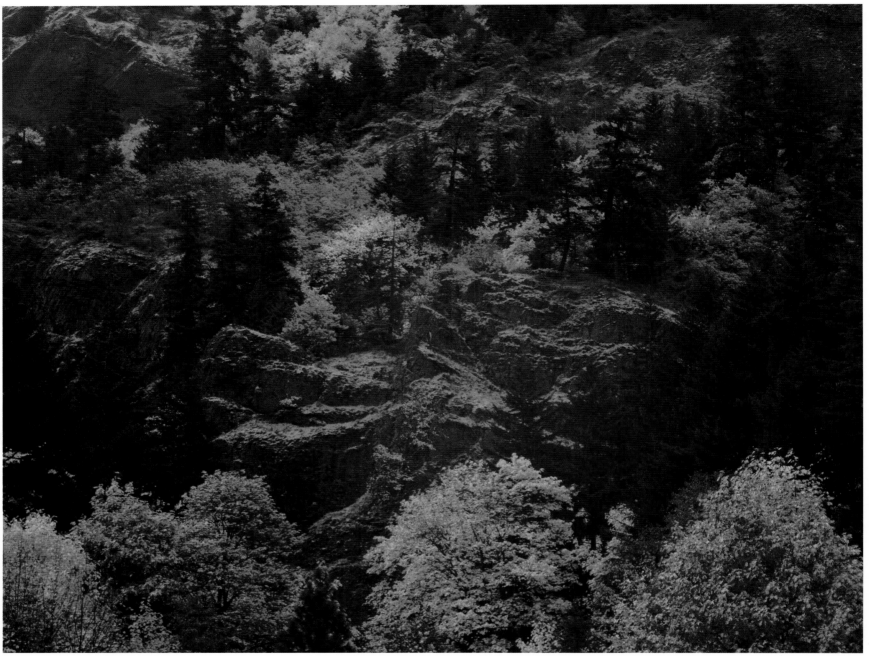

Mile 1842

ROCKFACE AT STARVATION CREEK, OREGON. The steep cliffs of the Columbia Gorge create vistas unmatched on the continent. It is easy to imagine the effect these verticle walls of rock had on pioneers from the East who had spent so many months crossing such a vast and seamless expanse of prairie.

The scenery all along the Columbia both above and below the Cascades is said to be
the most beautiful of any on the Continent, which cannot be
fully described by other than an artist's pen.
Harriet A. Loughary, 1864

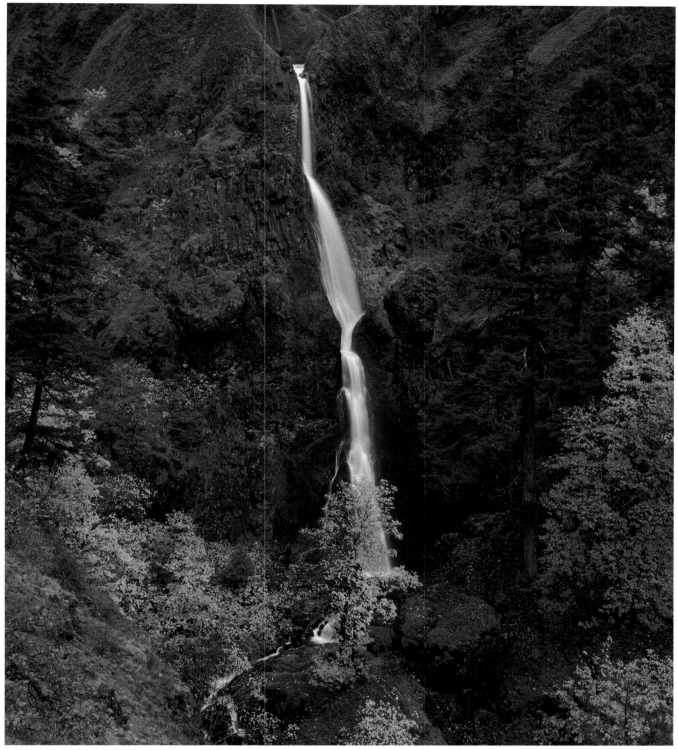

Mile 1842

STARVATION CREEK FALLS, OREGON. Self-inflicted wounds declined as pioneers went west. At first, no man moved without his musket. Beyond South Pass, few hauled a weapon from a wagon. Though these falls were not named until later, the enemy now was hunger.

Some packers . . . bought some flour, which they tied up in their handkerchiefs, then poured some water upon it . . . as soon as it would stick together, ran a stick through the dough and held it before a hot fire until it was baked.
Origen Thomson, 1852

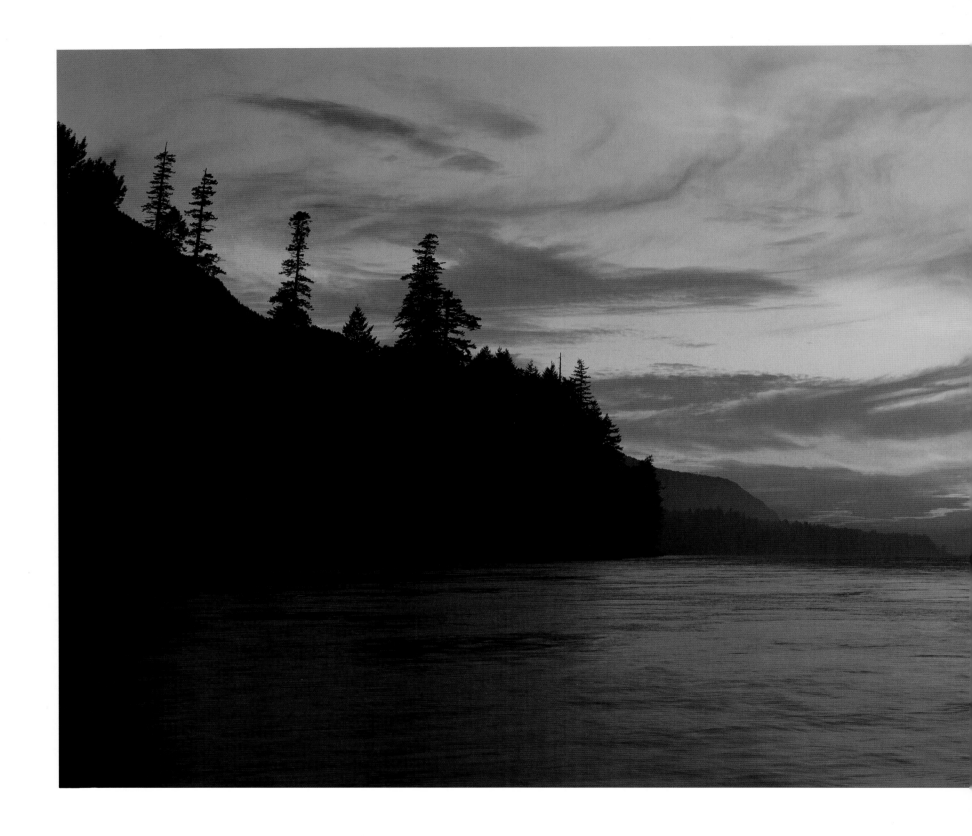

THE VIEW DOWNSTREAM FROM MOFFETT CREEK, OREGON. Pioneer writing, and reminiscing, viewed the West with awe. Everything resembled this vista: grand, magnificent, awesome, huge, and limitless— especially limitless. This mindset helped breed the environmental consequences of the twentieth century.

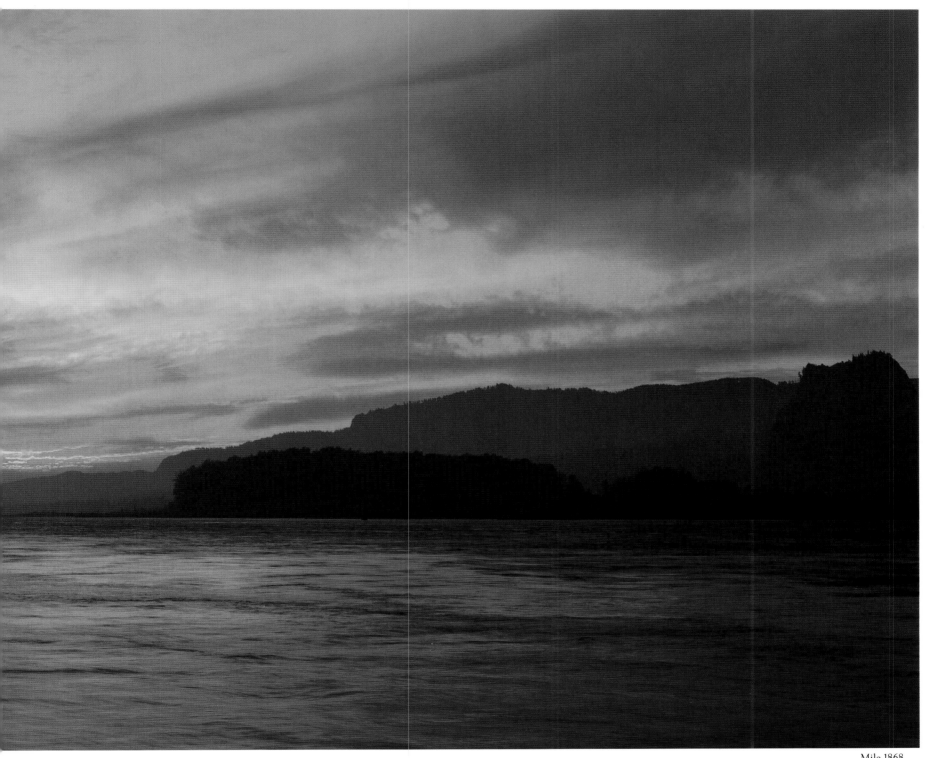

Mile 1868

*We breakfasted off the last of our beans. We were without bread, without flour,
and we did not have a morsel of meat. What would become of us? We
had no idea how long we would have to remain in this place.*
Honore-Timothee Lempfrit, 1848

Mile 1873

ASH TREES IN THE FIRST SNOW OF WINTER, OREGON. Winter sometimes begins early in the Columbia River Gorge, and pioneers, who had to reach a safe haven and camp out each night during their downstream journey, discovered both refuge and firewood in the ash forests along much of the river.

My husband is sick. It rains and snows . . . I carry my babe
and lead, or rather carry, another through snow
and mud and water almost to my knees.
Elizabeth Dixon Smith, 1847

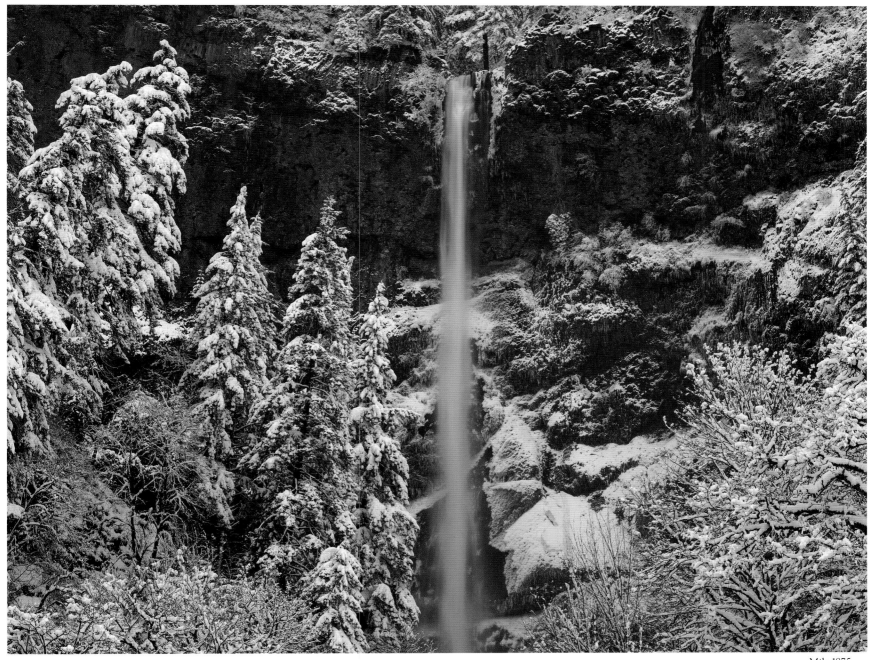

Mile 1875

MULTNOMAH FALLS IN THE COLUMBIA RIVER GORGE, OREGON. Those pioneers who chose to end their journey by risking the passage down the Columbia River—their disassembled wagons lashed to rafts or packed aboard Hudson's Bay Company bateaux—passed an astonishing array of waterfalls.

We can say we have found the most splendid and beautiful
country, with rich prairie land and timber adjoining,
together with good water and springs . . .
Truman Bonney, 1846

117

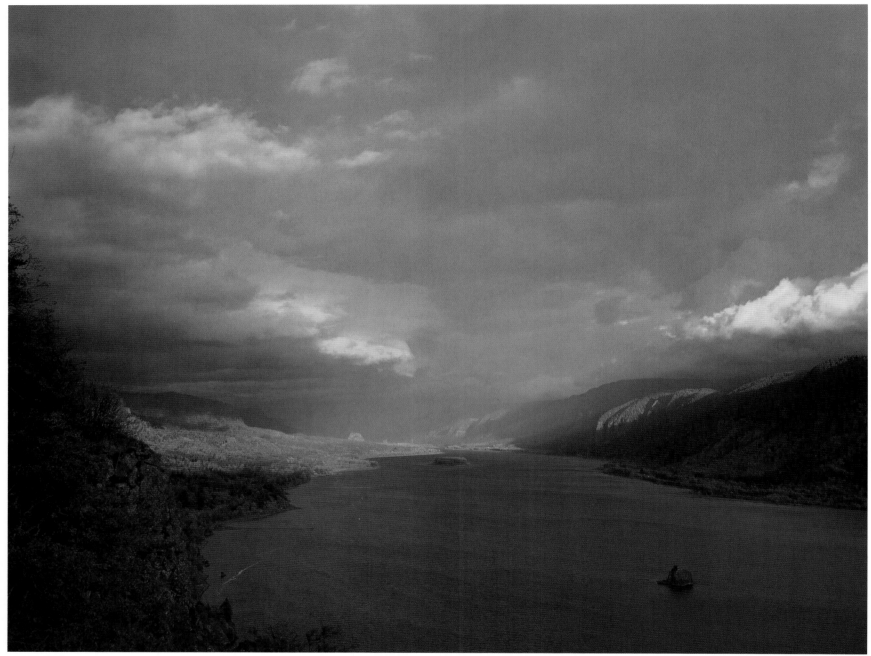

Mile 1882

BEACON ROCK FROM CAPE HORN, WASHINGTON. The towering cliffs of Cape Horn channeled the winds into one last obstacle to the rafters making their way to Oregon City. From here, it took only about two days of further travel to reach Fort Vancouver, established in 1829 by the Hudson's Bay Company.

One female with us at the time . . . was illy prepared to withstand the chilling storm,
being scantily clothed; but her husband, true to the instincts of a noble
manhood, divested himself of his own well-worn blanket . . .
Stephen Staats, 1845

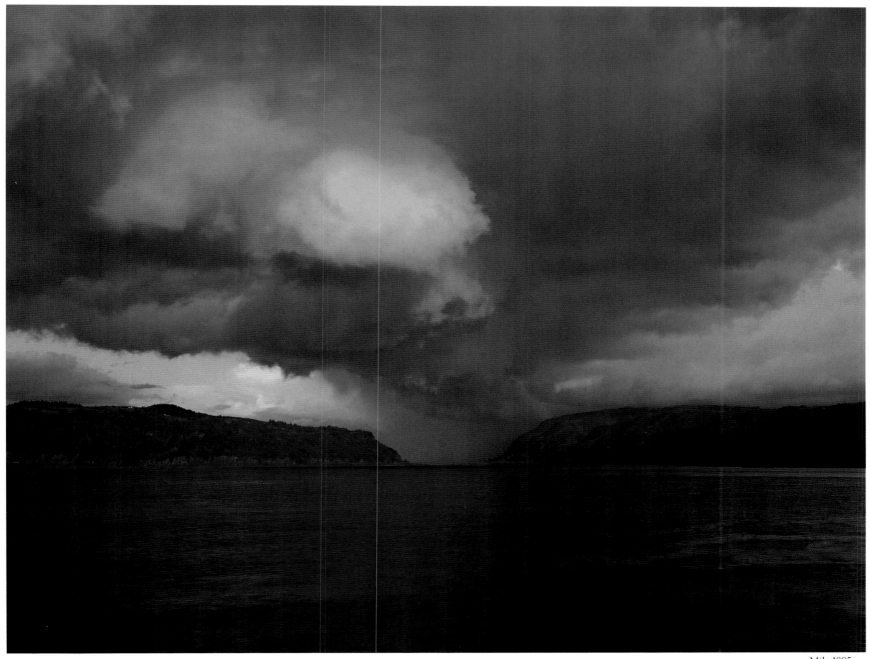

Mile 1885

A CLEARING STORM FROM BROUGHTON REACH, OREGON. In 1792, George Vancouver's British expedition navigated the Columbia River to this point. This section of water is named for one of its officers, Lieutenant Broughton, who first saw Mount Hood and named it in honor of British Admiral Samuel Hood.

Here we were . . . compelled to run ashore, and remain until the next day. This frequently happens to voyageurs . . . In one instance, a crew of emigrants were under the necessity of throwing part of their loading overboard in order to gain the shore.
Overton Johnson and William Winter, 1843

WRITING DESK OF DR. JOHN McLOUGHLIN, OREGON CITY, OREGON. Pioneers could have met at Trail's end no finer friend than Dr. John McLoughlin, chief factor of Hudson's Bay Company. He provided them with seed, lumber, cattle—and credit. Artifacts courtesy McLoughlin House Museum, Oregon City.

Yankees could go right over to China with
their ox wagons if they desired to do it.
Dr. John McLoughlin, 1847

The Portal to Paradise

Pioneers reaching The Dalles found themselves at the end of the road, but not at the end of the Trail. As the Columbia River carved its great gorge through the Cascade Mountains, it created a passage too narrow for any road. So pioneers took apart their wagons, lashed them upon makeshift rafts or to the vessels of hired Indian boatmen, and floated into the jaws of this terrifying chasm. As they drifted into the windswept shadows, some pioneers sang hymns. Some still were singing as they drowned.

The Columbia has since been tamed, its torrent harnessed by dams that create a string of obedient pools. But in the middle of the nineteenth century, the Columbia Gorge presented a cacophony of rushing rapids, and the journey through it could be both prolonged and perilous. Many pioneers beached their crafts for days at a time, waiting for the waters to subside. In 1847, it took Elizabeth Dixon Smith's raft eighteen bone-chilling days to travel sixty miles.

It was at the end of this long journey, when the emigrants were exhausted, when their food was running out, when attention to detail was at its lowest ebb, that pioneers found themselves facing the greatest dangers of the Trail. It was understanding these perils that fired those already settled in the Willamette Valley to strive to help each succeeding wave of pioneers. The milk of human kindness certainly played a part in these proceedings. So did self-interest.

For many already ensconced in Oregon—missionaries, merchants, tradesmen, bankers, speculators, newspaper editors—a future livelihood depended in no small measure on word spreading that the West could be reached with relative ease. Stories of pioneers perishing at the very portal to Paradise threatened to cripple plans for Oregon's rapid development.

Those who suffered great hardship at Trail's end were unlikely to rush to write letters encouraging others to follow in their footsteps. Guides, escorts, and supplies were dispatched from Oregon, frequently traveling as far east as Fort Hall, Idaho. It was there, at the last possible parting of the ways, that boosters from California and Oregon frequently found themselves engaged in the act of dueling anecdotes, striving to outdo each other with tales of the perils awaiting on alternate trails.

It was at Fort Hall in 1845 that no fewer than forty-five of the wagons in Joel Palmer's Oregon-bound train were persuaded to turn instead for California. The following summer, Oregon made sure to have delegates at the fort talking up the Willamette Valley.

Also in 1845, more than two hundred wagons and some one thousand pioneers turned west at the crossing of the Malheur River. They followed Stephen H. L. Meek, a trapper-turned-emigrant-guide, who charged five dollars per wagon to lead them on a short-cut to the Willamette Valley. The detour added more than two months to the journey, and resulted in enormous hardship, including the loss of more than fifty lives.

In the meantime, an effort had been launched to find an alternative to the perils of the Columbia River. Oregon settlers raised two thousand dollars to bankroll Elijah White in an expedition to find a route across the Cascades. White failed, but later in 1845 Samuel K. Barlow, traveling west from Illinois, reached The Dalles and decided to lead his eight wagons toward Mount Hood in search of a way across the mountains.

When Joel Palmer reached The Dalles a few days later, he heard of Barlow's effort and immediately led his twenty-three wagons in hot pursuit. They joined forces, and blazed a trail over the mountains. It was Palmer, barefoot, for his moccasins had worn out, who climbed high on Mount Hood seeking a view of a pass through the mountains.

Snow eventually forced the party to cache their belongs for the winter. They pressed ahead with pack animals, their journey to Oregon City greatly spurred by a supply train sent to meet them. Its emergency rations included a hundred pounds of sugar. The following year, Barlow returned with more men and set about the task of clearing what became a ninety-mile route. For his efforts, he won from the territorial legislature a charter to levy a toll of five dollars per wagon. The Barlow Road opened.

The hardships pioneers faced along this road were scarcely less perilous than those along the river. Early snows often were a problem, and pioneers still had to negotiate Laurel Hill, a stone-strewn chute that funneled them down toward the Sandy River. This hill was so steep that wagons were tied off to large trees and lowered slowly down the hill. Rope burns on tree stumps still were visible in the 1970s.

Even once the Willamette Valley was reached, trouble was not over. The streets of Oregon City were not paved with gold. Many of the pioneers survived their first winter thanks largely to the help offered by John McLoughlin, who extended both Hudson's Bay Company credit and funds from his personal fortune to get pioneers started—and start they did, clearing land, tilling fields, harnessing the power of streams, throwing up cabins, tapping into the bounty of the land.

The young community in the Willamette Valley got a great boost from California's gold rush. It created a huge market for products Oregonians rushed to ship south—especially lumber and wheat. Nonetheless, a surprising percentage of pioneers remained restless. They moved on, wandering off to California, or turning back whence they had come. But most stayed, rolled up their sleeves, and set to work polishing Paradise.

Shoshonee Indian Preparing His Meal

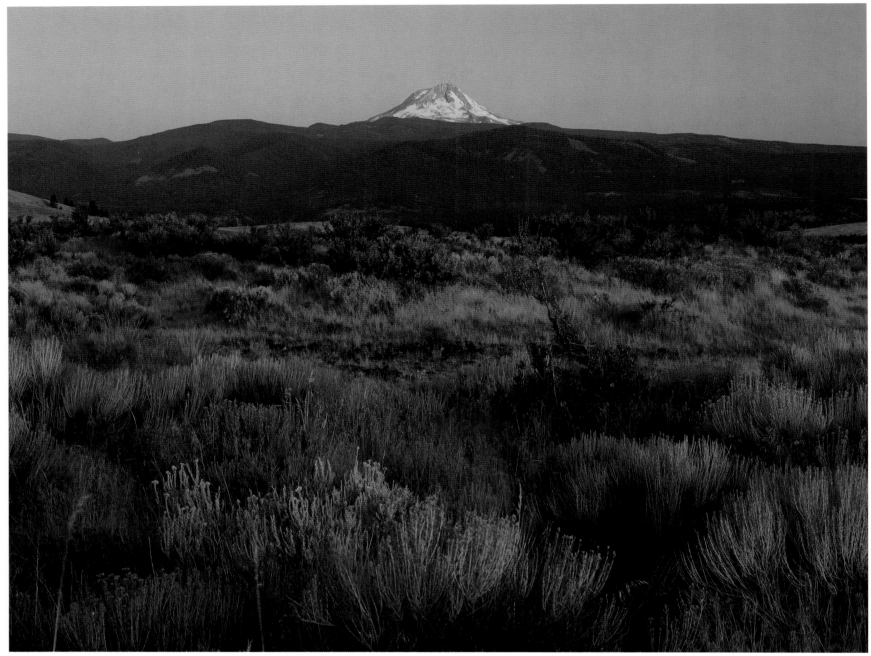

Mile 1843 Barlow Road

AT SUNRISE, MOUNT HOOD FROM THE BARLOW ROAD, OREGON. Many of Oregon's earliest settlers
aided Sam Barlow's effort to forge an easier route to the Willamette Valley. They knew development of their
new homeland depended on word getting out that the road west was as open as the welcome was warm.

The hardships and losses of emigrants at the latter end of the route is eminently calculated
to make them dissatisfied . . . many emigrants on their first arrival here . . .
write back to the States the most severe and discouraging letters.
A Representative, The Oregon Legislature, 1852

122

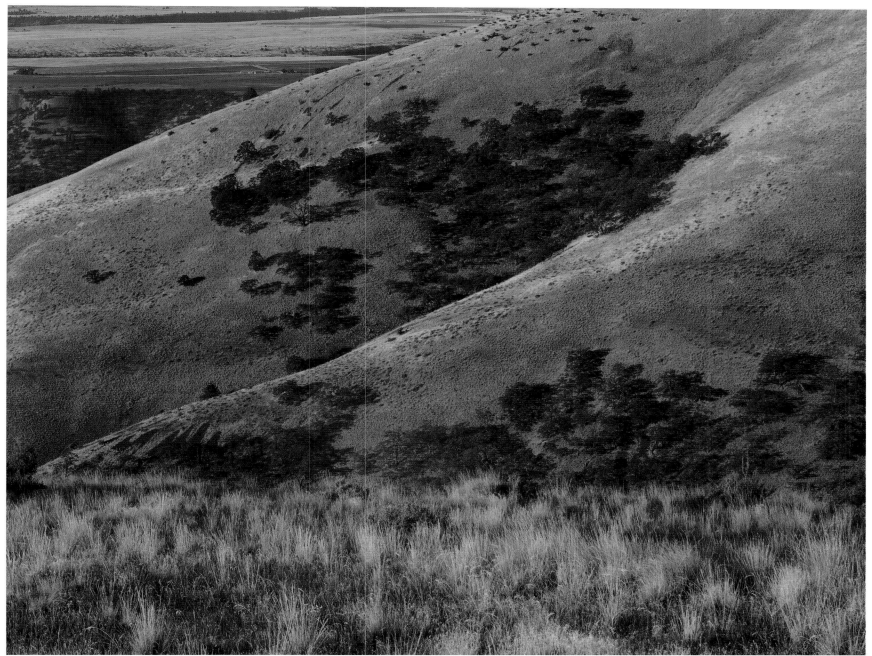

Barlow Road Mile 1846

TYGH VALLEY AND POSTAGE STAMP BUTTE, THE BARLOW ROAD, OREGON. After climbing the steep slopes south from The Dalles, the combined stage and Barlow roads descended into the Tygh Valley. From there, Barlow's road split off, heading west along the plateau into the foothills of the Cascades.

Our cattle were now so weak they could hardly walk . . . The poor creatures were literally worn out . . . I can see now how much wiser it would have been for us to have stopped every Sunday, just to have rested our poor, tired beasts.
Esther M. Lockhart, 1851

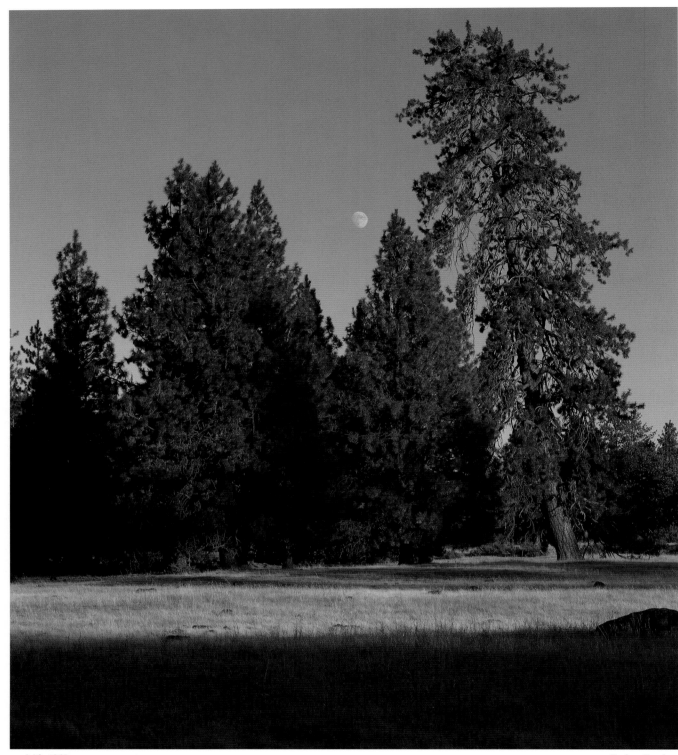

Mile 1857 Barlow Road

PONDEROSA PINES AT THE EAST TOLLGATE, THE BARLOW ROAD, OREGON.
When Sam Barlow opened his ninety-mile road from The Dalles across the Cascades into
the Willamette Valley, he levied a toll: five dollars per wagon, ten cents per head of stock.

Do not, for God's sake, ever start, or let your friends start,
on this route. It is attended with inconceivable
hardship and difficulties . . .
J. E. Squire, 1849

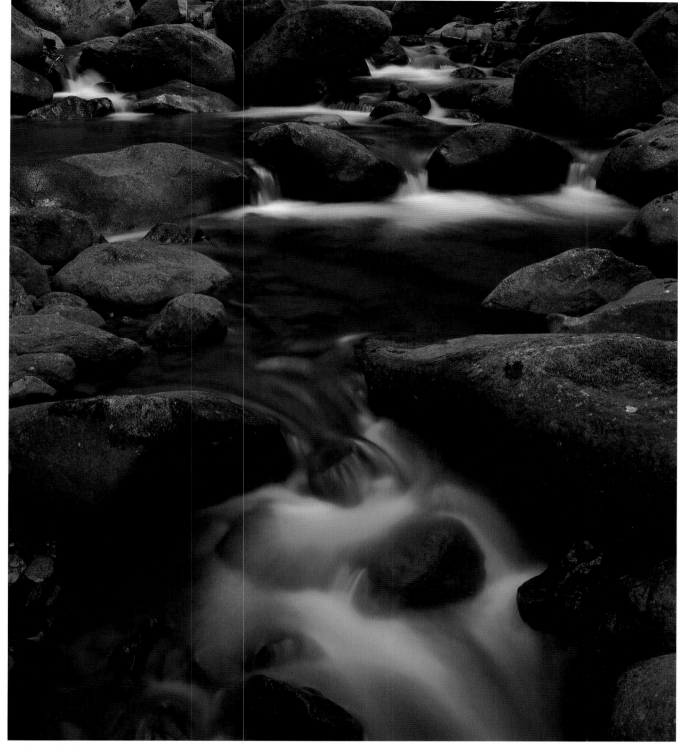

BARLOW CREEK, OREGON. On the east flank of the Cascades, pioneers found the deepest forest they had entered. Through it flowed Barlow Creek, the purest water they had tasted. This sip of "Eden" whetted appetites, providing the courage to persevere.

It would pay well for a man to go some little distance to see the timber . . .
the largest and tallest I ever saw, stands thick and some from six
to eight or ten feet through and said to be 300 feet high.
Jared Fox, 1852

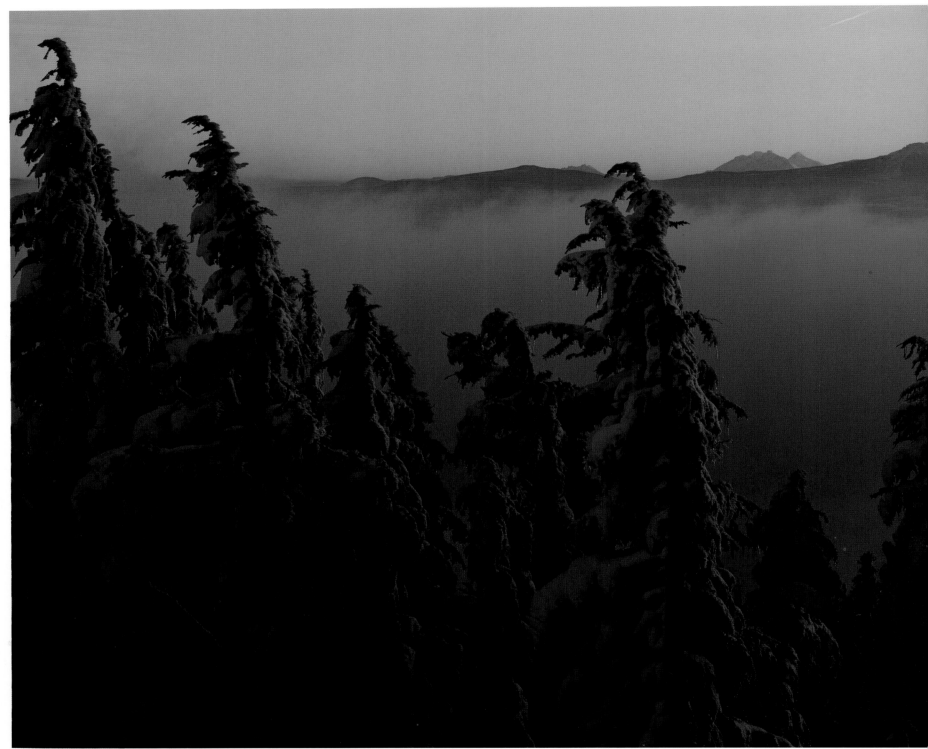

Barlow Road

JOEL PALMER'S VIEW OF MOUNT JEFFERSON, OREGON. In 1845, Joel Palmer climbed high on Mount Hood hoping to discover a pass through the Cascade Mountains that might be suitable for wagons. After finding a way through, he and Sam Barlow returned with laborers and built the Barlow Road.

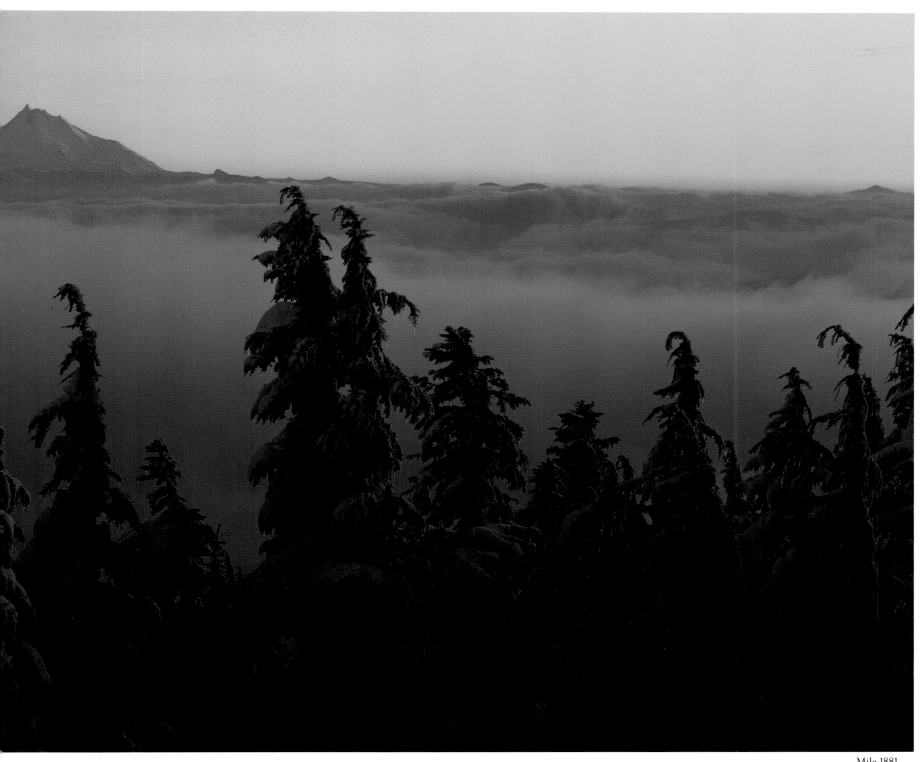

Mile 1881

After traveling four miles through the fresh snow . . . we came to where the Trail turned down
to the Sandy. We were glad to get out of the snow, as we wore moccasins,
and the bottoms being worn off, our feet were exposed.
Joel Palmer, 1845

127

THE BARLOW ROAD AT MULTOPOR SUMMIT, OREGON. Wending its way over stumps and around huge trees, the Oregon Trail here narrowed to a single track. Just ahead lay one of the most difficult of all stretches, the descent of Laurel Hill, where wagons had to be lowered by rope down the steep incline.

We traveled seven miles and came to the Laurel Hill. This is the worst hill
on the road from the States to Oregon.
Absolom Harden, 1847

WILD STRAWBERRY, CASCADE MOUNTAINS, OREGON. All their way across the prairie, pioneers had enjoyed the fruit of the wild strawberry. In the mountains, they found the plant's leaves made a fine tonic tea to help counter the affects of a poor diet.

We had left one wagon and team, and my two mares on the summit . . .
and our . . . entire stock left there perished . . . I found it out of the
question to get my family out of the mountains without help.
Reverend Neil Johnson, 1851

Mile 1888 Barlow Road

DOUGLAS FIRS NEAR THE WEST TOLLGATE, OREGON. Few campfires warmed only a man, his wife, and two children. More typical was the 1853 outfit of John Smith: his wife, three daughters, one grandson, a friend, four hired hands, three wagons, one carriage, five horses, fourteen oxen, thirteen cows, and a bull.

We had the worst road today we have ever had, and it rained.
Jesse Moreland, 1852

VINE MAPLE, OREGON. After struggling through the swamps at Government Camp, and plunging through the fall palette of Laurel Hill, emigrants pressed on to the Sandy River. With nearly two thousand miles of Trail behind them, Oregon City and the Willamette Valley felt at last within their grasp.

We soon find a suitable place, camp, and another is added to our
number. Mrs. Hutchison has a fine boy. We name it
Sandy . . . we only stop here one day.
George Miller West, 1853

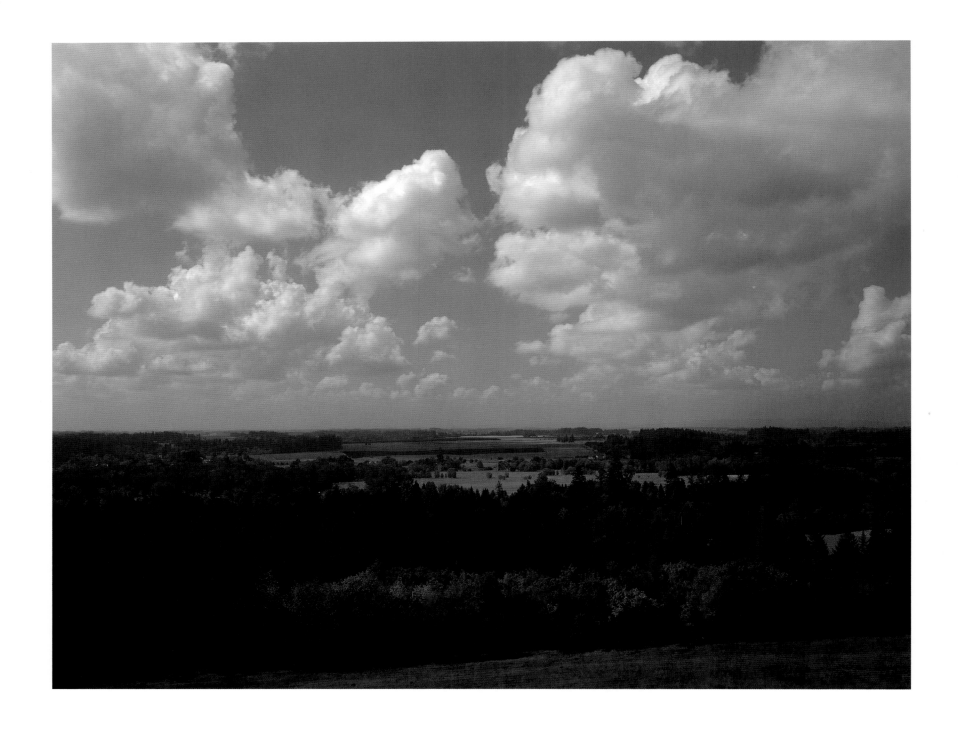

CHAMPOEG, OREGON. This is where it all began. John Jacob Astor's Pacific Fur Trading Company built a trading post at this Edenic spot on the banks of the Willamette River. It was to this little piece of Paradise that mountain men, when they tired of all their trapping, retired to reminiscing, and rocking chairs.

Two-thirds of the time of the settlers is . . . at their own disposal; and unless education,
with its moral influence, is attended to strictly in this young settlement,
these very advantages will prove its curse.
Lieutenant Charles Wilkes, 1841

The Land at Eden's Gate

Hundreds of reasons have been offered to explain what could have propelled a quarter of a million people to undertake the journey along the Oregon Trail. None fully explain this most remarkable episode in human history. Some people surely were in flight from something—the old. Some people surely were engaged in a desperate search for something—the new. All were clothed in some combination of despair and dreams.

But there was something else, something almost illogical about it all. It has to do with some basic human instinct: to be first, to be a trail blazer, to walk toward the setting sun.

The remarkable odyssey of these emigrants, whose journey comprised one of the largest peacetime migrations in history, was born in the most irresistible of human urges—the search for a fresh start. Pioneers were welded to their quest by the single most irresistible of human impulses—the surge of hope over experience. No matter how hard the journey, no matter how terrible the suffering, no matter how high the price, pioneers kept on taking one grueling step after another.

Their six-month march alternated between mind-numbing monotony and dreadful danger, between searing heat and fearful cold, between tempest and terror, deprivation and drudgery. Before they were through, one in twenty of them—more than ten thousand men, women, and children—lay in a Trailside grave. Still they came, year after year, for they were convinced that something unique awaited them in Oregon Country—a new beginning in a new land.

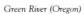

In fact, people had been living in Oregon for more than ten thousand years. The earliest inhabitants likely had come from the north, across the top of the world. They were probably hunters, searching for prey, traveling far from the land we now call Siberia.

By the eighteenth century, nearly one hundred Indian tribes and bands lived throughout Oregon, speaking a score of different languages. They settled first in the desert country of the high plateau, spread next along the salmon-choked Columbia River, and finally moved south into the mist-wrapped coastal estuaries and the lush forests that tumbled toward the Pacific shore.

Many Indians were hunters, fishers, and gatherers, living directly off the bounty of this land: game, waterfowl, roots, berries, salmon, shellfish. From the cedar tree they procured all manner of possessions: clothing, containers, and canoes. Some tribes engaged in extensive trading with Indians from as far east as the Great Plains—all under the never-blinking, always mischievous eye of the legendary Coyote.

Indians lived in harmony with the land, for theirs was a world in which all things—man, mountain, moon—were filled with the same spirit. The Indians of the Oregon Country were the kind of people who could walk ten centuries upon a land and leave little but footprints—and then something began to change.

Hugging the coast, but not too closely, the tall ships came; then went. They came again, and this time men stepped ashore; then went. And came again. And stayed. They traded for sea otter pelts, then for beaver fur. They looked, listened, learned—and they lied. Soon others followed, this time from beneath the rising sun. The first came in canoes; the next on mules. Finally, in 1843, came men, women, and children with wagons.

The pioneers did not find in the Willamette Valley everything that had been promised. The pigs were not born with knife and fork ready planted in their loins. The fence posts did not bear fruit. But it was indeed an uncommon place, this land of rainbows. Pioneers went after it with a vengeance, and Oregon gave up its secrets and its spoils. The soil was rich, the weather clement, the water clear, the air clean, the trees endless. Or so it seemed.

A century later, ninety percent of the old trees were gone. Gone, too, were ninety percent of the wild fish. Salmon no longer returned to the spawning beds hidden hundreds of miles inland, safe from all predators save one. By the tail end of the twentieth century, entire forests were dying, entire watersheds were crippled. Suddenly, it seemed there were limits, after all, and the end might be in sight. From the summit of every hill, it seemed possible to see a day when Oregon's cupboard might be bare.

From the earliest days, there had been calls to husband carefully this piece of Paradise, but the calls had been drowned by the roar of the steam engine, the whistle of the mill. For far too long, some people treated the Oregon Country as though one day, its resources depleted, they might simply move on—and some did exactly that. Those who remain face the challenge of forging a different relationship to the place they call home.

To many of those who crossed the Oregon Trail, the land they entered through Eden's Gate looked like a wilderness waiting to be tamed. They were tough people, maverick and stubborn. They were God-fearing folk, and devilishly determined to carve themselves out a future. They pressed on beyond the Willamette, slipping into the fog-shrouded coastal valleys, the fir-studded coastal hills, the sage-scented high desert country, and the great basin grasslands. They came to change the land, but found instead the land changing them. It made them Oregonians, and, one hundred fifty years later, still they struggle to find the balance in that blessing.

Green River (Oregon)

ANCIENT FOREST ALONG BAGBY CREEK, OREGON. As pioneers explored beyond the floor of the Willamette Valley, they found much of western Oregon to be a wilderness of huge trees and rushing rivers. With saws, axes, plows, and boundless optimism, they set about carving homesteads from this virgin land.

I cannot but view this Territory as peculiarly liable to the vice of drunkenness. The ease
with which the wants of man are obtained, the little labor required,
and consequent opportunities for idleness, will render it so.
Thomas J. Farnham, 1839

THE ROSE FARM, OREGON CITY, OREGON. Not all new arrivals took to the woods armed with an axe, eager to build a log cabin. Completed in 1847 by William and Louisa Holmes, the Rose Farm is the oldest American house in Oregon City. Territorial Governor Joseph Lane gave his first address from this balcony.

Came to the long expected City . . . worst
looking place for a City I ever saw.
Maria P. Belshaw, 1853

WHEAT FIELD NEAR MOUNT ANGEL, OREGON. Grain was one of the first crops raised by overland emigrants, most of whom came from the Midwest. In 1849, for instance, Micajah Littleton noted all fresh graves: 54 percent of all who died hailed from Missouri.

Nothing but the Pacific Ocean broke up the migratory habit.
John Carr, 1846

THE CASE HOUSE, CHAMPOEG, OREGON. This Greek Revival house was built in the 1850s by William Case to serve as the centerpiece of one of the largest farms in the Willamette Valley. It was restored in 1977 by Wallace Kay and Mirza Dickel Huntington.

Yes, we are at the end of our journey, and on some accounts
I half regret it, on others am heartily glad.
Eugenia Zieber, 1851

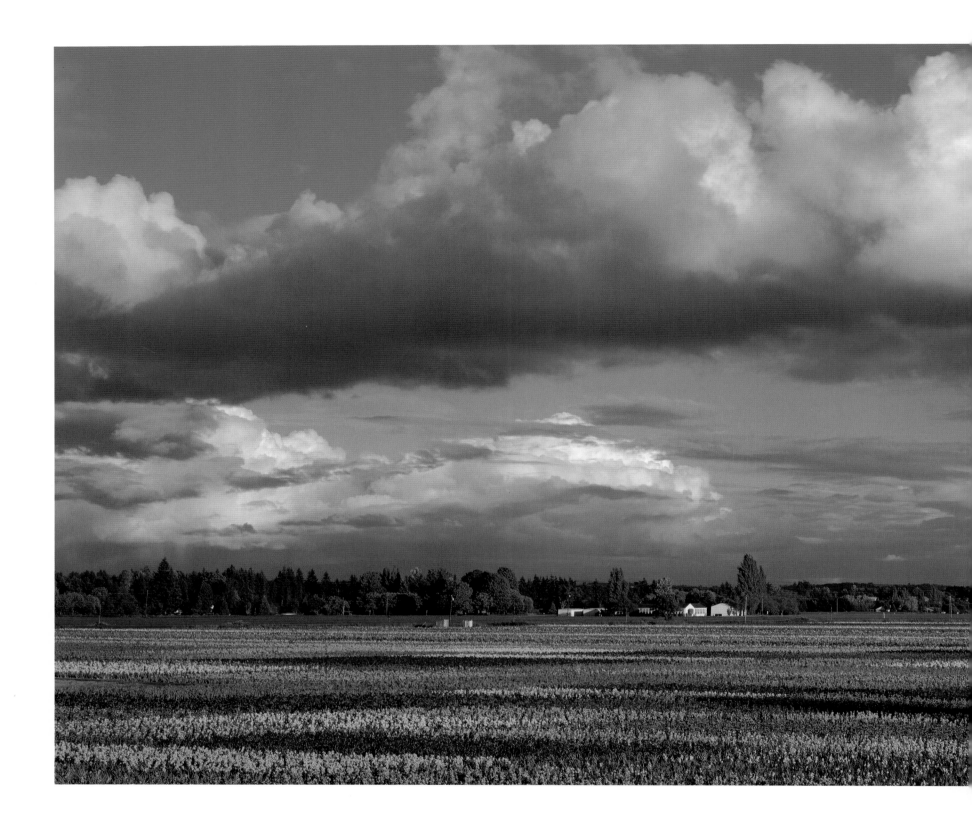

IRISES NEAR BROOKS, OREGON. Fenceposts plunged into this soil did not bear fruit, but the Willamette Valley was indeed a land of uncommon fertility. For six months, day after dreary day, pioneers had walked west. With every step they envisaged a Paradise at the end of the rainbow. Finally, they saw it.

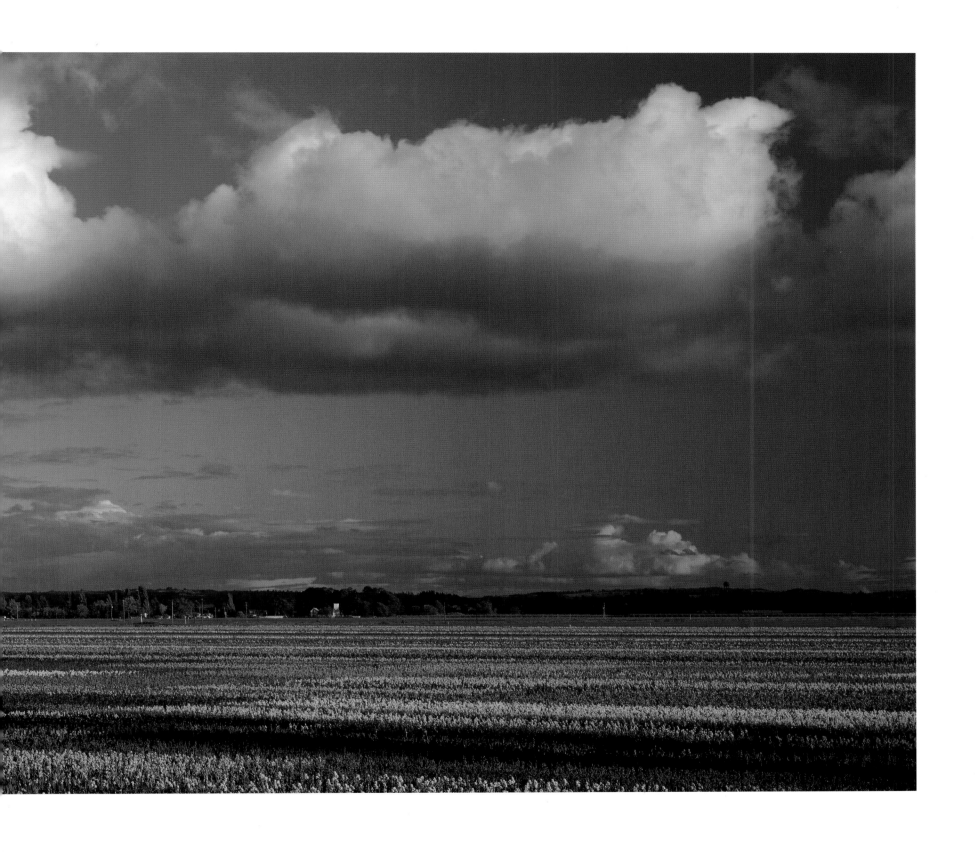

The handsomest valley I ever beheld. All charmed with
the prospects and think that they will be
well paid for their sufferings.
Virgil Pringle, 1846

THE JAMES F. BYBEE HOUSE ON SAUVIE ISLAND, OREGON. In 1847, James Francis Bybee settled on Sauvie Island, then left for a stint in the California goldfields. In 1858, he built this Classical Revival house, with nine rooms and six fireplaces. Restored by the Oregon Historical Society, it is open to the public.

To conclude, few portions of the globe, in my opinion, are to be found so rich in soil,
so diversified in surface, or so capable of being rendered the happy abode
of an industrious and civilized community.
Thomas J. Farnham, 1839

WATER LILIES, OREGON. On September 20, 1853, George Belshaw's wife, Candace, gave birth at a campsite beside the great river of the West. She named her Columbia. The child lived only two weeks. Belshaw, stoic to Trail's end, made no mention of his daughter as he inked the final entry in his diary.

*We started the cattle again, the trail goes near by the river most of the way
and good grass in patches . . . We drove about fifteen miles and
camped on a little creek just beyond the large mountains.
George Belshaw, 1853*

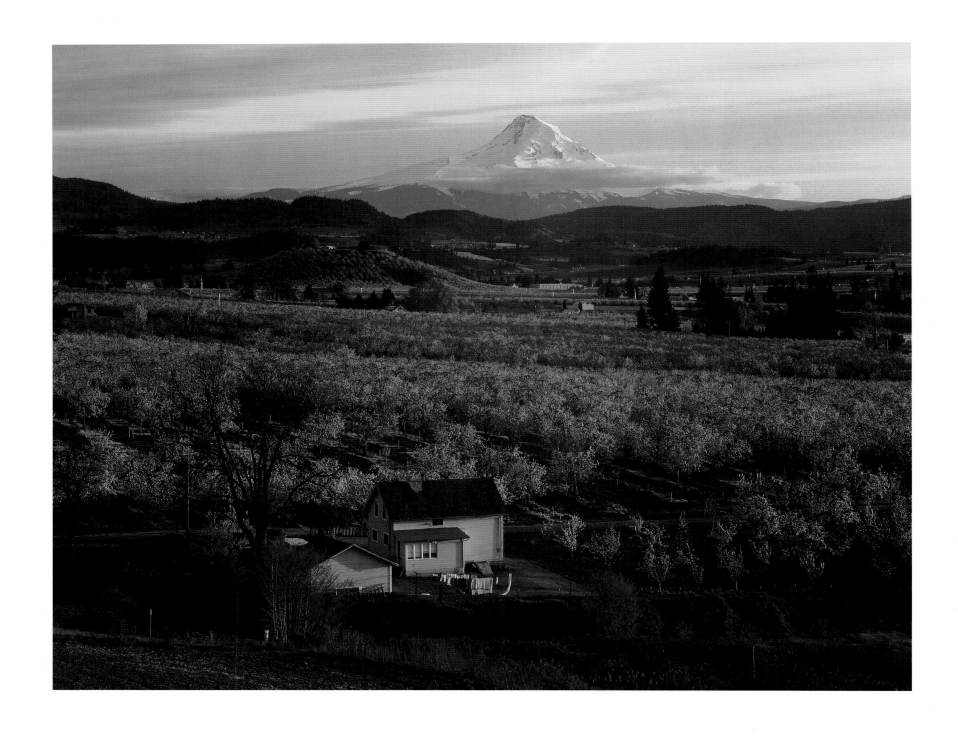

MOUNT HOOD AND THE HOOD RIVER VALLEY, OREGON. Settlers soon spilled over each side of the Willamette Valley, toward the coast, the foothills, the high grasslands, and the remote mountain valleys beyond. They had laid claim to Paradise; responsibility for its upkeep now lay at their door.

Then it may be asked why did such men peril everything . . . exposing their helpless families to the possibilities of massacre and starvation, braving death—and for what purpose? I am not quite certain that any rational answer will ever be given to that question.
James Nesmith, 1843

Companions, Campsites, & Conestogas

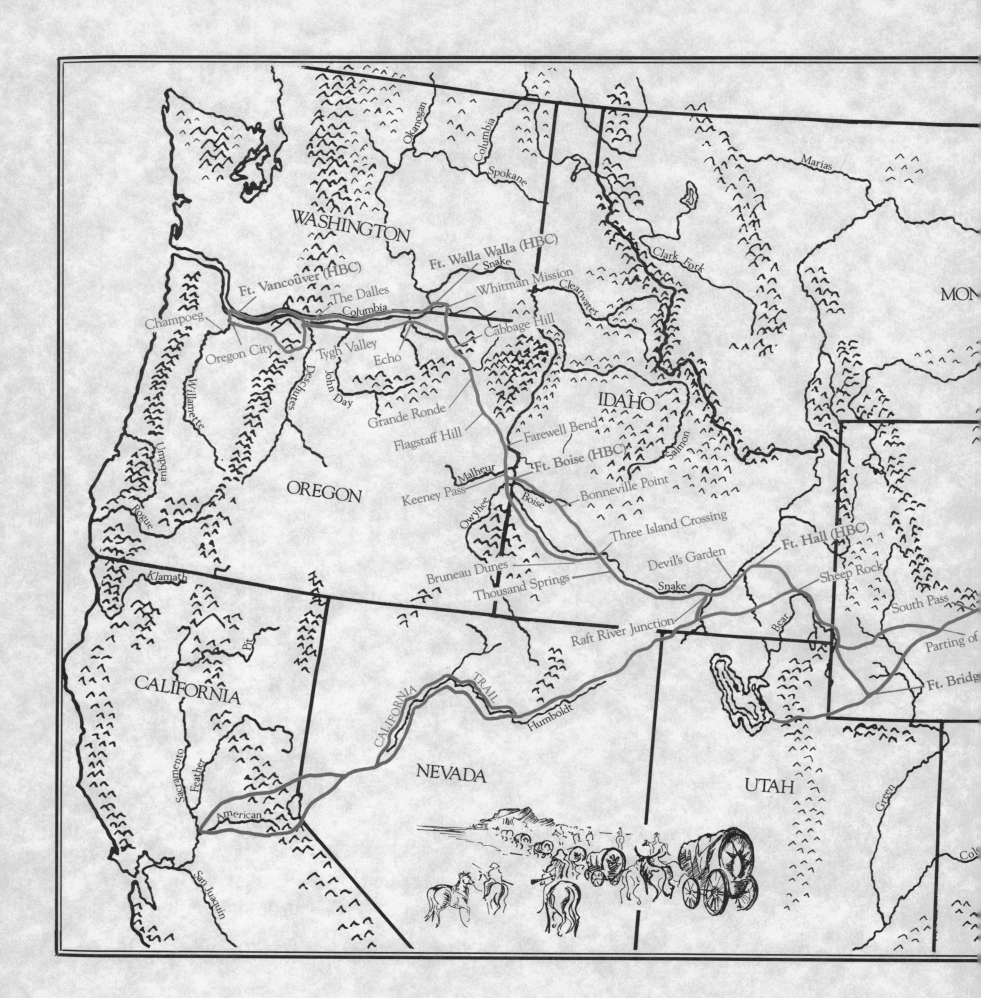